May, 2023

Kim Anh,

I am happy for you and your many accomplishments and successes this spring. Seeing you yesterday at the AP Art Show was a highlight for me and I am sure for you. I wish you all the best on your journey, and I believe in you finding the right path for you going forward. Warmly,

Jess Hill

MARY ELLEN PETHEL

Foreword by Martha Ingram

ALL-GIRLS EDUCATION *from* WARD SEMINARY *to* HARPETH HALL, 1865–2015

THE
History
PRESS

Published by The History Press
Charleston, SC 29403
www.historypress.net

Unless otherwise noted, all photos are courtesy of
THE HARPETH HALL SCHOOL ARCHIVES.

First published 2015
Second printing 2015

Manufactured in the United States

ISBN 978.1.62619.762.6

Library of Congress Control Number: 2014957215

CONTENTS

FOREWORD

From time to time, parents of young girls ask me about single-gender education. "Will my daughter find her place in the modern world if she attends school only with girls? Is single-gender education a wise choice?" I always respond with a resounding, "Yes. Single-gender education is a superb choice."

After attending the all-girls Ashley Hall in Charleston, South Carolina, and the then all-women Vassar College, I have spent much of my life in a mostly male environment as part of Ingram Industries Inc. and as a board member of Vanderbilt University, Baxter International Inc., Weyerhaeuser, Nashville City Bank, Commerce Union Bank, Nations Bank, Bank of America, First American, AmSouth, Regions, and Ingram Micro. The all-female education I received imbued a culture of achievement, conviction, and accomplishment—not a culture based on popularity and appearance. The single-gender education setting gave me the self-confidence, capability, and leadership skills to be fully comfortable in that mostly male environment. My educational experience enabled me to learn about myself early in life as I created an identity, explored my interests, and set about realizing my goals.

If the purpose of an education is to enable a girl to achieve her best and become a leader capable of improving the world, single-gender schools such as the Harpeth Hall School produce graduates who possess the skill set necessary to achieve success in any arena. The school emphasizes critical thinking, articulate public speaking, persuasive writing, honorable character,

and a respect for others. Harpeth Hall stresses and practices these attributes each and every day, guided by gifted teachers who fully engage students in an academic-centered environment. The school also provides a supportive and encouraging atmosphere where a girl can develop passion for endeavors appealing to her and learn to focus on goals that she sets for herself. Although doing so is a lifelong enterprise, what better opportunity exists to learn than simultaneously among friends and peers?

Mary Ellen Pethel's *All-Girls Education from Ward Seminary to Harpeth Hall, 1865–2015* captures the spirit and legacy of single-gender education over the past 150 years. Her narrative explores the intersection of active, visible, and fully engaged women with schools designed specifically for young women. She places the rich history of Harpeth Hall within the broader evolution of all-girls schools and the role of women, education, and the public sphere.

More than any other time since the 1960s, women are showcasing their talents and contributing positively to all sectors of society. All-female schools, like Harpeth Hall, have experienced a revival since the 1990s in part because such schools are uniquely qualified to prepare girls to lead and live full lives armed with confidence, intellect, versatility, and integrity. This book will be of significant interest to those who have benefited from the school as well as young parents pondering if Harpeth Hall is the best school for their daughter. It will also add greatly to the history of women and education, specifically in the American South. I think anyone reading this book will be impressed with the school's history, which Dr. Pethel documents so well and describes in a most engaging narrative.

Martha Ingram
Chairman-Emerita, Ingram Industries

Mother of Robin Ingram Patton, class of 1984;
Grandmother of Christina Chapman, class of 2010;
Reid Patton, class of 2014;
Martha Ingram, class of 2015;
Virginia Ingram, class of 2015

ACKNOWLEDGEMENTS

When I think about my tenure at the Harpeth Hall School, I am convinced that stars do, in fact, align. After completing my PhD history course work in December 2006 at Georgia State University in Atlanta, I began my dissertation with a focus on exploring the emergence of modern college life during the Gilded/Progressive Era. I chose Nashville because of its reputation as the "Athens of the South," and I sought to explore issues of gender, race, leisure, sports, and urbanization. By March 2007, I had begun the research process in earnest when I received a call from Kristina Bratt Rigsby, my college roommate and closest friend. Her sister, Lisa Bratt Keen, chair of the Harpeth Hall Science Department, had asked if I was interested in applying for a teaching position at the school. At the time, I was unaware of the historical connections between Ward Seminary, Belmont College, Ward-Belmont, and the Harpeth Hall School. Within eight weeks, I had interviewed, accepted the job, and moved to Nashville.

As I continued work on my dissertation, I realized that Harpeth Hall was a direct descendant of the girls' schools heavily featured in my research. In addition to teaching I began working with Emily Zerfoss, Sallie Norton, and Cathy McCain—alumnae who had devoted countless hours to preserving the school's history through the newly established Harpeth Hall Archives. If not for the Bratt family and others who helped me land and settle in Nashville, I would not have written this book. It makes one think it was all meant to be.

ACKNOWLEDGEMENTS

As the sesquicentennial anniversary approached, I asked then Head of School Ann Teaff if she would be interested in my writing a book to document the school's history and to place the history of Harpeth Hall within the broader context of girls' education since the Civil War. I also believed that such a project would firmly connect and clearly explain the lineage of Harpeth Hall with its predecessor schools. To my delight she said yes, and I will be eternally grateful to Ann Teaff for her interest in and support of this project as well as her faith in me. She ably led Harpeth Hall for sixteen years with vision and integrity, transmitting the school "not less, but greater, better, and more beautiful than it was transmitted to [her]."

The research and writing process for this book owes a great deal to a great many people. In the early stages, Ron Watson, George Tattersfield, and Jennifer Dickey helped me to find the right publisher. Many others gave generously of their time and energy through interviews, conversations, reading, revisions, and, at times, just good old-fashioned inspiration. This incomplete list includes Patty Delony, Dianne Wild, Anne King, Joanne Mamenta, Leslie Matthews, Peter Goodwin, Tony Springman, Janette Fox Klocko, Jenny Byers, Emily Zerfoss, Margie Martin, Marie Maxwell, Susan Timmons, Beth Trescott, Molly Rumsey, Allen Karns, Nicola Pollard, Emily Berry, Jennifer Webster, Polly Linden, Lynn Heath, Alexis Hyrup, Becky Gregory, and Megan Wakefield. Rob and Joseph Pethel, and particularly my parents, Stan and Jo Ann Pethel, have written this book vicariously with me, checking in regularly from Georgia through every development and stage of the process. I remain grateful for their unwavering interest and enthusiasm through many, many conversations about "the book." I would also like to express my appreciation to members of the class of 1968, the class of 1982, the class of 2015, and Reese Witherspoon for providing me with wonderful anecdotes and reminiscences about their years at Harpeth Hall and their recognition of the unique experience provided to them through single-gender education. I also offer my sincere gratitude to Martha Ingram for writing such a thoughtful and articulate foreword. I can think of no one better to represent the success that can come with girls' education and the continued support of its mission.

Advancement Director Susan Moll and Alumnae Relations Director Scottie Coombs were invaluable throughout the process, and I thank them for their collaboration, time, and attentiveness. Harpeth Hall is lucky to have them. The school is also lucky to have more than six thousand supportive alumnae in forty-nine states and abroad. In particular, Harpeth Hall alumna Amy Grant has inspired me through her music for as long as I can remember.

ACKNOWLEDGEMENTS

Director of Communications Joanne Mamenta; Lauren Finney, the school's graphics designer extraordinaire; and Capell Teas Simmons, class of 1982, assisted enormously with searching, scanning, and selecting images. Their efforts brought life to the narrative through wonderful images, each with its own story to tell. In addition to being my division head, Jess Hill provided me with content information and a careful reading. She is Harpeth Hall's North Star, and I am thankful for her mentorship as well as her charismatic combination of reassurance and good humor. Ophelia Thompson Paine was the muscle behind the might of this project. She served as my copyeditor but also my reference for Nashville history. Ophelia helped transform this book in ways I could not have done without her guidance, insight, and poignant attention to detail. I remain deeply indebted and count myself as one of her biggest fans. I would also like to express my gratitude to Head of School Stephanie Balmer, who has taken the torch passed to her as she continues to shine the way forward for Harpeth Hall and the empowerment of young women. She celebrates our past and our present anniversary while keeping her eye on the future pulse of girls' education. Of course, my students also deserve a hearty thanks, as they provided me with encouragement, brilliance, and vision—most often without realizing it.

While I have done my best to be accurate and comprehensive, there are surely errors and omissions in the pages that follow. Any mistakes are unintentionally mine. At its heart, this book traces the evolution of girls' education from Ward Seminary to the Harpeth Hall School and seeks to provide all who are connected a sense of self, school, and community. Ward-Belmont alumna Jan Ellen Tye, class of 1949, wrote before her graduation, "[O]ur journey does not end here, there is still much to learn and much to give."[1] I echo her charge. Writing this book has been a journey of discovery and a labor of love. It remains my deepest hope that it is also a joy to read.

Introduction

NASHVILLE AND SINGLE-GENDER EDUCATION IN CONTEXT

Ask any local Nashvillian about significant historic landmarks in downtown Nashville, and most quickly name Ryman Auditorium, Union Station, the Hermitage Hotel, War Memorial Auditorium, Hume-Fogg High School, the U.S. Customs House, or even Second Avenue's warehouse buildings. In fact, none of these structures existed before the late nineteenth and early twentieth centuries. In the fall of 1865 Ward Seminary opened literally in the shadows of the Tennessee State Capitol building. The capitol presided over a growing but still largely residential neighborhood that included the Old First (now Downtown) Presbyterian Church (1849) and the striking Italianate building now called the Smith House (1859), the only remaining grand town house in downtown Nashville. There were no electric streetcars, only horses and buggies, and while downtown likely bustled with the comings and goings of families and businessmen, there were no flashing lights or tourists. Country music, the Grand Ole Opry, and radio would not emerge until the first decades of the twentieth century.

After Tennessee's secession from the Union, Nashville became the first southern city to be occupied by Union forces following the fall of Fort Henry and Fort Donelson in February 1862. For most of the war, Nashville remained under Union occupation, and in many ways, the city benefited from the presence of its occupiers. As other cities in the South experienced destruction through fire, evacuation, and derailment,

Nashville escaped such widespread devastation. After the Civil War, as a "New South" model began to transform largely agrarian areas into industrial centers, Nashville remained uniquely poised to follow this vision due to the city's demographic and cultural composition.[2] Nashville was an emergent southern city, with growing middle and upper classes, positioned to become the "Gateway to the West" as a railroad hub and a river connection extending as far as New Orleans.

In 1868 *Nashville Union and American* touted Nashville as "far-famed in the musical world for the eminent talent of its amateurs and professionals in the Apollinarian art."[3] This reputation for cultural arts would grow alongside Nashville's new pursuits, which included music publishing, venues, and broadcasting from 1865 to 1900. In addition to new industry, transportation, and an emergent arts scene, education in the New South also expanded and reformed. Changes in education were aided by the creation of the Department of Education in 1867, the Southern Association of Colleges and Schools (SACS) in 1895, and the Southern Association of College Women (SACW) in 1903.[4] Businessmen and philanthropists Cornelius Vanderbilt and George Peabody would help to solidify Nashville's reputation as an educational center known as the "Athens of the South."

Immediately following the Civil War, Ward Seminary opened at precisely the right moment in urban and southern history. On September 4, 1865, Dr. William Ward and his wife, Eliza Hudson Ward, opened the new school in the heart of downtown Nashville with six boarding students and forty day students. They began the school "with the idea of establishing a private seminary for girls, which would prove an honor to the South and would become a self-sustaining institution… [to] influence not only the lives of all the students…but the intellectual and cultural life of the entire city of Nashville."[5] Privately owned and governed, female academies emerged in the early 1800s and expanded throughout the nineteenth century. The term "seminary" also became popular in the nineteenth century and referred to female schools whose curriculum was more academically rigorous than traditional academies. Such educational institutions were seen as culturally acceptable alternatives to traditional male schools and curricula.

Females attended colleges and seminaries in greater numbers throughout the United States after 1865 for several reasons. Many institutions of learning opened after the Civil War, particularly in the South, as women and their families increasingly valued and pursued education beyond the elementary level. Private or independent schools remained preferable for

middle- and upper-class families in order to insulate their daughters from the "moral danger" and chaos of urban public schools and to ensure that their education properly prepared them for marriage and life's work. Moreover, from 1865 to 1910, the education profession for primary and secondary schools shifted predominantly to women. Female teachers needed collegiate and pedagogical training, and as such, institutions of higher education were needed to train them. Still, education for females beyond the secondary level remained a controversial issue, especially in the South. Debates raged about the level of curricular academic rigor, the intellectual capacity of women, and the effects of educated women on society.

The Industrial Revolution, the growth of urban areas, and the increasing democratization of education greatly influenced educational reform on a national level during the Gilded/Progressive Era.[6] Leading educators such as Charles Eliot at Harvard, Andrew White of Cornell, and John Dewey at the University of Chicago challenged the components of classical education. Certain reformers argued that higher education should "broaden the scope of their curricula to incorporate more science, technology, non-classical languages, and other modern subjects."[7] Others believed that education should shift completely to an industrial and pragmatic curriculum. Educational institutions in Nashville also reflected these trends; however, some classical study was retained in all of the city's private schools.

By the late 1880s, Ward Seminary had garnered national attention as a reputable school offering instruction from the primary level through introductory college level courses. The school championed the value of single-sex education and earned national acclaim from educators in the North: "[Ward's] has educated a great many of the most prominent women of the present and previous generations. Thousands of its former students live in the city…[and] among these are the daughters of leading educators, clergymen, and numerous other citizens of the highest culture who esteem…the ideals to which [the school] clings."[8] President Noah Porter of Yale College also commented on women's education in 1885: "I have no objection to learned women, but I would have them remain women; and, if they were to be perfect women, they must be trained as women; and womanhood, even in girlish years, requires isolation and reserve, if nothing more."[9]

In 1890 the number of "learned women" would increase in Nashville when a new school for females opened just west of downtown. Two

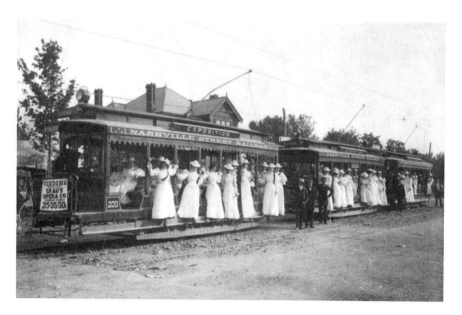

Students aboard a Nashville trolley to attend Ward's Day at the Tennessee Centennial Exposition in Nashville, 1897.

female educators from Philadelphia, Susan Herron and Ida Hood, opened Belmont College for Young Women with ninety students the first year. The campus was located on the Belle Monte estate, which Hood and Heron purchased in 1889 after visiting Nashville to attend the National Education Association conference. This beautiful estate, once home to antebellum heiress Adelicia Acklen, was described as follows: "Like Rome resting on her seven hills…to the north can be seen the picturesque city of Nashville…to the south stretch the purple outlines of the Harpeth Hills; to the west the splendid spaces of landscape; and to the east the winding Cumberland River."[10] The opening of Belmont further established West Nashville as the home of Nashville's educational center seven years before the 1897 Centennial Exposition, which cemented the city's reputation as the "Athens of the South."

Neither Ward Seminary nor Belmont College was accredited to confer bachelor's degrees, but after the two schools joined forces in 1913, the Ward-Belmont School maintained a status equal to an elite college preparatory school and, later, a junior college and music conservatory by 1930. The school was located less than one mile from the campuses of Vanderbilt University and Peabody Normal School after its merger. Nearly all of Ward-Belmont's students were young ladies from affluent

families across the South, and they created a new image based on custom and ritual as well as innovation and progress.[11]

The concept of a finishing school was used historically to describe all-girls schools devoted to the preparation of young women for lives in society. The term assumed a somewhat negative connotation in the twentieth century as girls' schools offered an increasingly rigorous academic curricula comparable to that of boys' schools. From the late 1800s to the early twentieth century, single-gender institutions of secondary and higher learning shifted from finishing schools to springboards for limited professional opportunity and continued education. The emergence of new colleges and universities from the 1860s to the 1920s, combined with greater freedom, allowed for individual expression and active involvement in the public sphere to create the "modern woman." Such a new generation of women not only took advantage of educational and entertainment opportunities but also participated directly in physical recreation through bicycling, gymnastics, and sports. Women pursued and mastered their academic studies and increasingly participated on the public stage as they sang, acted, traveled, and debated—all the while still submitting to strict standards of dress and decorum. As Nashville urbanized in the early 1900s, the city's growth and modernization paralleled evolving cultural views regarding education and gender, despite the slower pace of Southern Progressivism. As a result, a new generation of young women emerged—young women who indelibly shaped new acceptable cultural norms, transitioning from roles largely relegated to private spheres to more visible participants in public spaces and institutions.

Following the Great Depression and World War II, many all-female institutions closed their doors as high schools and colleges moved toward coeducational models, replacing many of the outdated traditions and engendered educational tracks for women. Ward-Belmont also fell victim to this trend. The school was sold to the Tennessee Baptist Convention in 1951, to the dismay of its many devoted alumnae, faculty, and students. The college reopened as a religiously affiliated four-year coeducational institution—today's Belmont University. However, the Nashville community and alumnae from across the nation saved the college preparatory division of the school, relocating it farther west and reopening as the Harpeth Hall School in the fall of 1951. Non-parochial, single-gender education would be saved in Nashville through the efforts of visionary leaders and community members who displayed a resilient commitment to girls' education that not only survived but thrived after a period of transition.

INTRODUCTION

By the 1970s, single-gender schools, particularly all-female campuses, seemed on the brink of extinction. The Educational Amendments of 1972 included a provision known as Title IX, which was intended to bring gender equity to any school receiving federal funding and sought to provide equal access to educational opportunities for boys and girls. Ironically, in an effort to promote gender equity, nearly all public single-sex schools were combined or closed. This phenomenon trickled down to independent schools as well, with the number of single-sex schools in steep decline by the 1980s. However, in the long run, public policy in the form of Title IX shifted the debate in positive ways for girls' schools. With female students receiving the promise of educational equity from the federal government, women's sports allowed girls to participate and compete in varsity athletics for the first time since the 1920s. At Harpeth Hall and other girls' schools throughout the country, greater participation in competitive athletics complemented the confidence young women gained from academic achievements. Surviving women's colleges and college preparatory schools from the first half of the twentieth century began to benefit from Title IX and related social movements by the 1990s. By the end of the twentieth century, the single-gender model had emerged once again as a viable and often enviable educational path for girls.

From the 1970s to the 1990s, the Harpeth Hall School endured two decades of transition and emerged with a renewed purpose and vision—reinforcing the advantages and values of an all-girls school. Girls' schools also worked on branding a new image reflective of the reality of a rigorous education that served as a gateway to the nation's top colleges rather than lingering perceptions associated with finishing schools. Single-gender education evolved and adapted to strengthen curriculum, expand extracurricular offerings and sports, encourage leadership, and reassert the importance of an academic reputation of excellence and honor. Increasingly, since the 1990s, women and local communities traded in the notion that independent all-girls schools existed as a practical alternative (albeit one still borne out of gender segregation and discrimination) and began to see that all-female schools were advantageous in their own right. Single-gender schools afford greater prospects for meaningful learning in the classroom while providing a safe environment for young women to grow as strong thinkers and achievers. In the last decade alone, multiple U.S. Department of Education studies and an independent study conducted by the University of California–Los Angeles (UCLA) have shown that single-gender education provides female students with positive role models, reduces sex stereotyping in curriculum and the classroom, and offers abundant learning possibilities.

Single-gender education allows girls greater opportunity to be confident leaders, learners, professionals, and, above all, critical thinkers who fully engage within their communities. As the National Coalition of Girls' Schools states, "Simply put, girls' schools teach girls that there is enormous potential and power in being a girl."[12] An analysis of the shared histories of Ward Seminary (1865), Belmont College for Young Women (1890), the Ward-Belmont School (1913), and the Harpeth Hall School (1951) reflects the growth of women's education since the Civil War on regional and national levels. In its storied 150-year history, the vision for and desire to provide the best education for young women has remained constant. Educational pedagogy and opportunity related to females have changed even since 1972. Similarly, expectations and possibilities for young women after graduation have grown substantially. The history of the Harpeth Hall School adds greatly to existing scholarship on issues related to gender, education, and urbanization—particularly in the South. The school's historical narrative provides a clear case study in which to follow these issues back in time and trace their path to the present. This study will tell the larger story, from the vantage point of one institution, of the evolution of single-gender schools from the late nineteenth century to the early twenty-first century. It is a story about all girls.

In 1877 President Rutherford B. Hayes announced, "Nashville's importance as a strategic point during the Civil War forecasted her importance as a commercial center, and I believe you will live to see her a city of a half million population."[13] In fact, census reports show that Nashville's population reached just over 80,000 people in 1900, and other southern cities, such as Atlanta, Memphis, and Birmingham, had far surpassed Nashville as the largest populated southern urban centers at that time. Yet Nashville's inimitability arose from a variety of factors that garnered the city national recognition as the "Athens of the South." As such, Nashville emerged as one of the premier cities in which to live in the early twenty-first century. The city continues to shine as a beacon for those who want to pursue opportunities in business, publishing, music, education, technology, and healthcare. Nashville, now a city of more than 600,000 people, has a history of success in all of these areas, adding to the city's stability and appeal.[14] The developing urban environment of Nashville over the past 150 years has served as the stage that shaped—and was shaped by—its educational institutions. From its inception as Ward Seminary in 1865 to the present, Harpeth Hall's students/alumnae, families, faculty, and community supporters have played key roles in determining and defining the city's growth and expansion.

Chapter 1

"VASSAR OF THE SOUTH"

Ward Seminary, 1865–1913

There are many excellent schools for girls in the United States, but we believe they do not offer a wider range of instruction and observation, nor greater attention to accomplishment and good manners, than this Seminary.
—Annual Announcement for Ward's Seminary for
Young Ladies, *1885–86*

Hosting a luncheon, girls conversed in French as they welcomed special guests and served elegant French dishes, including coq au vin and mousse au chocolat. For their own amusement, students in European history planned and re-created a Renaissance feast complete with linens and rich-colored costumes. A class discussion about moral ethics heats up when the instructor asks, "What would Aristotle do?" At the end of each class, students pack their things and say, "Thank you," to the teacher as they depart.[15]

These examples may sound more typical of female seminaries in the late nineteenth century, but such events still occur today at the Harpeth Hall School, the direct descendant of Nashville's Ward Seminary for Young Ladies, which opened in the fall of 1865. However, Ward Seminary students from 150 years ago would hardly recognize the academic curriculum of the Harpeth Hall School in 2015. In the twenty-first century, girls are encouraged to pursue STEM (science, technology, engineering, and math) as well as other academically rigorous courses. Harpeth Hall graduates pursue bachelor's, master's, and doctoral degrees and develop the necessary skills and strengths to become leaders in their communities. Collegiate and

professional success is celebrated—not discouraged. As women's education has transformed and developed over the past century and a half, the roles of women at work and in their communities have also changed enormously. A close study of the evolution of women's education, particularly in the South, sheds light on both the history of education overall and the changing roles of women since the Civil War.

Women's education gained greater social acceptance after 1865, primarily because most institutions were established under the finishing school model, which provided a combination of culture, etiquette, and academics for "ladies." The number of girls' schools exploded in the South from a handful in 1865 to 142 in 1910.[16] In 1912, there were approximately 24 schools offering "collegiate work" in Tennessee alone.[17] Paradoxically, rather than offering a modern and progressive curriculum, female colleges and preparatory schools promoted an educational philosophy still laden with undertones reminiscent of "Republican Motherhood." The idea of Republican Motherhood emerged from the Enlightenment and the American Revolution and emphasized that citizens must be educated to be virtuous. Therefore, women must be educated in order to teach their children. While women's education grew more accessible and affordable, the basic model remained the same: first, to allow middle- and upper-class daughters to gain education beyond the elementary level; second, to provide formal academic training within a diluted liberal arts curriculum; and third, to prepare them for marriage and society. In September 1865, Ward Seminary was established with a similar spirit and purpose six months following the surrender of General Robert E. Lee to General Ulysses S. Grant, formally ending the "War Between the States."

The Civil War had taken an enormous toll on both the North and the South, but the war's end brought a new vision for many southern cities, including Nashville. For the Ward family, it was the moment for which they had waited. In May 1865, Eliza Hudson Ward sent a letter from Nashville to her husband, Dr. William E. Ward, who was traveling in New York. Mrs. Ward anxiously awaited her husband's reply, and in June 1865, she excitedly read his answer: "I agree with you…. My idea runs thus—to secure a house, publish a card in the papers stating that I will open a school for females…[and] that girls can be taught as well and as cheaply there [Nashville] as here [New York]."[18]

The couple had long dreamed of opening a girls' school in Nashville, and Eliza Ward led the effort, pressing her husband through correspondence to begin a new educational venture. An educated woman herself, Eliza

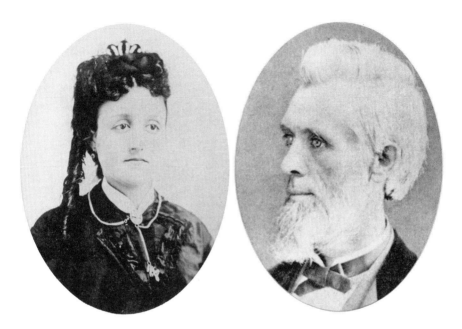

Founders of Ward Seminary: Eliza Hudson Ward and Dr. William E. Ward.

realized the value and opportunity that higher education afforded young women, especially those in the South. The *Ward-Belmont Hyphen* recounted the school's modest beginning:

> *In the dark years after the war when the South was trying to recoup in the midst of its destruction, Dr. and Mrs. W.E. Ward conceived the idea of establishing a private seminary for girls, which would prove an honor to the South and would become a self-sustaining institution.... Dr. Ward built the school into an institution which influenced not only the lives of all the students...but the intellectual and cultural life of the entire city of Nashville.* [19]

For the next twenty-two years, Dr. William E. Ward and Eliza H. Ward molded and managed one of the most prominent women's schools in the South. Ward Seminary was indeed established as a finishing school. While it offered excellent courses of academic study, it also provided a safer alternative to the more masculine world of traditional university study.[20]

William E. Ward is credited with establishing the school, but it was his wife who served as the driving force. Many female educational torchbearers, such as Eliza Ward, found it easier to affect change *through* their husbands

rather than to challenge a severely patriarchal society without male support. Amanda Eliza Hudson (Ward) was born in 1839. Her father was Virginian Dr. John R. Hudson, and her mother was Minnie Napier, daughter of well-known Nashville businessman John Napier.[21] Eliza Ward served as an early product of southern higher education for women after graduating in 1858 from C.D. Elliott's Nashville Female Academy. Her tall height and gracefulness matched her "remarkable degree of energy and candor and unselfishness of character."[22]

Dr. Ward's life reveals a storied professional and educational past. In physical appearance, he was "tall and spare-made...[h]is hair and long flowing beard gray—almost patriarchal, and decidedly venerable...[and] his eyes penetrating and his facial features sharply outlined."[23] Born on December 21, 1829, Ward grew up under the watchful eye of his father, owner of a large cotton plantation near Huntsville, Alabama.[24] In 1851 he graduated with an AB (Bachelor of Arts) degree from Cumberland University in Lebanon, Tennessee. Two years later, he completed his law degree at Cumberland and subsequently practiced law in Texas for three years.[25]

After a short stint in the legal profession, Ward decided to enter the Presbyterian ministry and returned to Cumberland University to enroll in divinity school. Preaching and traveling throughout the South, he gained experience in public speaking and the evangelical ministry, but it never replaced his passion for academia. As he traveled through Texas, Arkansas, and Missouri, Ward carried "a library of books in his buggy for study at odd hours, which he thoroughly saturated driving through swimming rivers in the Indian country."[26] In 1857 he purchased the *Banner of Peace*, a newspaper primarily serving the Cumberland Presbyterian Church, and moved to Nashville. While working for the religious periodical, he met and married Eliza H. Hudson in 1859. He served as the paper's editor until its discontinuation in February 1862, following the fall of nearby Fort Donelson.[27] As the Civil War came to a close, Dr. and Mrs. Ward began making plans for the new school. The couple made a veritable power team, capable and willing to tap into the growing demand for educational institutions for young women. Together they raised five children, having lost another four, all of whom died in infancy. William Ward Jr. was the couple's only son, and three of the couple's four girls attended and/or graduated from Ward Seminary.[28]

In September 1865, Ward Seminary for Young Ladies opened in Nashville with six boarding students and forty day students. During the school's inaugural year, Ward rented the Kirkman building near the Tennessee State Capitol to serve as a temporary campus.[29] In March 1866,

WARD'S
Seminary for Young Ladies

W. E. WARD'S SEMINARY FOR YOUNG LADIES is one of the noted institutions of the city. It has been in operation seven years, and has averaged about 300 pupils for four years past. It takes rank with the leading schools in the United States. The Building is magnificent in its proportions and architecture, and has all the late improvements. It has beautiful grounds, a graded yard for croquet, and a ten-pin alley for physical exercise. Its graduates rank high in scholarship, and many of them find good places as teachers. It was chartered in 1867. It is central to the city, and its pupils enjoy the best church advantages. Nashville is a beautiful and healthful situation for educational purposes. For catalogues and information, address

W. E. WARD,
NASHVILLE, TENN.

NOTICES FROM THE PRESS.

Mr. Ward has laid successfully the foundations of a Seminary of the first character. *Nashville Union and American.*

The Institution has no superior, and but few equals, in the South.—*Nash. Rep. Banner.*

The leading Female Seminary at Nashville.—*Atlanta (Ga.) Constitution.*

Ward's Seminary, at Nashville, is one of the most popular and well known institutions of learning in the South.—*Knoxville Press and Herald.*

This Seminary, under a vigorous management, a corps of most accomplished teachers, and a building unsurpassed, has grown to be the leading school in the State, if not in the entire South.—*Memphis Avalanche.*

This Institution has rapidly risen to a high position. It has just closed a very prosperous session.—*Nashville Christian Advocate.*

It enjoys a high reputation.—*Christian Observer, Louisville, Ky.*

The standard of this school is of the highest order.—*Gallatin (Tenn.) Examiner.*

No school for young ladies in the South ranks higher than Dr. Ward's Seminary, Nashville, Tenn.—*Brownsville (Tenn.) Bee.*

(7)

Early advertisement for Ward Seminary, 1872.

the Wards purchased a property in downtown Nashville on Spruce Street, later Eighth Avenue and recently renamed Rosa L. Parks Boulevard, and by the 1870s, enrollment had grown to two hundred students.[30] The new four-story building, with additional basement space, was purchased for $125,000 and included seventy rooms for housing and classes, a large recitation hall (also used for dining) and a chapel.[31] Students delighted in the "splendid chapel with new-style walnut desks."[32] In 1906 seven years before the school would move west to merge with Belmont College for Young Women, the Wards' son, William Ward Jr., provided a description of the campus in the 1870s:

> *In those days the school occupied what we now know as the big main building and one other. The massive front doors and long hall with its sweeping stairway, flanked on either side by the offices and double drawing rooms; the long galleries in the rear, and the chapel, where prayer and poem, essay and parting benediction were said*—that *constituted the Ward Seminary of the day.*[33]

Students paid an average of $170 tuition for the 1865–66 school term that included room, board, and laundry.[34] Dr. Ward operated the school on a cash basis without an endowment and without trustees. He believed that this arrangement gave the school autonomy over its curriculum and fiduciary needs. Many women's schools were founded and governed by religious denominations, such as Nashville's St. Cecilia Academy, established by the Dominican Catholic Order, and Atlanta's Presbyterian-based Agnes Scott College. Dr. Ward wanted to remain the autonomous head of a school that served as an independent institution as well as a family business venture. While Ward certainly managed the school's finances, Tennessee historian William S. Speer noted the invaluable role of Eliza Ward in 1888: "[T]he success of Ward's Seminary is perhaps as much due [to her] as to the superior management of her husband."[35]

From 1865 to 1895, the curriculum at Ward Seminary was grounded in classical subjects. In the school's first year, freshman students attended classes in Latin, grammar, United States history, French, and geography. On the sophomore level, the course of study included mythology, Caesar, ancient history, the "Life of George Washington," and French. Junior-year students took courses in algebra, rhetoric, Virgil, chemistry, mental philosophy, French, and elocution. Finally, seniors completed courses in trigonometry, logic, English literature, astronomy, moral science, Cicero, letter writing, and

EXPENSE PER SESSION.

(TWENTY WEEKS.)

Board, Fuel, Lights and Washing,

per Week, - - - - - $7.00

Regular Tuition.

ALL ENGLISH STUDIES, LATIN, GREEK, ELOCU-

TION AND PENMANSHIP.

For Beginners to Spelling, - - $20.00

In Preparatory Department, - - $30.00

In Collegiate Department, - - 40.00

Extra Tuition.

French, - - - - - - $15.00

Music—Piano or Guitar, - - 35.00

" Harp, - - - - - 40.00

Vocalization, - - - - 40.00

Use of Piano for practice, - - 5 00

Drawing, - - - - - 20.00

Oil Painting. - - - - - 40.00

Contingent Fee, pens, ink, etc., - 5.00

Payment In Advance.

Tuition and expenses, Ward Seminary, 1868.

dictionary.[36] In addition to upper levels of instruction, Ward Seminary also maintained a Junior School that offered classes and course work for children ages six through fourteen.

Moreover, Ward Seminary quickly gained a reputation for its Fine Arts Department, organized as the Ward Conservatory of Music.[37] Many students attended the school specifically to study voice, piano, and stringed

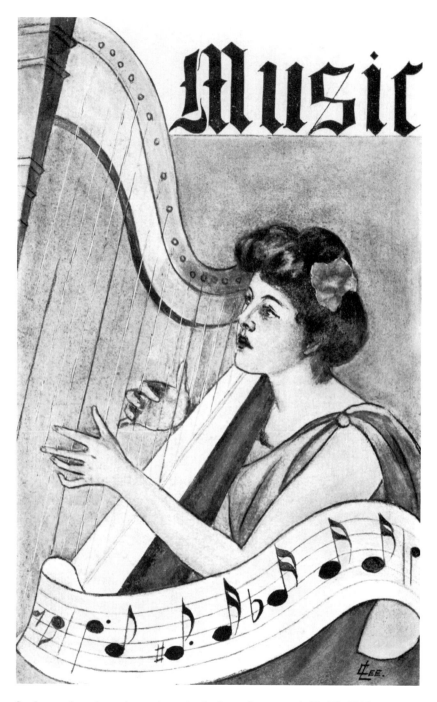

Student art introduces the music section in the student annual, *The Iris*, 1906.

instruments. The second commencement for W.E. Ward's Seminary provides evidence of the musical emphasis. Commencement weekend occurred June 26–28 in 1867 and included many student performances, such as a duet by the Currey sisters, an essay reading entitled "The Sunny South" by Miss Katie Donelson, and a vocal ensemble that sang "Whispering Winds" by composer H.A. Wollenhaupt.[38] Ward Seminary encouraged and promoted its young ladies in the performing arts, and such ceremonies allowed young women a formal venue in which to showcase their talents to the public. Nevertheless, such performances continued to fall within socially approved forms of expression for girls and young women—song, dance, and poetry.

Throughout the latter half of the nineteenth century, Ward Seminary continued to promote and retain definitions of feminine virtue based on antebellum and Victorian notions of womanhood. Although the school remained nondenominational until 1890 after Dr. Ward's death, the co-founders held their students accountable. The Wards also personally enforced rules that "preserved the moral virtue" of each young woman. In 1866 Professor Ward, as the girls called him, put his book down during a lesson to remind Miss Clark to "preserve her dignity" as she sat in the front row of class with her "feet protruding from the hem of her floor-length skirt."[39] In another instance that year, Dr. Ward caught several of his students in the first-floor parlor in their nightgowns as they listened to the serenade of their Vanderbilt beaus. One female student recounted, "It was the fashion for our boyfriends to serenade us with guitar, banjo, and their fresh young voices…. Suddenly Dr. Ward walked in…[and] [w]e got up those steps quicker than we had come down!"[40]

The Wards also instituted policies that focused on modesty and restraint reflective of the elite nature of their clientele. Students wore maroon-colored dresses as unofficial uniforms in the winter and light-colored dresses in fall and spring. By the early 1880s, the "school had adopted the color of blue for its year-round uniform."[41] Simple dress was expected, and one source admitted that student Annie Chadwell nearly cried "when the many dainty bows which held the fluffy tarleton drapery of the whole front of her dress had to come off."[42] Early catalogues proclaimed the school's moral highbrow nature: "It is our purpose to avoid all extravagance in dress…Positively no low-neck or short-sleeve dresses will be permitted on our school platform."[43] Dr. Ward also prohibited visitors on Sunday and closely supervised the students during recreation and off-campus trips. Despite a student body of well-to-do young ladies, the school instructed,

"Don't furnish your daughter with jewelry or [too much] money, as those who have none rarely think of it."[44]

In terms of faculty, Eliza Ward initially hired additional teachers in 1865 at the behest of her husband. Early instructors included Mrs. Robertson to teach music and Miss Mary Dunn to teach academic classes. According to Dr. Ward, these two female educators maintained a "fitness to teach, popularity with the public, and [an] ability to draw influence."[45] Dunn was a popular teacher in Nashville who "conducted a private school during the [Civil] War in any convenient location, for the school buildings were used for hospitals."[46] Mrs. Ward also taught art classes, while Dr. Ward put his divinity training to good use delivering sermons to the girls in daily chapel. By the mid-1880s, Ward Seminary employed about thirty faculty members, most of whom were women. Some hailed from the South; however, it was difficult to find southern women who had received enough education to be qualified teachers. Accordingly, many faculty members were graduates of schools from the North. This trend would change in the twentieth century as southern women's schools, such as Ward Seminary, and normal (teacher-training) schools, such as Peabody College in Nashville, produced graduates who could fill the demand for teachers in southern schools.

As Ward Seminary emerged as a premier school for girls, having received its charter in 1869 from the Tennessee legislature, the school's budget remained higher than that of most girls' schools, many of which were smaller and/or more rural. Although individual salary records do not exist, the 1885–86 *Annual Announcement* registered $160,000 paid to Ward Seminary faculty in its first twenty years. With approximately thirty faculty members during these years, the average salary was more than $200 per year; however, these figures do not reveal discrepancies in pay between male and female faculty members.[47] As general education instruction shifted to female teachers in the mid- to late nineteenth century, women were often paid less than men. For example, in 1876 in Boston, male educators earned up to $4,000, while female teachers' salaries were capped at $2,000 per year. Such statistics and salaries reflect national trends.[48]

The 1870s proved an exciting decade for Ward Seminary. The school had gained a reputation as the "Vassar of the South." In 1877 U.S. Bureau of Education commissioner John Eaton Jr. commented, "Ward has surpassed for many years all educational institutions of the South in numbers and facilities."[49] Graduating classes grew from fourteen students in 1866 to forty-seven in 1871.[50] The graduation program of 1871 included selected

senior student essays with titles such as "There Is a Poison Drop in Man's Purest Cup," "Religion: The Brightest Gem in Woman's Crown," and "The Beauties and Pleasures of the Sky."

Perhaps the most exciting event for the 1870s was a visit by President Rutherford B. Hayes. Hayes was in Nashville to lay the cornerstone for the U.S. Customs House. After his speech at a ceremony held in front of the Tennessee State Capitol, the procession made its way to the site on Broadway Avenue, making several stops along the route, including Ward Seminary. An account of the event is as follows:

> *The procession halted in front of Ward Seminary, which was decorated with flags, bunting, evergreens, and hanging baskets of flowers. On the broad galleries* [porch or balcony] *and on the yard settees* [benches] *stood about two hundred young ladies, each with a flag in her hand. As the carriage bearing the President,* [South Carolina] *Governor Hampton, and* [Tennessee] *Governor* [James D.] *Porter halted, Dr. Ward led out a small girl bearing a silver tray of rare flowers for the distinguished guest. After accepting the gift, President Hayes continued to the Customs House.*[51]

By the late 1870s, tuition had been raised to $200 per year; a new building was completed that provided twenty rooms, including facilities for physics and chemistry; and the faculty had grown to include eighteen members.[52] In 1879 another women's school merged with Ward Seminary. Located in Edgefield, Nashville's first suburb east of downtown, Mrs. Weber's Female Seminary opened in 1871 but later changed its name to Edgefield Female Seminary. After a period of financial strain, this small suburban school consolidated with Ward Seminary, and Mrs. Henri Weber joined Ward's faculty.[53] It was not uncommon from 1865 to 1900 to see smaller "one-room" schoolhouses merge with larger schools as women's seminaries and "colleges" solidified their niche in the educational market. Single-gender education at Ward Seminary, and other similar institutions, continued to provide a middle ground between secondary and university paths of study.

By 1880 Ward Seminary was operating primarily as a college preparatory school, although it still claimed some collegiate work and offered majors and courses of study. However, its founders were faced with shifting social expectations and students who desired an education to meet different needs from those of their antebellum counterparts. As a well-known leader in education, Dr. Ward struggled with the emerging

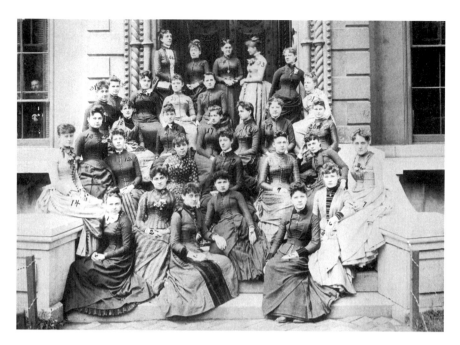

Graduating class of Ward Seminary pictured on the front steps of the school, May 31, 1888.

female role in society even as he dedicated his life to the higher education of women. His views reflected larger regional and national issues facing many educational institutions regarding a new class of educated women and notions of acceptable behavior for southern women.

The 1885 commencement address given by Dr. Ward, entitled "The Coming Woman," revealed his anxiety and reservation regarding the growing independence of women in the South and across the United States:

> *The coming woman ought not to be, but I fear she is aiming to make herself, independent of man. Just as far as she does this she contravenes the law of the Almighty, who made her for a help-meet for man…Woman is dependent on man; she is weaker; she ought never to be educated out of that idea. Independence perforce destroys sympathy, and sympathy is the subtle, all-pervading, and omnipotent energy that binds all mankind together. If the coming woman is to come to that, let her never come.*[54]

Dr. Ward's comments reflected the still prevalent ideology that women should seek education solely to better themselves for ultimate roles as wives,

mothers, and advocates of social benevolence representing middle- and upper-class interests. His words were not atypical of southern society in the late nineteenth century, as he presented his postbellum vision for an "improved Southern Belle" who still knew her place in the home and in society. Ironically, Dr. Ward also acknowledged that the coming woman would be more autonomous and use her education for her own betterment. Like Dr. Ward, many in the South clung to the image of the passive and gracious southern lady while simultaneously providing women with expanded opportunities for independent living, higher education, and a possible professional career.[55]

Mirroring the unofficial mission of Ward Seminary to produce refined young ladies, the school's official motto emerged in the 1880s: *Ubi mel, ibi apes* ("From bees there is honey"). The school's patronage remained closely tied to wealthy families in Nashville and neighboring southern states. In 1887 Nashville's *Christian Advocate* proclaimed that recent commencement exercises "were highly interesting, attracting large and delighted audiences of the *elite* of Nashville society."[56] Moreover, the 1904–5 student directory revealed that out of 330 students, nearly one-third of the girls' fathers held positions as judges, lawyers, doctors, professors, clergy, and high-ranking military officials.[57]

In the 1880s, coeducation began to emerge in the South and across the United States. In 1885 the administration of Ward Seminary addressed this trend: "[C]o-education of the sexes has been tried in many places, but it is on the decline and we do not believe it best."[58] The *1885–1886 Annual Announcement* defended this position: "They say it refines boys [to educate them with girls]…But what parent wishes to be put to such a use as refining boys, at the risk of the loss of their own [daughter's] delicate and feminine qualities?"[59] Thus, Ward Seminary presented itself as a "safe" place for elite and upper-middle-class families to send their daughters.

Yet Ward Seminary offered a challenging academic curriculum. By 1886 the school even offered what it called "post-graduate" courses in poetry, elocution, voice culture, and English. In many ways, all-female schools faced a quandary as they desired to legitimize themselves as institutions of college preparatory or collegiate learning while simultaneously reinforcing the notion that strenuous intellectual exertion would offend the perceived delicate nature of the female mind and body. Schools such as Ward Seminary boasted of their course offerings but also quickly reminded potential parents that the school's ultimate aim was to produce "young ladies." Perhaps an 1870s advertisement published in the *New Orleans Times Picayune* best walks this fine line: "Those who wish

to give their daughters a thorough education, not only in the elegant acquirements of life, but in all the studies going to make the accomplished scholar, cannot do better than place them in W.E. Ward's Seminary in Nashville, Tennessee."[60]

On July 20, 1887, the school's founding father passed away. During his tenure, more than 3,000 young women passed through the halls of Ward Seminary on Spruce Street, and more than 800 alumnae had emerged as graduates.[61] At the time of Dr. Ward's death, enrollment stood at 350 after beginning twenty-two years earlier with 46 students. More than 100 graduates had entered the teaching profession. Eliza Ward lived until 1900 but never remarried. William E. Ward had lived to see three of his daughters graduate from Ward Seminary. Sallie Ward Conley graduated in 1877, Florence Ward Chaffe earned her diploma in 1879, and Eunice Ward completed her studies in 1883.[62] For twenty-two years the Wards led the school with impeccable vision and financial management. While Eliza Ward devoted more than two decades to the school she co-founded with her husband, her work with the school ended with his death. Historian William Speer duly noted in 1888, "For more than twenty years her unremitting hand and heart have nobly and faithfully seconded her husband in the great work of education. She has stimulated the ambition of hundreds of timid girls, repressed and reformed many spirits violent by nature, and built up the true idea of refined womanhood in nearly every case brought within her influence."[63]

After Dr. Ward's death, J.B. Hancock was elected principal. According to an 1893 Bureau of Education report, the school's enrollment reached new heights under Hancock's leadership, with 345 students in 1889 and 1890.[64] Despite the Wards' insistence that trustees "hamper more institutions then they have ever benefited,"[65] in 1891 the nondenominational women's preparatory school was sold to the Presbyterian Cooperative Association of Nashville.[66] Although finances had remained solid prior to 1891, many school leaders believed that the seminary could expand more efficiently within a larger organizational infrastructure. Moreover, Dr. Ward had served as a Presbyterian minister prior to opening Ward Seminary.

The Presbyterian Cooperative Association appointed Reverend B. Charles as the head of the school. Charles served only two years before John Diell (J.D.) Blanton was named president of Ward Seminary in 1892, assuming leadership in 1893.[67] Blanton, who hailed from Virginia, was initially hired as an instructor of mathematics. He served on the faculty at Ward for only two years prior to his appointment as president, and no one predicted that his impressive tenure would span more than

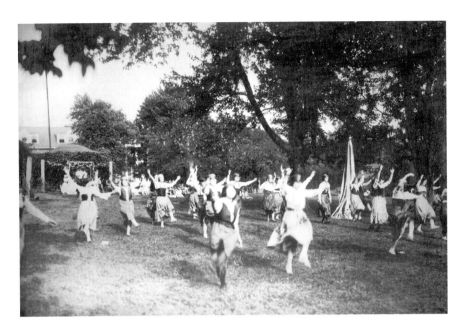

May Day festivities, circa 1896.

four decades. The 1898 *Iris* stated that Blanton was "a capable, Christian gentleman, whose sustained efforts to raise the school in curriculum and standing have not been in vain."[68] Blanton continued to teach one or two courses per year as needed from 1893 to 1906. Most frequently he taught courses in pedagogy, Bible, and/or psychology during those years—reflecting a continuing emphasis on religion, education, and social sciences.

Sadie Warner Frazer, the daughter of Percy Warner and Margaret Lindsley Warner, attended Ward Seminary from 1896 to 1903, early in Blanton's tenure. During her senior year, she served as class president, editor of the annual *The Iris*, and founder of the Argonauts (social) club.[69] According to Frazer, Dr. Blanton filled a "difficult [position] with skill and charm," but he was many times "too busy to be as social as some would have liked."[70] The girls, still known as the "Ward Ducks" in the early 1900s, marched behind the Blantons during their daily afternoon walk, just as they had with Dr. and Mrs. Ward. Students marched two by two downtown each day at three o'clock wearing navy blue uniforms— accompanied by matching wool hats in the winter and "blue-banded" white sailor hats and tops in the summer.[71] One of the favorite downtown promenades included a hike up to Capitol Hill, while other days the

Dr. J.D. Blanton and Mrs. Anna Hawkes Blanton.

students were granted greater privilege as they rode "bicycles or horses in divided skirts" as far as Mount Olivet, a cemetery two miles east of downtown.[72]

Dr. Blanton's wife, Anna Hawes Blanton, took an active part in campus life and joined the faculty officially in 1903 as the principal of the Home Department. Just one year earlier, the Blantons had suffered a family tragedy when their daughter Mary Miller Blanton, who also attended the school, passed away in her early teens from illness.[73] Both Dr. and Mrs. Blanton were beloved members of the community and school. One group of seniors proclaimed that Mrs. Blanton "worthily holds the highest place in the love and esteem of the class of 1906."[74] Prominent Tennessee journalist Louise Davis wrote that "Mrs. Blanton looked after the hundreds of girls as if they were her own, making sure that they kept their heavy underwear on through the last cold snap and making unbelievably wonderful ice cream to serve in her room at recess to various small groups of girls."[75]

Ward Seminary for Ladies continued as an archetype of gendered education in Nashville in the early twentieth century. Expectations remained high as female students combined hard work, study, and a bit of fun to achieve their goals. For example, the required senior essay was endearingly described by one student:

RECIPE FOR A SENIOR ESSAY: Soak a small brain in a copy of the Iliad *for two weeks; take it out and hurriedly stir it in a large cup of Encyclopedia Britannica; into this sprinkle a teaspoonful of quotations, and one-half drop of thought; flavor this with a stub pen and a little boarding school ink, not too strong; garnish this with a handful of commas and periods, and serve "warm."*[76]

Enrollment hovered at 360 students as the new century dawned, but the school's students were predominantly local, with more than 50 percent from Nashville and more than 75 percent from Tennessee. In 1900 base tuition for day students was $120 without extra fees, and boarding students paid $280 per year.[77]

As the twentieth century dawned, the *Ward Seminary Bulletin* outlined the school's curricular purpose, reflecting a new, more progressive view of educated women: "Memorized facts do not make scholars; mental training, power of concentration, and love for study are the essential qualifications for graduation."[78] The standard curriculum still represented a feminine focus of culture, arts, and social decorum rather than collegiate level scholarship and included "soft" course work such as piano, recreation, religion, literature, French, German, spelling, grammar, penmanship, and elocution. Ward Seminary offered far fewer courses in mathematics and/or science than coeducational colleges from its inception through the early 1900s. However, the school did maintain pace with new academic disciplines such as psychology and domestic science.

Upon completion of curricular requirements, Ward Seminary students received either certificates or diplomas.[79] Although such diplomas and certificates did not transfer to reputable four-year colleges or universities, each year a handful of college preparatory graduates continued their education at traditional colleges. By 1909 Ward Seminary had also added a certificate of "English," as well as "Practical Cookery." From 1900 to 1910, the school maintained an average of about thirty graduates in its "Seminary Course," with smaller numbers graduating from Piano, Voice, and College Preparatory Departments.[80] For the majority of graduates, certificates and/or diplomas served as terminal degrees of study, with the exception of those from the College Preparatory Department. Several college preparatory graduates from the class of 1912 were admitted to Wellesley, Vanderbilt, Peabody, and Randolph-Macon College.[81]

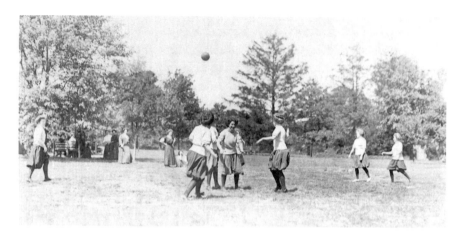

Physical education class, circa 1893.

The catalogue for Ward Seminary enticed students with its location as well as course offerings. The school noted that one of its major advantages lay in its location in a growing southern city "within walking distance of churches, concerts halls, libraries, and other places of interest."[82] Ward Seminary had also long encouraged athletics. Its inaugural basketball team, formed in 1897, participated in the first publicly played women's basketball game in Tennessee, losing 0–5 to Vanderbilt's women's team.[83] It should be noted that men were not allowed to watch the game, and baskets counted five points each. The only scored basket came from a pass from Vanderbilt's Stella Vaughn that bounced off the wall and into the basket as time expired. Emphasis was also placed on the school's Physical Culture and Domestic Science Departments. Students were required to participate for two hours each week in the gymnasium or three hours per week in outdoor sports such as tennis, croquet, and field hockey. The school also maintained bowling alleys. Finally, Ward Seminary had long boasted of its healthy environment, "splendid equipment," and the quality of care given to each student. In 1909 Ward Seminary introduced into its curriculum a two-year course in domestic science to teach "scientific housekeeping" and included courses in cookery, sewing and finances, as well as labs in nutrition.[84]

To reveal a typical day in the life of a Ward Seminary student at the turn of the century, the school's annual, *The Iris*, featured a submission written by an anonymous senior. According to this senior, a typical schedule began at 8:30 a.m. as the "gong sound[ed] twice" and students rushed to chapel

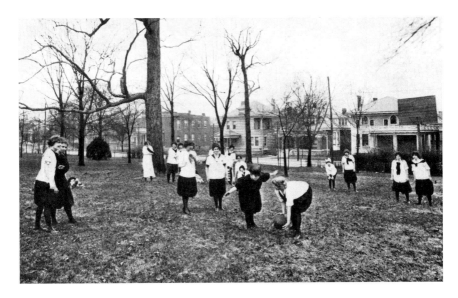

Basketball practice, with goal and backboard visible on the right, Ward Seminary campus annex, Ward Place, circa 1896.

only to find they were tardy—"as already ha[d] the Christian soldiers begun their onward march."[85] The day proceeded with thirty minutes of literature during which a typical lesson involved students discussing their reading of a "large, red book entitled *The Only Really Correct Way to Translate Cicero*."[86] Next, students attended the newly offered social science course of psychology from 9:45 a.m. to 10:45 a.m., where the senior author proclaims, "[W]e know that the mind is the subject to be discussed…[and] when we enter the classroom, to all appearances we have the wisdom of Socrates."[87] Recess seemed to remain a favorite among students from 11:45 a.m. to 12:00 p.m. until French class commenced at noon. In history class, from 1:00 p.m. to 1:30 p.m., students addressed two past test questions: "1. When did Rome fall? 2. Give the division of history with the dates."[88] The courses for the day ended at 2:00 p.m. Ward Seminary students attended different classes on alternating days, but this description reveals a notable absence of courses in mathematics or science.

Although the daily schedule seems quite different from modern-day education, students from yesteryear do share one thing in common with students today: the dread of final examinations. In 1906 one student wrote, "O Examinations! How long will you try our patience? How long will you make sport of our fears and ignorance? Go! Take your evil companions, tests, and topics with you; drain Ward's of its dregs."[89]

In 1907 the school desperately needed more room as its reputation resonated with families who desired the educational and social training offered by Ward Seminary. As numbers of women attending some form of higher education increased throughout the country, Ward Seminary's enrollment grew throughout the early twentieth century, requiring more faculty and a larger physical plant. J.D. Blanton and the Board of Trustees bought property that is currently occupied by St. Thomas Midtown Hospital, extending from present-day West End Avenue to Charlotte Avenue. This "suburban" annex was named Ward Place, and the students walked two miles between campuses. Although they could ride the trolley, many girls chose to save their trolley money to buy sweets and other treats such as fruit from Mrs. Tony's fruit shop. As one student remarked, "[F]or by the end of the week we had saved fifty cents for chocolate creams, bananas, and peanuts, which were most essential to our happiness."[90] Ward Place provided new housing for students, space for clubs and meetings, and new athletic fields. It also housed the Junior School's Kindergarten Department. Most classes and events for older students still took place in the main building.

In addition to the College Preparatory and "Collegiate" Departments, Ward Seminary had, from its inception, maintained primary and intermediate

levels of instruction. Most years between 1865 and 1912 listed kindergarten, intermediate, and irregular classes individually.[91] However, by the 1890s, classes below the college preparatory level were grouped together and named the Junior School. The Junior School included Kindergarten, Primary, and Intermediate Departments that provided instruction for children ages five to fourteen. Clare Boothe Luce, who attended Ward Seminary Primary Department, ultimately served as a congresswoman from Connecticut (1942–47). She later became the first female ambassador to a foreign country (posted to both Italy and Brazil), authored several books, and edited *Vanity Fair.*

The 1907 Ward Seminary basketball team.

She is perhaps best remembered as the playwright of the 1936 Broadway production *The Women*, which starred an all-female cast.[92]

Ward Seminary was known as a preeminent school for young ladies, but in fact, a handful of young boys enrolled in the Kindergarten Department each year from 1865 to 1912. Most attended for only one school year, but there was one male student who completed the entire Junior School program, the son of Dr. and Mrs. Ward. W.E. Ward Jr. wrote in 1906:

> *It was the fall of 1873 that I first entered Ward Seminary, a candidate for the infant class. Although strictly an institution for girls there was nothing to do but accept me, the first and only boy. For fourteen years I spent my time teasing the household of teachers…and pay a boy's tribute to the girls. Was ever a lad born under such lucky stars?*[93]

School announcements claimed that "since the foundation of Ward Seminary…it has maintained a Junior School to fit pupils for the College Preparatory and Seminary Courses."[94] The purpose of the Junior School remained to prepare girls for entrance into the college preparatory (high school) and seminary (collegiate) programs.[95] The Junior School, which today would represent kindergarten and grades one through eight, was ultimately phased out after the merger with Belmont College in 1913. By the 1930s, no lower grades were offered by the Ward-Belmont School.

By 1910 Ward Seminary maintained a School of Expression, School of Elocution, Conservatory of Music, Collegiate Preparatory Department, and Collegiate Department. In particular, the School of Expression and Conservatory of Music quickly gained national reputations for excellence. The School of Expression was led by French Canadian Edith Margaret Smaill, who joined the faculty in 1910. Smaill represented one of many faculty members who came from the North. She studied at McGill University in Montreal and the Curry School of Expression in Boston, and she completed graduate work with voice and drama teachers in the United States and England.[96] Smaill, also a vocal supporter of women's suffrage, came to the school highly recommended and with an impressive performance history throughout North America and Europe, including performances for British royalty.

Smaill infused the Ward School of Expression with a new sense of purpose and enthusiasm. During her tenure, the mission statement for the department was "to help the student to 'find herself' and realize her powers

and possibilities; to give such training as will develop her individuality; to train the voice and body to act in co-ordination with the mind; to learn how to think and what to do to become [independent] and strong."[97] In 1915 Smaill left Nashville to take a position at Wellesley College, where she would remain until the 1930s.[98]

Another professor, German-born Fritz Schmitz, studied with several violin masters and received training at the Royal Conservatory at Cologne. In 1891 Schmitz moved to the United States, and after a short stint playing for various orchestras in northern urban centers, he turned to teaching. Schmitz and his wife, Estelle, both joined the Ward Seminary Music Department in 1907 and remained for more than a decade. In what would be the last major performance of Ward Seminary before its merger with Belmont College, Edith Smaill and Fritz Schmitz executed the grandest dramatic and musical event in school history. They produced Shakespeare's *A Midsummer Night's Dream* in the spring of 1912. The play was performed on the Ward Place campus, about two miles west of downtown, outside "[u]nder the forest trees...[with] a seating capacity arranged for a thousand."[99] The play was a huge success, with a much larger crowd than expected. With more than 1,500 in attendance, Miss Smaill's students performed as the Vendome Theater Orchestra (a local theater) accompanied the twenty-piece Ward Orchestra led by Fritz Schmitz. A review was published in the *Nashville Tennessean* recounting the magical event:

> *The enormous trees formed the background and canopy for the stage, which was bordered with electric foot lights...The cast was composed of pupils of the Seminary. From the opening with the clown's march to the closing scene of the fourth act, the exactness and smoothness of the performance, the poise of those participating, reflected credit on the talented director* [Smaill] *and added another wonderfully successful entertainment to the institution.*[100]

On a national level, Progressive Era trends allowed women to pursue higher educational and professional goals. Such trends trickled down to the South and to Ward Seminary, as young women began to see higher education as a means for personal gain rather than simply as a way to prepare themselves for roles as wives and mothers.[101] Ward Seminary did not abandon the idea of women ultimately finding satisfaction with the home, family, and community. However, the school recognized more modern goals

Ward Seminary, class of 1911, English and seminary degrees.

of women's education and the desire of many students to continue their higher education:

> *The courses of study meet the requirements of the present ideals of education. There is a Primary and Intermediate course, which prepares students for the College Preparatory course. This latter course requires four years for completion. Students completing this course are admitted without examination to Randolph-Macon Woman's College, the Woman's College at Baltimore* [Goucher College], *Wellesley, Vassar, Chicago University, Vanderbilt University, and other institutions.*[102]

In truth, a diploma from Ward Seminary still equaled that of a high school education, but the school never made false claims. As early as 1892, the *Annual Announcement* stated, "We make no claim to a *university curriculum*, only modestly calling our work COLLEGIATE; still, we do say that our course of study is as comprehensive as any school in the South."[103] The school would not become an accredited college until after its merger with Belmont College in 1913.

Ward Seminary began a new chapter as Ward-Belmont School in the fall of 1913. Its downtown campus was later demolished, but the school had survived the first era of expansion and development for women's education. It began and ended as both an academically strong finishing school and an alternative to traditional colleges and universities. Elizabeth Avery Colton, a college professor and crusader for women's education in the South, authored a study and report in 1912. The report argued that many women's schools were "overburdened in trying to be

ILLUSTRATORS

KATHERINE STREET, ART EDITOR OF IRIS

Art club, Ward Seminary, 1912.

preparatory schools, finishing schools, and colleges," with inconsistent standards, admissions, faculty, and non-accredited diplomas.[104] While Ward Seminary boasted of its challenging curriculum, it was like many "colleges" of its day as it searched for an identity in a shifting educational and cultural landscape. It was certainly a success in its own right, with a well-documented history and educational reputation; however, the union of Ward Seminary and Belmont College for Young Women would serve to strengthen both institutions.

Chapter 2

BELMONT BELLES

Belmont College for Young Women, 1890–1913

Belmont began when two school-girl friends dreamed of a beautiful home...
[a]nd purchased a beautiful old building at the highest point of the "Athens
of the South" and realized in part their dream.
 —Blue and Bronze, *1913*

Charles W. Eliot, president of Harvard University from 1869 to 1909, delivered a speech at the 1899 inauguration of Wellesley's new president, Caroline Hazard. Wellesley College was then one of the "Seven Sisters"—a group of elite women's schools in the North founded between 1838 and 1889.[105] These colleges represented the best of women's education and were seen as the female equivalent to the all-male Ivy League colleges. One might hope that Eliot would attend such an event and give a resounding endorsement of all of the progress and opportunity made by and for women and the schools that served to educate them. Instead, he proclaimed that "[w]omen's colleges should concentrate on an education that will not injure women's bodily powers and functions.... It would be a wonder, indeed, if the intellectual capacities of women were not at least as unlike those of men as their bodily capacities are."[106] Nine years before Eliot's speech, Belmont College for Young Women had opened its doors. Clearly, American society was still at odds with the nature, scope, and purpose of women's education. Despite Eliot's lack of confidence, women's roles in society were evolving, and education would play a large role as young women increasingly participated in the public sphere.

While the numbers of women's schools and their enrollment increased dramatically after the Civil War, opposition to equal curriculum and professional opportunity on a par with men remained high. Some worried that it would disrupt the family structure, while others believed that women were too frail and that too much study would drive them to infertility and nervous breakdown. Common throughout the North, these views were even more prevalent in the South. Irene Harwarth, one of multiple authors of *Women's Colleges in the United States: History, Issues, and Challenges* (1997), argued that women's schools or educated women from the North represented "an implicit threat to sex segregation in the workplace," while in the South "it was understood that graduates would not enter the work force."[107] However, the founding of Belmont College coincided with the growing "demand for [southern] young women to know Greek and Latin, to read the Bible, and to better understand Western civilization." Moreover, some sort of education beyond the age of sixteen also "signified a women's upper-class status" and "improved their status for marriage."[108]

Many schools such as Ward Seminary retained the title "seminary," which resonated better with southern culture. Belmont College for Young Women opened twenty-five years after Ward Seminary, at a time when schools increasingly preferred the more modern title of "college" over that of "seminary." However, while Belmont chose to advertise as a college, the lines remained quite blurry for educational institutions until after the turn of the century due to a lack of accreditation agencies, educational requirements, and faculty training. By the school's own admission, an early prospectus announced that its mission was to combine "all that was good in the old-fashioned finishing school…with every worthy thing in twentieth century education of mind and heart."[109] And yet Belmont College for Young Women was also founded with an intentional scholarly purpose.

The college began in a stunning Italian villa–style antebellum mansion perched atop a hill on the west side of Nashville. The house was built circa 1850 by one of the South's most prominent society couples, Adelicia and Joseph Acklen.[110] A graduate of the Nashville Female Academy at the age of sixteen, Adelicia Hayes Acklen ultimately built her fortune as a savvy businesswoman and was one of the wealthiest women in the South by the mid-1800s. She was married three times and widowed twice; she had her second husband (Joseph Acklen) and third husband (William Cheatham) sign prenuptial agreements. Adelicia hosted lavish parties attended by governors, businessmen, and members of the southern aristocracy, and she welcomed the public to the estate's gracious gardens. The estate was first named Belle

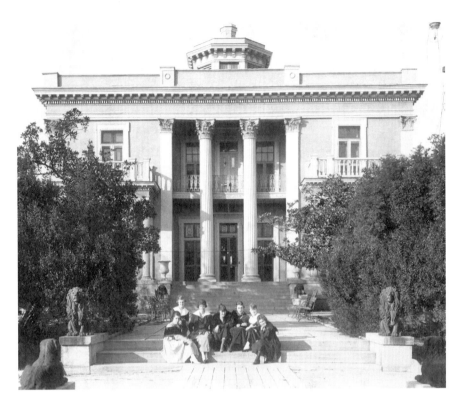

Belmont for Young Women students on the steps of the Belmont Mansion, circa 1899.

Monte ("Beautiful Mountain") but came to be known simply as Belmont. She sold the home in 1887 just before her death. Later that year, much of the estate was unceremoniously partitioned and sold as residential lots, but the heart of the estate remained intact.[111]

Two years later, Ida E. Hood and Susan L. Heron attended a meeting of the National Educational Association held in Nashville. According to Hood, while visiting they "chanced" to see the Belmont Mansion, and "Miss Heron was at once extravagantly pleased with the place and we forthwith made arrangements for locating here, bringing with us that first year many of our girls and…[Martin College] faculty."[112] They purchased the mansion and its surrounding fifteen acres for $72,000.[113] W.T. Glasgow, who served as Hood and Heron's business manager, was also listed on the purchase agreement.

In the fall of 1890, Belmont College for Young Women opened its doors with ninety students "from all over the South, [and] one young lady from far-away Montana."[114] The school was an instant success, drawing from Nashville as well

Ida Hood and Susan Heron, lifelong educators, founders, and co-presidents of Belmont College for Young Women, 1890–1913.

as upper- and middle-class families across the United States. Advertisements boasted that Belmont was "[t]he ideal college home of the South."[115] Founders Ida E. Hood and Susan L. Heron stated the school's purpose:

> *We desire to impart practical knowledge in such manner as best develops power, recognizing that far higher than this is the unconscious influence that emanates from the atmosphere and environment of a wisely directed school and is woven into the lives of all that come within its contact. It is our purpose to furnish opportunities for a broad and scholarly education.*[116]

The opening of the school was a day of excitement both for the school's founders and for the city. The *Nashville Daily American* proclaimed, "Yesterday was a red letter day in the educational annals of the city, the opening of the Vassar of the South, Belmont College."[117]

Neither Heron nor Hood was from Nashville or the South. Both women were born in Pennsylvania; they met as classmates at the Shoemaker School of Oratory, also called the National School of Elocution and Oratory, in Philadelphia. Hood graduated in 1880 at the age of thirty-two, and Heron graduated soon after. After graduation, the two began looking for work and

Children stand on top of Belmont Tower looking over campus toward Belmont Mansion, circa 1892.

discussed starting a school together.[118] Miss Hood wrote about a conversation that would shape the rest of their lives:

> *One perfectly beautiful moonlit night we were sleeping in my country home on the borders of Philadelphia, and not being willing to be separated we then and there determined we would have a school of our own. Shortly after that I received a letter from a cousin…[in] Virginia…. He wrote me that as I was now neither studying nor teaching it was time to visit them. I answered that I could not come as I had a friend with me. He wired back, "Come and bring your friend with you." We went for a long visit and some weeks later the State Teachers' Association was meeting in Washington, Pa. [There] we met an old professor…and we told him of our plan to start a school of our own. He said, "I will not say 'Go West, young women,' but I will say 'Go South.'"[119]*

In 1881 the energetic and determined pair headed south but separated when Heron accepted a job at Jennie Higbee's school in Memphis. Two years later, Hood accepted a position at the Tennessee Female Academy in Franklin. In 1885 they learned of a vacancy at Martin Female College in

Tennessee. They "visited Pulaski to meet trustees and were given a two-year contract as joint administrators."[120] Hood wrote of her experience:

> *I remained at Franklin two years and I had there some of the most delightful experiences of my whole teaching life. While there…* [a friend] *suggested that Martin College…was in need of a principal and she and her family warmly urged that I write the Board of Trust of our desire and intentions. I did so and this letter brought a speedy and encouraging answer. So not long after this Miss Heron and I went down, looked the ground over, determined to invest our all and opened school there that autumn.*[121]

Ida Hood and Susan Heron had fulfilled their dream of operating a school for girls in the South. Martin College was desperate for the right kind of leadership and business approach to keep its doors open, and Hood and Heron were "inexperienced but enterprising women."[122] They became co-superintendents of the school and paid rent of approximately $500 per year.[123] If not for the power play of certain local leaders, Hood and Heron might have spent their entire careers in Pulaski.

Martin College, affiliated with the First Methodist Church, became religiously diverse and prospered under Hood and Heron. Susan Heron was Presbyterian and Ida Hood a Quaker. By the end of their first year at Martin College, the faculty included "another Presbyterian, an Episcopalian, two Baptists, a Universalist, and only a single Methodist."[124] In just four years, Hood and Heron had secured financial stability, increased enrollment, attracted highly qualified faculty, and established a more rigorous academic curriculum. However, in 1888, T.J. Duncan and R.K. Brown, local ministers in the Methodist Church, led a movement to restore the school's leadership to Methodism. The Martin College Board of Trustees and community supported the women, but Reverend Duncan eventually filed a lawsuit to remove Heron and Hood. The court ruled in favor of Martin College's trustees, but the entire affair had convinced Heron and Hood to begin looking for a less contentious working environment.[125]

Religiously affiliated schools were not uncommon, and as the number of secular private schools began to grow in the late 1800s, many feared that religious leanings and teachings would be trumped by changing societal views. In particular, the Catholic Church responded to this trend by expanding primary and secondary schools to include higher education for women. Five Catholic women's colleges were founded between 1899 and 1905, with the College of Notre Dame of Maryland as the first.[126]

Neither Belmont College nor Ward-Belmont School was demoninationally affiliated; however, even secular schools maintained strict rules and required chapel. The following excerpt from the 1895 *Annual Announcement* reflected the college's emphasis on religion:

> *Our school is strictly non-sectarian, but our educational system is based upon sound Christian principles as the only substantial basis for character. Students attend the church and Sunday-school designated by their parents. A systematic course of Bible instruction is conducted by Miss Blalock and Miss Cooke, with students meeting on Sunday and at determined intervals during the week. A period of Saturday night is spent in the preparation of the Sabbath-School Lesson, and one hour of the Sabbath is given to selected readings of a religious or spiritual nature...Ministers of the gospel are cordially invited, whenever convenient, to visit us and address the students.* [127]

Such practices dominated both parochial and independent schools in order to maintain moral codes, Christian standards, and social propriety.

Led by Misses Hood and Heron, and later Dr. Landrith as regent, Belmont College for Young Women maintained strict regulations designed to protect the virtue of young women and to "help" them avoid social temptations. Chapel was, for a time, required before and after dinner six days a week. The first published *Announcement and Prospectus of Belmont College* in 1890 articulated rules regarding promptness, daily exercise, tidy rooms, neat dress, and reverence for the Sabbath. Students were not allowed off campus without a chaperone, and "gossip [was] discouraged." Students were required to wear their uniforms, and girls were not permitted to wear "silk dresses or dress with low necks and short sleeves on campus." [128] By 1895 the list of regulations contained certain revisions, many of which involved the behavior of students outside class. "Gentlemen callers" were required to bring letters of introduction, and the young ladies could not receive dates on Saturday afternoons.

Moreover, students were punished if they were caught "burning lights after the last bell," and pen ink wells were not allowed in rooms for fear of spilling or staining. Additionally, students could not receive packages containing "eatables," except for "boxes of fresh fruit." [129] All mail first passed through the school's office, and the administrators reserved the right to open suspicious letters in the "presence of the student" or to forward inappropriate correspondence to the student's parents. Finally, local day students and boarding students were deliberately segregated and strictly prohibited from interacting with one another. In fact, day students attended

classes in a separate building and were forbidden to enter the dormitory room of a boarding student.[130] The girls donned brown uniforms—hence the yearbook's title from 1905 to 1912, *Milady in Brown*. The "Milady" refers to the chivalric notion of "My Lady," suggesting a reverence for Victorian notions of the behavior expected of upper-class young women, as well as colloquial overtones of engendered humility and modesty.

The initial years of Belmont College demanded much of its founders, faculty, and staff. The mansion and grounds were in need of repair and did not have modern amenities such as running water or electricity. As Hood stated, "Those first years here were not always pleasant, but through the efforts of a loyal friend and cousin—the water, sewer, and city lights finally came to our door."[131] Adelicia's beloved Belle Monte mansion was divided into fifty-two separate rooms.[132] Hood and Heron "adopted a new plan which retained the outside features of the mansion but remodeled the interior by partitioning the second floor into small bedrooms and providing classrooms, a dining hall, and apartments in the basement."[133] The mansion was affectionately renamed Faith Hall by the faculty and administration. The transition from home to school required other renovations, as the "gardens were modified; the fountain in the center of the Recreation Hall was removed; the bowling alley became a practice hall."[134]

With major campus renovations completed by 1899, Belmont College for Young Women attracted prospective families and students from across the country. In the first decade of the school, more than $300,000 was dedicated to renovations, the equivalent of more than $8 million today, making the buildings and grounds more comfortable for teachers and students. One advertisement makes note of such upgrades: "[There is] steam heat and gas in every room, and hot and cold water on every floor."[135] An addition to Faith Hall was built in the late 1890s to provide greater space for learning and living. The addition, named Friendship Hall, essentially enclosed the mansion's courtyard and attached the mansion's two original wings.

The architectural style of the campus also clearly reflected the antebellum definitions of the southern lady and classical education. In the early 1900s, Friendship Hall added a third floor, as well as Ionic columns to the front of the building facing Wedgewood Avenue, Peabody College, and Vanderbilt University. In 1905 Fidelity Hall was built to provide more dormitory space, but the building also housed the School of Music, which had garnered an impressive reputation in just fifteen years. Student Harriet Goodin wrote, "Out of this old homestead as a chrysalis, which we call Faith, came first Friendship, the cementing of the two hearts. From this

body grew a slender wing which we call Fidelity."[136] As the school neared its twentieth anniversary, the dining hall in the original mansion had grown cramped, and the kitchen needed more space and renovation. Founders Hall, named in honor of Heron and Hood, was built in 1909 as a new dormitory with a large dining hall on the first floor to accommodate the school's growth.[137] Even the building names reflected feminine qualities of loyalty, trust, morality, and tradition.

Belmont's student enrollment grew incrementally from nearly 100 in 1890 to nearly 150 in 1905. As the school's reputation as an elite boarding school for young women broadened, so did the geographical diversity of students, who hailed from twenty-eight states during the 1904–5 school year. This was quite an accomplishment for an administrative staff that advertised, traveled, and recruited heavily throughout the 1890s. The grandeur of the campus and its location in an attractive southern city also contributed to the scope and size of Belmont College's enrollment during its first decade. As one account stated, "Never has the grand old place looked more beautiful. The palatial old mansion has had every improvement that money and science can furnish, and combines the stately grandeur of an ante-bellum mansion with the cost convenience of modern invention."[138]

Most of the students were from southern states, with Tennessee topping the list. Students from Tennessee averaged 33 percent of the student body at the turn of the century. Beyond its home state, Belmont consistently attracted students from other southern states, such as Arkansas, Mississippi, Alabama, Louisiana, and Kentucky. Moreover, Texans represented approximately 15 percent of the student population from 1900 to 1912.[139] Beyond traditional southern states, Illinois sent the highest number of students to Belmont, but class rolls indicate a handful of students who ventured to Tennessee from even farther away. Charlotte King, class of 1906, came to Belmont College for Young Women from Alamagordo, New Mexico. Georgine Reid, who was in the "irregular" class, hailed from "Muscogee, I.T.," a city located in then Indian Territory—present-day Oklahoma.[140] And sisters Mary and Sara Geers came from Buffalo, New York; Mary entered as an "irregular" student, and Sara joined the class of 1909. Of no known relation to the school's founder, Ida M. Hood came to Belmont from Battle Creek, Iowa, and graduated in 1910.[141]

"Classes" were also divided into several interesting groupings that included seniors, sub-seniors, juniors, sophomores, freshmen, and irregulars. "Irregulars" were students not seeking a specific course of study. These students typically received a "Special Diploma" upon

graduation and many times represented a significant portion of the student body. For example, in 1906, with just over 350 enrolled students, 101 of them were "irregulars." For those in the world of higher education, the heavy enrollment of "irregular" students was an indicator that the school provided primarily college preparatory work or fine arts training and was not truly a college. A leading women's educator noted in 1912, "Irregular pupils affects the standard of a college...[and] constitutes the leading characteristic, and, at the same time, the leading weakness of southern colleges for women."[142] Some years also report the existence of other "classes" that included sub-freshman and the preparatory class; this suggests smaller classes of younger students.[143] After completing their junior year of studies, students entered a grade level unfamiliar to most today, that of the first-year senior (also called sub-senior). The sub-senior courses required completion before students could begin their senior year.[144] The BA tract included prerequisite courses, which could be satisfied with one year in Belmont's Preparatory Course, and five years of collegiate study. However, BA degrees awarded by Belmont, like at many women's schools, did not carry much weight in the professional world.

Upon the opening of Belmont in 1890, locals boasted that the school's "faculty and curriculum will compare with that of any college," and the school's inaugural year produced three graduates: Lulu Record, Hattie Osborn (both from Texas), and Virginia Green of Mississippi.[145] In truth, during the 1890s and early 1900s, Belmont was partly a college preparatory school while also retaining the qualities of a finishing school. In 1905, the college offered basic science and math courses, with the majority of faculty dedicated to the study of English, foreign language, and music. Music remained the largest department, in number of courses offered, with nine music instructors out of thirty total faculty members in 1906. However, as young women began to enter the workforce in larger numbers in the early twentieth century, trends reflected greater emphasis on academic course work. One local editorial noted, "We have been more than pleased to [see] an increasing interest in solid study, and a decline in 'specializing' on an insufficient foundation." The author, most likely an alumna, continued: "Some students have been reviving their interest in mathematics and Latin...and are preparing to enter the ranks for the BA degree. We congratulate both teachers and girls and exclaim, 'All honor to our beloved Belmont.'"[146]

By 1906 curricular programs included an interesting mix of academic tracks. The college's "Plan of Work" boasted eleven "schools": School of

English, Modern Languages, Ancient Languages, Mathematics, Natural Science, Philosophy, Elocution, Physical Culture, Art, Music, and the Preparatory School.[147] Students could receive a "Special Diploma," Certificate of Distinction, or Certificate of Proficiency. Belmont also conferred "in-house" diplomas in Expression, English, Latin, Music and, in cases less common, Bachelor of Arts.[148] Typically, four to five students graduated with a BA out of a class of twenty, but this number did increase after 1905. In addition, the 1906 course catalogue also lists postgraduate courses in English, with a notation "Leading to degree [M.A.]." Graduate-level training was also offered in music under the tutelage of Edouard Hesselberg, requiring additional recitals and intense study.[149] Perhaps mirroring national trends that reflected growing numbers of women as secretaries, operators, and clerks, Belmont added courses in stenography and typing. The school also required each student to take classes in physical culture (education).

The meaning of "college work" for women grew more academically rigorous after 1900, in part because of the emergence of accreditation agencies such as today's Southern Association of Colleges and Schools (SACS), which formed in 1895, and the Southern Association of College Women (SACW), which was officially established in 1909. However, Belmont was neither a member nor accredited by either body. Elizabeth Avery Colton, a professor at Meredith College (all-female) in Raleigh, North Carolina, documented the "Standards of Southern Colleges for Women" in 1912. She argued that out of 142 colleges for women in the United States, only four women's colleges in the South had been recognized by SACS: Agnes Scott College (Decatur, Georgia), Goucher College (Baltimore Maryland), Randolph-Macon Woman's College (Lynchburg, Virginia), and Sophie Newcomb Memorial College (New Orleans, Louisiana). Colton noted that all other women's colleges "have never been classified according to any national or sectional standard."[150]

Belmont did not attempt to mislead its students, parents, or the community. Like many institutions of its time, the school was founded on principles of higher education and continued to evolve in a quickly changing society and economy. Quite simply, the "University Era" and the explosion of colleges and schools from 1865 to 1918 produced a new, rather unregulated era of education. As nonprofit accreditation agencies and state/federal government educational reform developed in the first half of twentieth century, such discrepancies and inconsistencies between colleges and preparatory schools would dissipate.[151] In the 1920s, most schools gained accreditation and educational classifications began to normalize.

Regardless of the degree track or course of study, students enjoyed "college life" on a campus located on the grandiose grounds of the former antebellum Belle Monte estate. Students attended classes, chapel, and club meetings on campus. Student Laura Lewter was a junior whose schedule reveals the typical day of college girls in the early 1900s.[152] Lewter attended French I, American history, geometry, physics, and English in the mornings. From 12:00 p.m. to 12:30 p.m., students participated in "Devotional Exercises" before lunch. Lewter then returned to the classroom to take a Latin Cicero class until 2:00 p.m. Most likely the afternoon was free for recreation, clubs, and sports. Chapel was held before dinner, which was served at 6:00 p.m., and studying commenced at 7:00 p.m. and ended at 8:30 p.m. The "light bell" rang at 9:30 p.m. and signaled the day's end and time for bed.[153]

Belmont College certainly appeared to be a college, with young women mostly between the ages of seventeen and twenty-one; classes, dining halls, and dormitories; and campus clubs, sports, and sororities. While Ward Seminary did permit some sororities, Belmont College remained more dedicated to its Greek system, even allowing sorority houses. Early sororities included Beta Sigma Omnicron, Theta Kappa Delta, Tau Phi Sigma Sorority, and Chi Omega.[154] Apparently, Hood and Heron feared secret societies or sororities: "There was a time when [secret societies] threatened to be disturbing elements at Belmont."[155] Nonetheless, several properties near the campus were available for purchase, and because of increased enrollment in the 1890s, the school obtained four nearby houses and "offered them to the four sororities which had arisen in the college on condition that each would become responsible for the protection of their chapter-houses."[156] An adult woman resided in each chapter house and acted as a chaperone and a hostess. The girls of the four sororities "accepted this opportunity for community life with avidity, and not only gave the guarantee asked for, but have made good their pledges with true womanly fidelity."[157]

In addition to sororities, the year included many school-wide social events such as picnics; a Halloween Carnival; Thanksgiving Dinner; a yearly visit from Vanderbilt's Glee Club; a sorority-sponsored Valentine Dance; Colonial Day Tea; Tally-Ho parties (when students loaded up in trucks and rode around town); May Morning Breakfast; "Park Day," held at nearby Centennial Park; Senior Luncheon; Alumnae Banquet; and the Principals' Reception Day (similar to an Awards Day).[158] The Halloween Carnival was a particularly exciting event that students anticipated from the start of the school year. Student Willye O. Smith provided a detailed account of the evening in 1904:

Belmont College maintained formal houses for each of its sororities, including Beta Sigma Omicron, Theta Kappa Delta, Tau Phi Sigma, Sigma Iota Chi, and Sigma Tau Psi.

It was an ideal night for ghosts and goblins. The air was charged with mystery, and the college stood like some haunted mansion…. Everything was silent in Belmont Park… [and] *you shuddered when you thought of wandering spirits…. Suddenly the bell pealed forth a loud summons, and almost instantly the campus became alive with…witches, wizards, spectres, and spooks…. From one tent came the sound of the banjo…from another came the muffled voice of a fortune teller…. The girls marched round the fires, forming a large circle,* [and] *sang…After this everyone enjoyed a general feast, roasting apples on long sticks over the fires and popping corn.*[159]

If Halloween marked the highlight of the fall semester, graduation was the highlight of the spring semester. Activities related to commencement lasted for more than a week, with dances, concerts, a May Day Festival, and the graduation ceremony held at the beginning of June. May Day Festivals were commonplace in girls' schools and some co-ed schools

Both Ward Seminary and Belmont College maintained "State Clubs" for all boarding students. Here is the Texas Club, pictured on the Belmont Mansion steps, 1909.

throughout the country, but they held a particularly special place in the South—reinforcing proper feminine behavior as they simultaneously reconceptualized the notion of the Southern Belle. Ilana DeBare, author of *Where Girls Come First: The Surprising Rise, Fall and Surprising Revival of Girls' Schools* (2005), has written the most comprehensive history of all-girls schools in the United States. As DeBare noted, "[M]any girls' schools and women's colleges instituted annual May Day celebrations that involved an elaborate pageant with gowns and flowers, and the selection of a May Queen and her court. These rituals celebrated spring, but they also celebrated and promoted the Victorian ideal of woman as delicate, graceful, pure, and virtuous."[160]

From the beginning, clubs were a major part of the Belmont experience. These included "State Clubs" (determined by the student's home state), athletic clubs, and music clubs and ensembles. Although the school regularly advertised and emphasized the school's nonsectarian status, religious overtones were ever present in school culture. The largest religious club, the Young Women's Christian Association (YWCA),

began in 1892 and emphasized moral character, community service, and healthy living. The YWCA club at Belmont fluctuated in size, but regardless of numbers, "the faithful few met, sewed, sang, read and prayed, thus keeping alive the flame on the altars of their hearts."[161] By 1904 the club had 135 members, nearly 75 percent of the student body at the time, and maintained of an annual budget of $350. The growth and development of the YWCA reflected national trends related to "Muscular Christianity" that included women and emphasized moral living, hard work, and physical/mental strength.

The variety of Belmont's music clubs and groups testified to the school's fine arts emphasis, particularly in piano and voice. Beyond the more general Glee Club and Choral Club, several "specialty" clubs paid homage to students' favorite composers. The Clara Schumann Piano Club was first organized in 1896, and members stated that "[t]he purpose of the Club is not absolutely for pleasure, but for improvement."[162] With thirty members by 1904, the club studied not only piano and particular musical pieces but also the lives of the composers who wrote them. The club's namesake, Clara (Wieck) Schumann (1819–96) from Germany, was perhaps the perfect choice. Schumann was herself a masterful pianist and composer as well as the spouse of famed composer Robert Schumann (1810–56).[163] Another distinct musical club at Belmont College for Young Women was the Leschetizky Club, named for Polish pianist and composer Theodore Leschetizky.[164]

Much like Ward Seminary, Belmont College for Young Women maintained an excellent Music Department, a common characteristic of many all-female schools. One advertisement boasted that Belmont offered "[m]usic according to principles of famed European conservatories, [with] teachers educated abroad."[165] The school's emphasis on music was evident early with a solo by Madame La Sogue, a prominent opera singer at that time, at the school's opening ceremony in 1890. Moreover, music teachers composed a majority of the faculty by 1905, with six of eighteen teachers dedicated to voice, piano, violin, theory, music history, guitar, and even mandolin and banjo.[166]

Perhaps the most well-known music faculty member at Belmont was Edouard Hesselberg, a famous Latvian composer and pianist who studied in Russia. He was appointed director of music at Belmont in 1905 and served in this capacity until the school's merger with Ward Seminary in 1912–13. Hesselberg was born in Riga, Latvia, in 1870 and graduated from the Moscow Philharmonique of Music and Dramatic Art. After

touring throughout the "Old World and New World," he accepted the position of director and chairman of the Music Department. Under his leadership, the school made "valuable additions to the music faculty," and the department grew tremendously. By 1908 he had composed more than one hundred original works for voice, piano, and violin. Hesselberg also wrote the song "Belmont Belles," which was adopted as the official march song of the school. Grace Mauzy, a student from 1910 to 1913, commented on the legacy of Belmont music as the school looked ahead to its merger with Ward Seminary:

> *In after years specific instances of success will be forgotten, the memory of certain brilliant careers will fade away and many trained fingers will have become piano-weary and numb, but the memory of Belmont's music as a whole, in all its richness of variety, will always remain as one of the most attractive, most blessed of Belmont's influences.*[167]

In 1904 after fourteen years in the business of higher education, Misses Hood and Heron realized that they needed an additional administrator to help with school affairs and oversee future building projects. Although the two women continued to reign as matriarchs of the campus, both were over fifty years of age and no longer desired the weight and responsibility of managing the school by themselves. Dr. Ira D. Landrith was named regent of Belmont College for Young Women and held this position from 1904 to 1911. Landrith served as the main official and administrative head of the school. As a result, Hood and Heron stepped away from daily duties while remaining an integral part of the academic and cultural life of the school.

Dr. Landrith's life and career mirrored that of Ward Seminary founder Dr. W.E. Ward, although the tenures of the two men were forty years apart. In fact, Landrith was born in 1865, the year William and Eliza Ward opened their school for girls. Landrith was Texan by birth but earned his bachelor's degree in 1888 at Cumberland University in Lebanon. Like Ward, he remained at Cumberland to pursue graduate work and earned additional degrees in law (1903) and divinity (1904).[168] Also like Dr. Ward, Landrith served as editor of the main newspaper of the Presbyterian Church, the *Cumberland Presbyterian*, from 1890 to 1903 before entering the world of women's education as an administrator. In 1900 he served as a minister in the Lebanon Presbytery, commissioner to the General Assembly in Chattanooga, and member of the Committee of Education for the Presbyterian Church (USA).[169]

Unlike Ward, Landrith was a frequent public speaker and a political activist. He was the chairman of the Tennessee State Committee of the YMCA, helped establish the Tennessee Anti-Saloon League, and served as the Prohibitionist Party's vice presidential nominee in 1916 after resigning from Ward-Belmont in 1915.[170] Woodrow Wilson won the election of 1916, but Landrith continued to travel and speak across the country. One source provided a description of Landrith in appearance and character: "Ira Landrith is a Texan—big in body, big in mind—'a man of many inches, and every inch a man.'"[171]

Prior to his arrival in Nashville, Ira Landrith married Stanford Corinne Burney in July 1889, but she died in August, one month after their marriage. Two years later, Landrith married Hattie Canfield Grannis.[172] Their daughter Grace, born in 1894, would be the couple's only child to survive to adulthood.[173] Grace attended Belmont College for Young Women from 1908 to 1912 and graduated, after the merger, from Ward-Belmont School. She was active in the French Club, the Leschetizky (music) Club, and the Nashville Club. Grace also served as a reporter for the *Ward-Belmont Hyphen* and as a member of the Athenian Athletics Club.[174] She graduated from the Speech Department and was clearly a beloved student.[175] Her classmates wrote of her in 1915, "Grace, Grace, the name that charms the ears, And must dispel all human fears; Grace Landrith, loving and sincere, By every Senior heart held dear."[176]

Graduates of women's schools past and present cite the significance of special bonds with their fellow classmates as part of a powerful sisterhood. As Ilana DeBare explained, "[T]he single-sex environment added a twist to girls' relationships that could increase their intensity."[177] Mallie Gaines Wilson (Farrell) and Elizabeth Ross, class of 1905, provide interesting profiles of students who demonstrated leadership, ambition, friendship, and a special bond with the school. Both were awarded Bachelor of Arts diplomas and were members of the YWCA, Glee Club, German Club, and *Milady in Brown* staff. Elizabeth Ross came to Belmont from Louisville, Kentucky. She served as editor-in-chief of the *Milady in Brown*; business manager of the Belmont's literary periodical, *Blue and Bronze*; and president of the Athletic Association. Ross was also a member of the German Club, Mandolin Club, and Theta Kappa Delta, and she was named tennis champion in 1905.[178] Mallie Wilson hailed from Pulaski, Tennessee, and was president of the senior class, manager of the Glee Club, and head of the Literary Committee for *Milady in Brown*. She earned a diploma from the School of Expression in addition to a BA.[179] She was a member of the Choral Club, Tau Phi Sigma, Tennessee Club, and

GRACE LANDRITH

Grace, Grace, the name that charms the ears
And must dispel all human fears;
Grace Landrith, loving and sincere,
By every Senior heart held dear.

Grace Landrith attended Belmont College from 1908 to 1913 and completed her studies at Ward-Belmont, graduating with the class of 1915. She was the daughter Ira Landrith, who served as regent of Belmont College (1904–12), president of Ward Seminary (1912–13), and president of Ward-Belmont School (1913–15).

Athletic Association.[180] Mallie was a prolific writer, authoring many poems, short stories, and articles published by Belmont from 1901 to 1905. One poem of note was entitled "Belmont Snowbound," a mythic tale of winter, snow, and nostalgia.[181]

These two outstanding young women had lively personalities and abundant talent. Both seemed to understand the importance of attending college during this time of transition for young southern women. They adored their time at Belmont and made the most of school, friendship, and college life. Their fellow seniors listed post-graduate predictions and chided one another with humorous forecasts of the future: "Genevieve Evans loses a bottle of ink…Tearing up the ground for a new building…Lida Pritchett goes to the infirmary."[182] As for Mallie and Elizabeth, their classmates wrote, "All the stragglers are in except Mallie Wilson and Elizabeth Ross," and "Mallie Wilson and Elizabeth Ross finally come back."[183] Ironically, one of them did return to Belmont. Mallie Wilson began her teaching career at Belmont College for Young Women in 1908 as an assistant instructor for English, history, and mathematics.[184] As her time at Belmont came to a close, she wrote a short poem, entitled *Retrospection* that captured the beauty of Belmont and her time there:

How often have I sat on those old steps and watched the evening fade into night! Against the pale pink and blue and gold of the lingering sky one tall, shapely tree daintily traces a lacework of bare branches. O, the delicate beauty of it! The fairy fingertips that seem to touch my very soul. As "silently one by one blossom the lovely stars," my whole nature is bursting with an inexpressible something. And is it not this same something that makes the mocking bird, more bold than mortals, put forth its rapturous melodies? The same something that makes the flower lift its smile to heaven, and that impels the blind savage heart to reach out after a Being higher and holier than itself?[185]

DeBare also pointed out that from the 1860s to the 1910s, having a best friend was of particular importance, especially considering that casual interaction with young men was "completely off limits."[186]

From the school's inception, Belmont's primary competitor remained Ward Seminary. Ward Seminary was more established and maintained a time-tested reputation for academic rigor with more stringent entrance exams and prerequisites than Belmont. Although both schools attracted young women from across the South and the nation, entrance into Ward Seminary remained more difficult. Ward Seminary was also located in downtown Nashville, the regional hub of commercial activity and residential living before and immediately after the Civil War.[187] In contrast, Belmont College for Young Women boasted a much grander and expansive campus in West Nashville, which by the turn of the century was home to all of Nashville's major colleges and universities.

Although Belmont continued to grow, its founders grew weary as they neared retirement. In 1911 the school also "fell on financially hard times."[188] Dr. Ira D. Landrith, who had served as Belmont's regent since 1904, resigned from Belmont to become the president of Ward Seminary in 1912. J.D. Blanton, who had served as Ward Seminary's president for twenty years, stepped down and assumed the duties of vice president. In 1912, Dr. Landrith and Dr. Blanton, representing Ward Seminary, "offered over $1,000,000 for their [Belmont College's school and campus] property and institution." Ida Hood and Susan Heron sold the property and school, retired, and built a new home in Belle Meade that later became the residence for Vanderbilt's chancellor. The newly formed Ward-Belmont School took its place as a "thriving college campus, gaining a national reputation for its high academic standards and social prominence."[189]

In 1967 a four-page document entitled *Background and History of Belmont College* referred to Hood and Heron as "spinsters" who established the school in 1890. Others identify them as co-principals, partners, companions, founders, friends, teachers, and mentors. Despite official and unofficial titles, Ida Hood and Susan Heron devoted their lives to educating young women just as the "modern woman" began to emerge at the turn of the twentieth century. Professionally, they spent their careers working and teaching side by side in four different schools for more than thirty years. Beyond school walls, the two also spent the majority of their adult lives together as they attended church and club meetings, traveled to raise money and recruit students, and shared a residence. Students and faculty at Martin College and Belmont College often referred to them as "Hood and Heron," and they introduced themselves as business partners. The two women also share a headstone at the Mount Olivet Cemetery in Nashville that reads, "Entered into rest, Friends eternally, and Founders of Belmont College."[190] These educational torchbearers established a strong school and beautiful campus that fostered a culture of educational opportunity for women. Their lives and legacy provided the cornerstone on which Ward-Belmont School, Harpeth Hall, and Belmont University, located today on the original campus, would build.[191]

In 1934 the *Ward-Belmont Hyphen* described the closing of Belmont College and its reopening as follows:

> *Years passed. Belmont College grew into one of the leading institutions of the South. However, Miss Heron began to lose her health and she decided that she must have a rest and a change. Since Ward Seminary was seeking a suburban location at this time, it was thus, that the two foremost girls' schools united and Ward-Belmont was formed.*[192]

The idea of a new school did not immediately inspire the transfer of loyalty from one school to another for students; they had been rivals for more than twenty years. As one Ward student wrote, the campus of "Belmont College was retained and the old Ward Seminary buildings were no longer the home of a great school."[193] Lillian S. Craig, Belmont student and a "First Senior" from Texas, proclaimed in 1912, "Thousands of loyal and devoted Belmont girls widely dispersed over these United States are constantly proclaiming their loyalty to you and beautiful Belmont, 'Beautiful, beautiful Belmont.'"[194]

From the beginning, however, the merger allowed the schools to offset their weaknesses and build on their strengths. Members from both faculties

remained on staff when Ward-Belmont opened its doors in 1913. Ultimately, the merger of Ward Seminary and Belmont College was good for women's education and the local community. While many modern historians and educators dismiss these early schools as finishing schools, "motivated girls could find extremely bright teachers who pushed them to think," and ironically, "[t]oday's parents of both boys and girls aggressively seek out schools that offer many of the same liberal arts courses that the old finishing schools did—classes in music, drama, studio arts, and modern languages."[195]

HALCYON DAYS

The Ward-Belmont School, 1913–1951

[We sang] *"The Bells of Ward-Belmont"* *with great spirit and deep emotion*
and with certain appreciation that the strict discipline and the positive and
undisputed authority which governed our formative years was assuredly a good
and powerful force in shaping our lives. Indeed it did not stunt our growth.
–Mary Elizabeth Cayce, Sarah Colley Cannon, and Sarah Bryan Benedict[196]

The Ward-Belmont School emerged during the height of the Progressive
Era, which produced the first significant number of female college
graduates and witnessed the mass entrance of women into the workplace. In
1900 only 5 percent of middle-class white women worked outside the home,
and less than 3 percent attended college; by 1925, approximately 20 percent
participated in the workforce, and nearly 10 percent attended college.[197]
Ward-Belmont still reflected the values of a traditional girls' school for the
majority of its students and patron families. However, the school developed
legitimate academic programs, attained junior college accreditation in
1925 through SACS (first in the South), and solidified its reputation as a
center for aspiring musicians. Ward-Belmont did not offer bachelor's or
master's degrees, but it *did* fulfill a specific niche by providing a reputable,
socially conservative school for southern women. And eventually, most of its
graduates went on to complete their college degrees at accredited colleges
and universities.

Across the nation, women's colleges in the first half of the twentieth
century "provided women both liberal arts and practical training, enabling

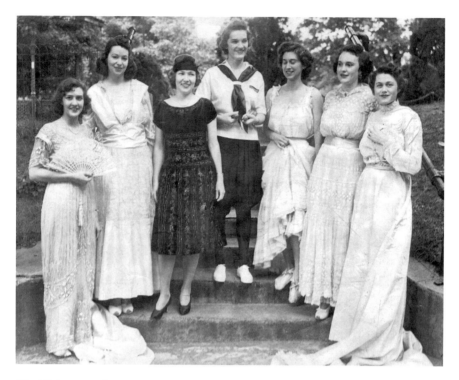

Ward-Belmont students, circa 1938.

some graduates to establish careers, pursue social service and activism, and sometimes to combine one or both of these with the more common role of the homemaker."[198] Such is also the story of the Ward-Belmont School, which served a variety of purposes and measured success by many standards. Despite the differences of experience for Ward-Belmont students and alumnae, the common thread and legacy remains a story of camaraderie, study, discipline, and play. Among the hundreds of Ward-Belmont graduates over the years, four women spanning four decades used their education as a catalyst for highly successful careers in vastly different fields.

Mary Elizabeth "Betty" Pruett Farrington graduated from the newly merged Ward-Belmont School in 1916 with a general diploma and earned a BA in journalism from the University of Wisconsin–Madison in 1918. She hailed from California, served as president of the California State Club, and was best known on campus as a capable leader and *Milestones* editor. Her classmates wrote, "There was a young lady named Pruett, Who on every subject she knew it. So strong was our belief, That we made her editor-in-chief, Because we knew it—Miss Pruett could do it."[199] Two years

after graduating from college, Betty Pruett married Joe Farrington. They moved to Hawaii to co-manage the *Honolulu Star Bulletin* and became deeply engaged in politics. After Joe's death, Betty succeeded him as the Hawaiian territorial delegate in the U.S. House of Representatives from 1954 to 1957. She strongly advocated for Hawaiian statehood, which was achieved in 1959. She failed to win reelection; however, Farrington remained active in politics and business as owner of the *Honolulu Star Tribune*.[200]

Mary Elizabeth Cayce was born in Nashville in 1909. She was the daughter of James Cayce, a prominent businessman and founder of the Nashville Chamber of Commerce. She attended Miss Annie Allison's Preparatory School, Ward-Belmont School, and George Peabody College for Teachers. Cayce graduated from Ward-Belmont in 1928, and upon completion of her bachelor's degree, she joined the Ward-Belmont faculty as a physical education teacher, a position she held from 1930 to 1945. She was an active force in the movement to establish the Harpeth Hall School after the sudden closing of Ward-Belmont and served on the original Board of Trustees. After her career as an educator, Cayce joined the B.H. Steif Jewelry Company. In 1945 she was named the company's vice president, ultimately becoming president and owner until her retirement in 1970. Cayce's community activism continued as a philanthropist and as a member of multiple organizations until she moved into the "Old Woman's Home on West End Avenue" in 1984.[201]

"Sarah" Colley Cannon was born in rural Centerville, Tennessee. She attended Ward-Belmont from 1930 to 1932, graduating with a general diploma from the School of Expression. After traveling with a theatre company in the mid-1930s, she joined the Grand Ole Opry in 1940 as "Cousin Minnie Pearl." She sported a dime-store hat with a $1.98 price tag still hanging from the brim and told stories based on a fictional hometown, Grinder's Switch, where she was always looking "for a fellar." Cannon remained with the Opry until 1991, when she suffered a stroke.[202] Her stage career led to an iconic legacy as a performer and the Opry's preeminent comedian. Off stage, Sarah and her husband, Henry, were active in the Nashville community, passionately devoted to cancer research following the death of her sister and Sarah's own fight with breast cancer. Upon her death, a portion of her estate was used to endow the Minnie Pearl Cancer Foundation and the Sarah Cannon Research Institute (SCRI).[203] Throughout her adult life, Cannon frequently referenced the importance and influence of her time at Ward-Belmont, and she regularly visited Ward-Belmont's successor school, Harpeth Hall, to speak to the student body.[204]

Sarah Ophelia Colley Cannon, better known as "Minnie Pearl," pictured in 1931 before her graduation in 1932. Shortly after graduating from Ward-Belmont, she began her performance and comedy career. According to the Grand Ole Opry, during her Ward-Belmont days she went by Ophelia, but her nickname was "Ophie." Throughout adulthood, she was known offstage as Sarah Cannon. *Courtesy of the Grand Ole Opry Archives.*

Mary Margaret "Curly" Neal hailed from Miami, Oklahoma, graduating from Miami High School in 1942 before arriving at the Ward-Belmont School to continue her education. She graduated in 1944 and enrolled in Northwestern University in Chicago, earning a BS in chemistry in 1946. A standout student at Ward-Belmont, Neal returned to teach chemistry at her alma mater in 1947.[205] Despite teaching for only two years, Neal is fondly remembered as an influential teacher. According to Jean Ward Oldfield, class of 1947 and great-granddaughter of Ward Seminary founders William and Eliza Ward, "Curly Neal was one of the all-time best teachers…. [She] seemed to know what was going to be hard for us to understand and took the time to explain things well…. [And] she was also a wonderful person."[206] In the private sector, she worked as a chemist for Baxter Laboratories and Shell Development Company until 1955 and then returned to Northwestern to obtain a master's degree in physical education. Combining experience in

two vastly different fields, Neal taught and coached tennis at San Jose State University until 1964 and then at Stanford University from 1964 to 1985. While at Stanford, she also served as the dean of the Women's Physical Education Department. Remembered as a remarkable student, teacher, scientist, athlete, administrator, and friend, Curly Neal represented the best of Ward-Belmont.[207]

These four vignettes are but a chosen few from a remarkable cadre of accomplished alumnae who attended the Ward-Belmont School from 1913 to 1951. Over the course of four decades, Ward-Belmont improved the depth and breadth of women's education in Nashville amid a dramatically shifting social landscape. The school offered cultural opportunities, granted limited individual autonomy, inspired civic and social responsibility, and instilled discipline and moral character. Ward-Belmont retained the best values of a finishing school while providing a first-rate education, albeit with a curriculum designed specifically for females.

The school opened in September 1913 with Dr. Ira D. Landrith as president (formerly regent of Belmont College, 1904–12) and Dr. John Deill (J.D.) Blanton as vice president (formerly president of Ward Seminary, 1893–1912).[208] Dr. Landrith had resigned from Belmont College for Young Women in 1911 to become the president of Ward Seminary. Dr. Blanton, who had served as Ward's president since 1893, stepped down to assume the role of vice president. Almost immediately, the two began preparing for a potential merger between Ward and Belmont. Their dream of expansion and growth was fulfilled with the opening of the Ward-Belmont School, and Landrith and Blanton continued as president and vice president, respectively. After the graduation of his daughter, Grace Landrith, Dr. Landrith resigned from his position as president of Ward-Belmont and moved to Boston in 1916.[209] Dr. J.D. Blanton returned to his role as chief administrator along with his wife, Anna Blanton, who was a teacher and administrator over the course of her forty-year educational career. Dr. Blanton would remain in this position for seventeen years until his death in 1933, making his thirty-five years the longest tenure of any head of school at Ward Seminary, Ward-Belmont, or Harpeth Hall.

Working together, the Blantons were primarily responsible for the school's growth and success through several periods of transition. The two served with steady hands and clear hearts in the spirit of Ward-Belmont's traditional mission of preparing young ladies for the home and society while also remaining flexible as the school, and its students, sought to fit into a progressively modern society. Dr. Blanton led building campaigns

and facilitated departmental expansion, all while maintaining the school's devoted focus on discipline, character, and academic study. An outstanding administrator, Blanton nevertheless had a reputation for being aloof and absent-minded. Longtime friend and fellow educator Clarence B. Wallace (founder and headmaster of Wallace University School, 1886–1941) told the following story in 1950: "A not unfamiliar sight [at the NC&StL railroad station] was our dear friend Dr. Blanton.... Once the dear man could not find his railroad ticket for the conductor.... Dr. Blanton said 'I have got to find that ticket, for I have forgotten where I am going.'"[210] On another occasion, Dr. Blanton quickly boarded a departing train. After traveling for more than an hour, he inquired about the train's arrival time in Memphis. The conductor replied, "Lor[d], Mister, this ain't the train for Memphis, this train is going to Chattanooga."[211]

Blanton's occasional moments of distraction and preoccupation were attributable to the demanding nature of his job as president of a growing school. During his tenure, enrollment increased from about two hundred to more than six hundred students, buildings were erected and existing structures renovated, equipment was updated, and faculty positions more than doubled. Moreover, Dr. Blanton's administrative career paralleled a national movement of educational accreditation that ultimately standardized entrance requirements, programs of study, and degree offerings. He was responsible for upholding the prestige of the school not only on the local level but also among college preparatory and collegiate programs nationwide.

Ward Seminary brought to the merger of the two schools its status as a nationally recognized school for young women with a strong academic reputation, while Belmont College contributed the physical West Nashville location and a campus poised for growth. The school's impressive six-page weekly newspaper was, in fact, named *Ward-Belmont Hyphen* in honor of the "combination of these two fine schools."[212] The Ward-Belmont School operated as the equivalent of a two-year college and college preparatory school with "an outstanding reputation as a school not only for upper-class belles but also for academically aspiring young women, who at this time had few choices for higher education in the South."[213]

World War I produced many advantages for young women attending colleges as their numbers and positions of leadership increased with the absence of thousands of young men drafted to fight. Moreover, the Nineteenth Amendment to the U.S. Constitution granted women's suffrage in 1920, giving women the opportunity to invest fully in their communities as equal citizens with their male counterparts. In the

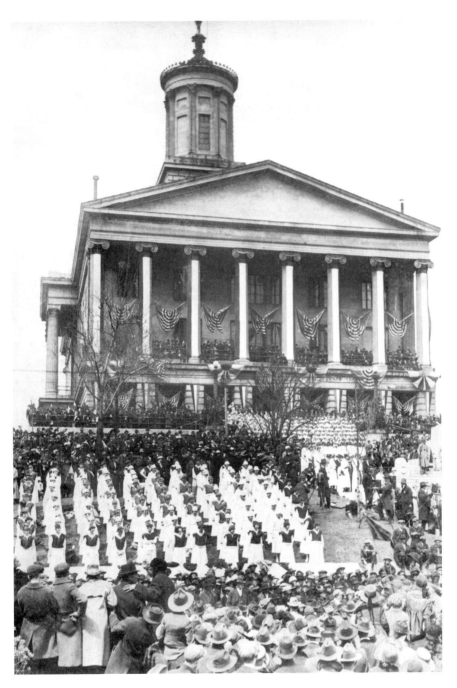

Ward-Belmont Word War I "Flag Rally," held in April 1919. Miss Catherine Morrison organized this celebration to honor Colonel Luke Lea and the Tennessee troops. Ward-Belmont girls dressed in crepe paper replicas of the American flag wait at the foot of the Tennessee State Capitol.

1920s and 1930s, women began to assert themselves in new ways in regard to public spaces, recreation and leisure, and community and professional leadership.

Ward-Belmont's curriculum never contained classical majors, and conferred diplomas were awarded predominantly in literature, music, and education; however, in single-sex schools, this practice was not uncommon. By the end of World War I, Ward-Belmont had also established courses in domestic science, business and secretarial work, and physical education.[214] Adding more practical and industrial elements to the curriculum was an important new development. Some women's colleges and seminaries embraced practical courses, while others chose to remain true to Victorian ideals, where the emphasis remained on "refined" academic subjects intended to prepare graduates for sophisticated society. Ward-Belmont's divisions, departments, curriculum, and courses of study reveal the school's attempt to attract families seeking a variety of outcomes for their daughters.

Prior to 1925, the Ward-Belmont School offered several courses of study. The classical "Collegiate" course included four years of college preparatory work and two years of collegiate work, after which many graduates finished their course work at four-year institutions. Courses in early school catalogues show that some classes overlapped between the College Preparatory and Collegiate Departments, particularly for those students who attended both. For example, within the liberal arts and sciences track in 1917, college prep and college-level courses were listed together.[215] Another academic track was the General Course, consisting of four years of study whereby graduates who did not intend to further their education at another college received the equivalent of a high school diploma or an associate's degree. Ward-Belmont also awarded several specialized "degrees" in piano, expression, voice, home economics, and physical education. Moreover, the school offered certificates of completion for first-year collegiate work, college preparatory, high school, organ, art, domestic science, domestic art, business and secretarial, and arts and crafts.[216]

Between 1913 and 1925, students were classified as a freshman, sophomore, junior, junior-middle, senior-middle, or senior.[217] Those pursuing college courses were deemed either senior-middle or senior. A student's designation was based generally on age but also on previous education and level of skill. In short, the system may have allowed for greater flexibility, but the lack of standardization and consistency further

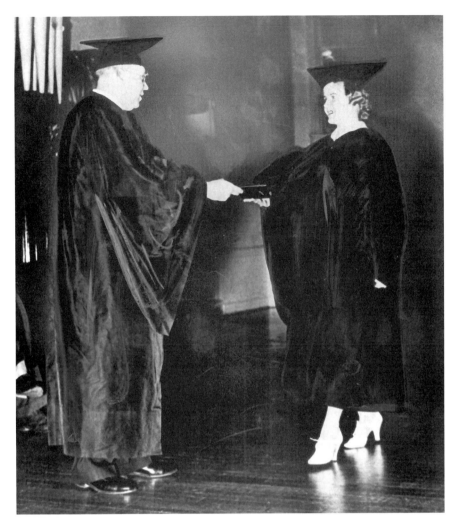

Grace Benedict Paine, class of 1936, receives her college diploma from her father, Dr. Andrew Bell (A.B.) Benedict, who served as Ward-Belmont's vice president and business manager in 1936.

muddied the waters for Ward-Belmont's institutional status. Ward-Belmont was not alone in attempting to offer multiple programs of study. All-female colleges and religious colleges, as well as certain coeducational and men's colleges, struggled with curricular challenges. With the rise and acceptance of accreditation agencies and the solidification of the U.S. Department of Education in the 1920s, schools began to better define their institutional missions, academic programs, and degree offerings.

By the 1940s, certificates and special diplomas would yield to traditional degrees, and names such as "seminaries" faded from the educational lexicon. The titles given to classes also changed in the 1940s to include three versions of a "senior": a high school senior was a senior-prep, a first-year college student was called senior-middle, and a second-year college student was given the stand-alone title of senior. Although these groupings seem confusing today, to those at Ward-Belmont these distinctions were apparent. No longer are phrases such as "senior-middle" and "junior-middle" used in education, and far fewer schools maintain high school and college divisions under a single institutional umbrella. By 1950 modern college curriculum and degree programs had largely standardized, and schools either gained collegiate accreditation, restructured, merged, or closed.

By 1920 Ward-Belmont boasted nearly six hundred students from thirty-six states, Alaska Territory, and Canada, although most students hailed from Tennessee and neighboring southern states. In 1925 Ward-Belmont received the first junior college accreditation granted by the Association of Colleges and Secondary Schools of the Southern States, and soon it joined the American Association of Junior Colleges. In order to conform to accreditation standards, the school was divided into two distinct entities: a college preparatory division and a junior college division. Within each division, day students were largely separated from boarding students, and college prep students rarely interacted outside of class with their collegiate

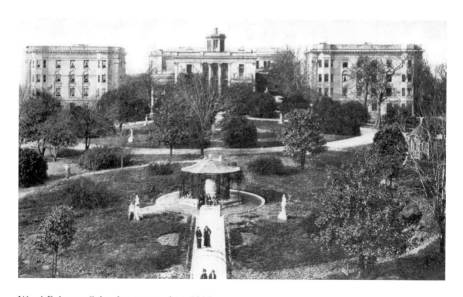

Ward-Belmont School campus, circa 1915.

counterparts. Moreover, young women who were part of the school's Conservatory of Music and other separate departments spent much of their daily schedule apart from those seeking a general education degree.

In the late 1920s, the Ward-Belmont Conservatory of Music was added as a "music school" and operated within the junior college. Beginning in 1927, the Music Department published its first catalogue independent of the main school's catalogue. In 1928 the name was changed from the Ward-Belmont School of Music to the Ward-Belmont Conservatory of Music. This title brought more prestige to the previously separate Voice, Piano, and Violin Departments. Even by 1935, the Conservatory of Music was authorized to confer only certificates. While diplomas could be issued, certificates held more legitimacy—in part because they were typically awarded for mastery of a particular instrument or in voice. Diplomas remained an "in-house" distinction that carried little weight and were not the equivalent of an associate's or bachelor's degree. As the 1930 music catalogue notes, "Students intending to enter the music profession as teachers or performers, or those desiring a broad training, making possible the acquirement of true musicianship, are advised to enter the certificate course."[218]

This period would also bring music faculty members to campus who would leave lasting impressions. From 1918 to 1927, Italian singer and instructor Gaetano Salvatore de Luca was as well known for his mustache as for his voice. De Luca wore spats, gestured enthusiastically, and spoke with a pronounced Italian accent. He led the Voice Department with great command and attracted many voice students to the school. Under his direction, the Ward-Belmont School of Music presented an impressive production of the opera *Cavalleria Rusticana* at Ryman Auditorium in 1927.[219] De Luca left Ward-Belmont to open the Nashville Conservatory of Music in 1928.

Another memorable Ward-Belmont musician and educator was Kenneth Rose, who graduated from Butler University in Indianapolis. Rose served as head of the Violin Department from 1918 to 1951, succeeding the beloved Fritz Schmitz, who taught violin from 1908 until his sudden death in 1917.[220] The Piano Department also had several teachers who maintained long tenures and served as excellent teachers as well as performers. Fritz Schmitz's wife, Estelle, began with her husband at Ward Seminary in 1908 and continued to teach piano after her husband's death, teaching in Nashville for twenty-six years (until 1934). A new piano teacher, Eva Massey, arrived on Ward Seminary's campus the same year as Fritz and Estelle Schmitz.[221] The 1910 Music Department

A Ward-Belmont Conservatory of Music diploma was awarded to Lavelle Thompson in 1931. The conservatory was a major part of Ward-Belmont's student culture and educational success. By 1930 it had achieved a national reputation of excellence and was accredited by the National Association of Schools of Music in 1938.

brochure touted her expertise: "[She] came to Ward Conservatory two years ago at the full maturity of her powers."[222] Massey graduated from the New England Conservatory of Music, taught at Converse College in South Carolina and Wesleyan Female College in Georgia, and studied in Berlin and Paris. In 1908 the *Nashville Banner* reported that Miss Massey had "immediately won her audience. To a real artistic temperament she unites a perfect sincerity whereby she seems to vibrate not an instrument but the soul of the composer whose work she is interpreting."[223] Massey began teaching at Ward Seminary and remained after the merger to serve on the faculty of Ward-Belmont until her death on May 7, 1924.[224]

The Piano Department was directed by Lawrence Goodman, who studied in Switzerland and at the Peabody Conservatory of Music in Baltimore. Goodman came to Ward-Belmont in 1920 and remained the director of the department until 1934. Under his leadership, the Piano Department grew in size and scope. The 1927 Ward-Belmont catalogue boasted of the school's ninety pianos, including ten Steinway Grands.[225] In 1938 the Ward-Belmont Conservatory earned an important accreditation

when it was admitted as a member of the National Association of Schools of Music (NASM). This certification gave the program, its faculty, and its graduates a new level of credibility in the professional worlds of music education and performance.

Another dearly loved member of the faculty who later became an administrator was Annie Claybrooke Allison. Allison had operated her own preparatory school, Miss Allison's School, which closed in 1923. She came to Ward-Belmont in 1926 as a Latin teacher. In 1932 she was appointed to the newly created position of Preparatory School principal. Dakie Caldwell Cowan, author of *Annie Was a Lady*, recalled that "Miss Allison's academic and moral judgment set the campus theme." Moreover, Allison encouraged students to "say what you think" and to "be all that you can be."[226] She would remain principal until 1945 and was a cherished member of the school. She was succeeded by Susan Souby in 1946.[227]

Two other faculty members who contributed greatly to the school were Theodora C. Scruggs and Catherine E. Morrison, both of whom began their careers at Ward Seminary in 1911 before continuing at Ward-Belmont after the merger. They remained with the school until their retirements in 1944 and 1951, respectively. Scruggs, an English teacher, received her bachelor's degree at Wellesley College. She later studied at the University of Chicago for graduate studies in literature and European history.[228] Scruggs was a firm but beloved teacher who set the academic bar high for her students at Ward-Belmont. Catherine E. Morrison taught physical education, including gym, athletics, and swimming. Morrison graduated with a diploma from Posse Gymnasium in Boston and also received training under the status of "special student" at the Chalif Normal School of Dancing in New York.[229] In 1926 Morrison was honored by the student body: "Because of the trust she has placed in us, because of the standards she has maintained for us, and because of the ideals she has given to us, this *Milestones* is affectionately dedicated."[230] Student accounts reveal that students saw Miss Morrison as a teacher, mentor, and administrator of sorts—often lovingly mocking her "perform form." Morrison served as athletic director for Ward-Belmont from 1932 until the school closed in 1951.[231] Until her death at the age of 104, she recognized every former student who visited her.

Morrison demonstrated her control and command on a particularly special day at Ward-Belmont. On November 17, 1934, President and Mrs. Franklin Delano Roosevelt came to campus while on a visit to Nashville. Official accounts note the beautiful sight of the "entire drive

lined with white-clad girls" cheering as the black car entered the gate and Arthur Henkel, head of the Organ Department, played "Hail to the Chief" on the bell carillon.[232] Behind the scenes, before the arrival of President and Mrs. Roosevelt, "[B]edlam broke loose! Girls were running back and forth everywhere…. Out of the blue and far overshadowing the sound of the carillon bells came the resonant sound of Miss Morrison's gym whistle. This brought attention when nothing else would…we knew Miss Morrison meant business and we settled down right away."[233]

Allison, Morrison, and Scruggs represented part of the "old guard"—unmarried women who devoted their time and energy to the education of young people. They were members of an earlier generation of educated women, and they continued to impart values of propriety, discipline, and gender-appropriate subjects well into the twentieth century. These women exhibited "tough love" typical of schoolmarms who began their careers before 1920. Morrison, in particular, anchored the school with her consistent leadership. While never an official administrator, she was in charge of May Day festivities, graduation, and the George Washington celebration. The retirements of Allison, Morrison, and Scruggs, and the closing of the school, represented a shift into a new era of women's education and opportunity in the public sphere after World War II.

Major cities such as New York and Chicago experienced significant social change between World War I and World War II (1918–41). As a mid-sized southern city, Nashville did not experience the same social change as larger northern cities. However, Nashville's entertainment, publishing, and commercial industries boomed in the 1920s and 1930s. It was a "city that liked to entertain," with WSM, the Grand Ole Opry, and Ryman Auditorium at the heart of its growing reputation as Music City. For Nashville's young women, behavioral expectations reminiscent of antebellum culture and the Victorian era shifted to a more active, self-reliant "Gibson Girl." Girls at Ward-Belmont were allowed to bob their hair or cut it short, a punishable act before 1923. By 1933 sailor tops, bloomers, long stockings, and lace-up boots had been traded in for tennis shoes and lighter clothing, including navy blue wool shorts and white shirts. Students were also allowed to wear skirts that revealed their legs. While smoking by students was strictly forbidden on campus, some students smoked when they traveled off campus or out of town. However, girls *could* be expelled if caught drinking alcohol or smoking. Although there was not a dress code on campus, students were expected to dress plainly, and makeup was allowed only for dinner and off-campus

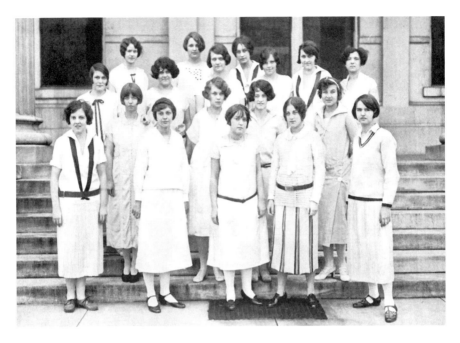

Freshman class at the Ward-Belmont School, 1925.

excursions. When going out in groups for non-school activities, girls were required to wear long dark dresses, gloves, and matching dark hats.

Modesty and propriety remained important values at Ward-Belmont through the 1930s and 1940s—a reflection of regional and national trends at most all-girls schools across the country. Institutions such as Ward-Belmont were determined not to let the sexual revolution of the 1920s upset the notion of proper behavior and dress needed to become a true "lady" and, in particular, a "southern lady." On the whole, the Ward-Belmont administration and faculty succeeded, clearly meeting the continued demand of parents and grandparents who desired to send their daughters to a place that offered modern amenities and abundant opportunity yet revered tradition and ritual. These values would remain true until after World War II, when a new era of social change and reform emerged, a period (the 1960s) in which prevailing notions of gender and women's education were challenged once again.

At all-girls schools, school rules and social decorum dominated the student community and affected daily life. However, author Ilana DeBare explained, "As time went on, girls' schools gradually replaced the explicit

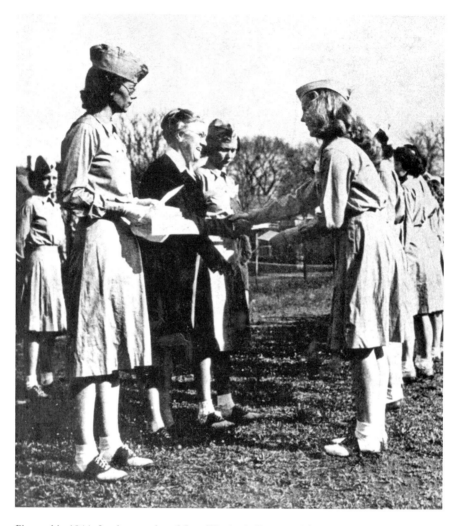

Pictured in 1944, faculty members Mary Elizabeth Cayce and Catherine Morrison led a new campus organization, "TOPS" (Training Offered for Patriotic Service), which was formed to aid efforts during World War II.

teaching of manners with an atmosphere in which proper upper-class behavior was conveyed by example. Social events often took the shape of formal teas…nightly sit-down dinners with white tablecloths, nice dresses, and assigned tables."[234] Ward-Belmont offered a distinctive southern flavor to its students' activities. The 1940 catalogue proclaimed, "Since the whole school, especially beautiful Acklen Hall and the club houses, were built for gracious living, it is natural for Ward-Belmont to carry on the best southern

social traditions. In addition to the usual class and school organizations…there are picnics, trips, week-ends away from school, many teas, receptions, dinners and dances, both formal and informal."[235] Rachel Breck, a graduate of Miss Porter's School in Farmington, Connecticut, echoed the near-universal sentiment of students in all-female schools from 1920 to 1950: "It was sort of a subtle [etiquette] training. You watched other people do it, and so you did it yourself…If the Old Girls did it, and you were a New Girl, you did it too."[236] One Ward-Belmont alumna recalled a story of eating grapefruit at dinner. When finished eating the fruit, the student watched to see if fellow students hand-squeezed the grapefruit to extract the juice, as she had always done growing up. No one did and the student followed her classmates' lead and refrained. Her mother was relieved when she heard the story but was also mortified that her daughter had thought it proper to squeeze a grapefruit with her bare hands.[237]

Certain rules regarding chaperones also changed for young women who boarded and were part of the junior college. From the 1880s to the 1920s, students were required to have a chaperone whenever they left campus. By 1934 students could travel into downtown Nashville or on other short excursions provided they were, at a minimum, in groups of three and traveled by either taxi or streetcar.[238] However, dates with young men were still chaperoned and required written parental permission. If a young man came to visit a student on campus, the girls could "entertain their dates in the parlors just off the recreation hall where the chaperone on duty would wander back and forth like a sentinel guarding his post."[239] Students in the 1930s and early 1940s found the restrictions on socializing with men nearly unbearable. Alumnae Sarah Bryan Benedict, Sarah Colley Cannon, and Mary Elizabeth Cayce wrote:

> *Arranging for a date on the cloistered campus compared in process to getting behind the iron curtain. A gentleman wanting a date was screened by the Home Department; the girl's family was asked to file a written permission for her to have a date with a certain young gentleman. This process having been accomplished, a pink permission slip was issued to the girl. The young gentleman called at Acklen Hall, gave his name to the distinguished butler, Whitaker, who invited the caller in with pomp and dignity, reported his arrival to the Home Department, and summoned the young lady of his choice to the reception rooms. One wonders if all this procedure was worth a two-hour visit in a Victorian parlor equipped with full length mirrors at strategic points, hard horse-hair sofas, and a gliding chaperone who somehow floated through the rooms continually making her presence known by clearing her throat![240]*

Group of Ward-Belmont students in front of Sanssouci Palace in Potsdam near Berlin, Germany, in July 1936. The group attended the opening ceremony of the 1936 Olympics but reported that they refused to cheer Hitler when he arrived. A journal entry by Grace Benedict Paine recalled the day: "We are all going to the dance festival the opening night of the Olympics but so far Miss Morrison has only obtained seven tickets for us for the afternoon ceremonies. If we don't get any more, we'll have to draw. This is an impromptu snapshot of the party taken on our way to see the gardens of Frederick the Great. We had to wear great big wool slippers into the castle and had more fun skating in them through the ballrooms. Everybody is wild with excitement about the Olympic Games."

In an era when most young men and women mingled and socialized without restriction at dance halls, sports venues, movie theatres, and in automobiles, Ward-Belmont's dating protocol remained rigidly Victorian. Alumna (1922–28) and faculty member (1930–45) Mary Elizabeth Cayce noted that along with the rich history of Ward-Belmont's predecessor schools "came also the heritage of high moral standards and stringent requirements for deportment which were, perhaps, unparalleled in any comparable school for girls in this era [1920–50] with the possible exception of convents."[241]

Boarding students could travel out of town only one weekend per month, and such trips required advance approval. Most commonly, girls traveled home with fellow students on holidays or school breaks. While

Pictured during the Ward-Belmont era, the antebellum bell tower was original to the estate of Adelicia Acklen. In 1929 a bell carillon was installed. The name of the student literary publication, *The Chimes*, was inspired by the bell tower and carillon.

many students at Ward-Belmont were young women over the age of eighteen, the "finishing school" mentality persisted through the 1930s and 1940s. Parental permission was required for anything not planned or sponsored by the school. For example, alumna Gilbertine Moore, class of 1935, recounted a trip to the home of her roommate, Lattie Graves, in Scottsville, Kentucky, "For this privilege we were required to have written permission from home plus a written invitation from our hosts to the school authorities."[242]

Other expected parts of Ward-Belmont life included weekly chapel meetings, Vesper services, Sunday church services, and attendance at designated concerts. Most of these events were required only of boarders and served to further distinguish the experiences of boarding students from those of day students. Boarding student Gilbertine Moore explained, "As an extracurricular advantage, Ward-Belmont offered a concert series…[a]nd the opportunity of hearing a great classical artist had not been mine until that first concert [with violinist Jascha Heifetz] at Ward-Belmont."[243] It was common for girls' schools and women's colleges in the United States and in Europe to expose students to visiting lecturers, concerts, and special events. In addition to concerts and speakers on campus, students often attended events at War Memorial Auditorium, Ryman Auditorium, Vanderbilt University, and Peabody College. Historian Gillian Avery noted in *The Best Type of Girl* that some schools had enough money to bring lecturers, musicians, and other professional performers to campus. Other schools took students to local performances to expose them to culture.[244] With its location in Nashville, a center of music, theater, education, and entertainment, Ward-Belmont was able to do both.

Vespers were not required, but most boarding students attended them each Sunday night. These student-led religious and reflective services were held outside in the Club Village and inspired the seniors and alumnae to raise money for five years (1924–29) to purchase and present a carillon to the school. A carillon is a set of twenty-three bells typically played, using the hands and feet, from a keyboard housed in a belfry with broomstick-like keys.[245] At Ward-Belmont, a carillon was purchased for the antebellum bell tower on campus that stood as one of the school's major landmarks.

The first carillon concert was held at a memorable Vespers service on April 12, 1929, a date that corresponded with homecoming.[246] On that beautiful spring evening, Percival Price of Canada christened the

Club tennis team, circa 1920.

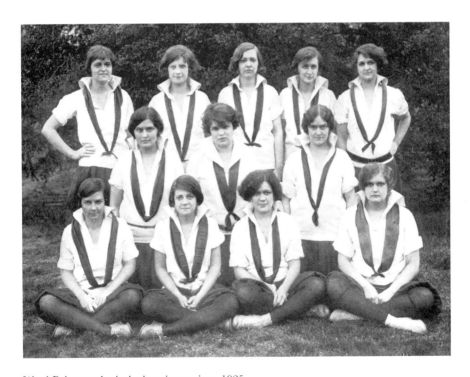

Ward-Belmont physical education majors, 1925.

bells, broadcast nationwide by Nashville's WSM radio.[247] The concert began with "America the Beautiful"; included "Ode to Joy" (Beethoven), "Andalle" (Schumann), and "Harmonious Blacksmith" (Handel); and ended with "The Bells of Ward-Belmont." One student recalled, "Those bells! How on earth could anyone attempt to describe how they sounded? I'm writing to the music—it's hard to believe they are real—it's fairy tale music."[248] The carillon's chimes led to the naming of the student literary magazine, *The Chimes*, which was published annually from 1936 to 1951. The bell tower's music certainly reinforced the school's alma mater, "The Bells of Ward-Belmont," and the reference to students and alumnae endearingly called the "Belles of Ward-Belmont." Today's Belmont University features the bell tower as its emblem.

Sports also grew increasingly popular among women, especially during the early years of Ward-Belmont. The faculty and student body modeled the increasing importance of a healthy and active lifestyle. The school built a new gymnasium and horse stables in the early 1920s and also featured bowling alleys, tennis courts, playing fields, and a natatorium.[249] Moreover, physical education became its own department and issued special diplomas. Students seemed to view athletics as inspiring loyalty and unity. Student Rosalyn Kirsch penned a popular poem among the girls in her memory book:

> *There's a school in Tennessee,*
> *Where we all just love to be.*
> *Everyone should want to see,*
> *The sports at W-B.*
> *We've tennis in the spring and fall,*
> *In winter we play basketball.*
> *We stand together one and all,*
> *And loyalty is our call.*[250]

In a 1925 *Hyphen* article, students compiled a "Ward-Belmont Alphabet" providing insight into female school life and culture in the Roaring Twenties: "*G* stands for *gym*, not 'Jim,' if you please; *H* stands for *hockey*, an athletic disease."[251]

However, the growth of varsity women's athletics in the Progressive Era (1900–1920) led to a sort of backlash, as many schools reduced some or all intercollegiate competition by 1930. In part, the movement away from competitive varsity sports was fueled by the formation of the Women's Division of the National Amateur Athletic Federation (WDNAAF). In 1925

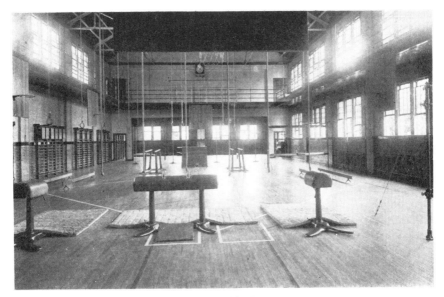

GYMNASIUM

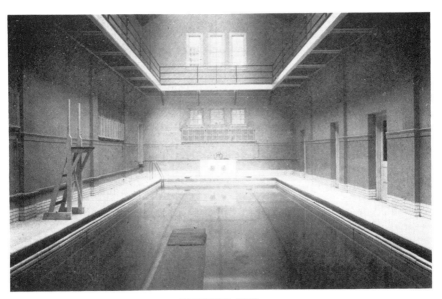

SWIMMING POOL

Ward-Belmont gymnasium and natatorium, circa 1930.

the WDNAAF passed a resolution barring extramural competition and publicly played games that required purchased admission. The argument against women's sports was based on fears that certain sports, namely basketball, challenged traditional notions of femininity and could lead to issues related to men's sports (gambling, violence, and cheating). Ward-Belmont did follow this national trend, and while Tennessee did not ban female athletics, as the state of Colorado did in 1929, the emphasis shifted from competitive athletics to a "sports for sports' sake" mindset.[252]

School societies and clubs filled the need for athletic competition as varsity competition diminished after the formation of the WDNAAF. Societies and clubs were also developed in part to fill time spent outside the classroom and to keep the girls from the temptation of activities not approved by the school.[253] Beginning in the mid-1920s and carrying through to the school's closing in 1951, Ward-Belmont students were divided into fourteen clubs, which acted as sororities as well as athletic teams. Each of the ten clubs for boarding students had its own house; and Club Village, as it was called, encircled the Ward-Belmont Bell Tower. The four clubs for day students met in a large house adjacent to the campus.[254] Social life on campus ran almost solely through the clubs and consisted of teas, dances, and other events. Athletic competition included tournaments in basketball, hockey, archery, swimming, and bowling. Other women's schools sponsored similar types of social clubs, although some opted to create an official Greek system whereby students joined local chapters of national sororities. However, the club system at Ward-Belmont followed a more inclusive model, perhaps reflective of the noncompetitive atmosphere. Clubs did host a "rush week" similar to sororities, but in the end, each girl was invited to join a club. As one alumna noted, "No one was left out."[255] Dances, special dinners, and holiday parties were also sponsored by the clubs. Because men were not allowed in the club houses, girls danced together, as they had since the days of Ward Seminary and Belmont College, with no taboo.

One of these "man-less" dances was the special dinner and dance held each year on George Washington's birthday. Students dressed as members of early American society—a tradition carried on by Harpeth Hall with some modification. One student recalled that "those who did the leading most of the time had a rather hard adjustment to make when they went on to coeducational institutions and found themselves dancing with boys rather than girls."[256] Each year also culminated in a spring formal, similar to today's prom, which boys were allowed to attend. Beginning in the late 1930s, the school also sponsored a Senior–Senior Middle Day at which the two college classes competed in field day–type competitions.[257]

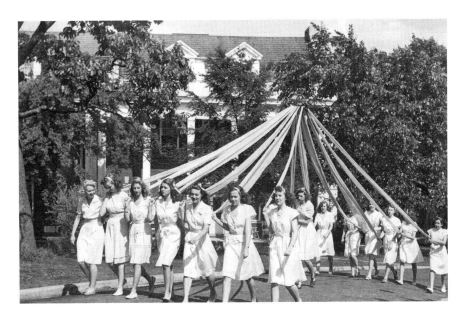

May Day Parade, circa 1947.

In addition to social club activities, Ward-Belmont students also participated in school-wide events. The School of Expression, also known as the Drama Department, produced regular performances for the school body. In 1937 the senior-middle class (present-day college freshmen) presented *Treasure Island* to the school in honor of the senior class (present-day college sophomores). However, the event of the year remained the May Day Festival, which was held just before commencement weekend and graduation. Usually barefooted and in white spring dresses, seniors danced, sang, and paraded in front of parents, family, faculty, alumnae, and friends. Ellen Bowers Hofstead, class of 1936, recalled that May Day her senior year was held on "the coldest Saturday in May."[258] Students danced around the maypole, holding on to streaming long sashes and directed by the always adamant Catherine Morrison. Sarah Colley Cannon, better known as "Minnie Pearl" of the Grand Ole Opry, recalled that she "had bungled her part in the May Day festivities at Ward-Belmont, stumbling through the maypole dance and forgetting which direction to go."[259]

This tradition was carried over from Ward Seminary and Belmont College to Ward-Belmont and occurred nationally at most all-female schools until after 1950. Like its predecessors, Ward-Belmont School crowned a May Queen, chosen as the school's best representative from

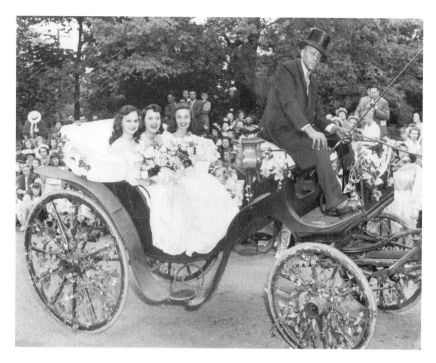

May Day Parade, with the May Queen and her Attendants (College Maid and Preparatory School Maid), circa 1942.

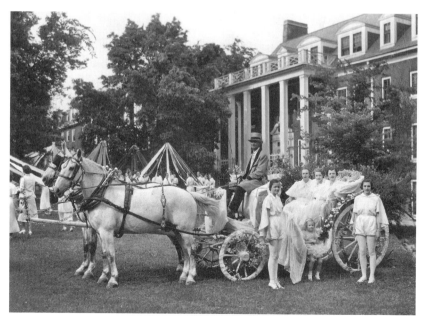

May Day parade held in 1935, featuring Ellen Bowers Hofstead, class of 1936 (left beside carriage), and Louise Douglas Morrison, class of 1938 (on right).

the collegiate senior class. However, the ritual was symbolically linked to marriage and fertility, intended to signal the maturity of young women as they were presented to society. The May Day Festival paralleled similar debutante and cotillion exercises for the daughters of the upper class. A handful of schools, such as Girls Preparatory School in Chattanooga, have continued this tradition into the twenty-first century; however, May Day and the crowning of the May Queen ended at Ward-Belmont with the sale of the school in 1951.[260] The Harpeth Hall School continues a modified variation of this tradition through its Step Singing ceremony whereby seniors and juniors sing and wear white dresses. In addition, the modern-day May Queen, known today as the Lady of Hall, is honored and remains a featured speaker of the Step Singing ceremony.

School life and tradition at Ward-Belmont settled into a comfortable routine in the 1920s, but the cost of attending the school continued to rise. Tuition increased to approximately $900 by 1929 for boarding students. Additional fees were charged for laundry, use of linens, entertainment, special classes, typewriting, and physical education.[261] Specifically, music lessons substantially increased tuition. For example, voice lessons with Signor de Luca added $375 to annual tuition, pipe organ lessons were $250, and piano lessons with Mr. Goodman were $325. Aside from extra costs associated with music, most students paid more than $1,000 in tuition. Other costs included $100 extra for the physical education normal course, $100 for art, $85 for domestic science and cookery, $10 in science lab fees, and $60 for membership in the Riding Club that included weekly lessons.[262] Ward-Belmont continued to refine its academic programs while also standardizing the assortment of diplomas, certificates, and "special student" statuses that had existed since 1913. The early 1920s catalogues still listed several courses of study: general, classical, high school, music, expression, home economics, physical education, art, domestic art, and secretarial.[263]

After gaining accreditation in 1925, courses of study were streamlined and standardized as the junior college offered a liberal arts classical diploma and a general diploma for those who did not plan to continue their education at a four-year university.[264] Most students from 1925 to 1935 graduated with a general diploma from either the college or the Conservatory of Music, reflecting a terminal degree. Increasingly, in the 1940s, students began to use Ward-Belmont's status as a junior college and college preparatory school as a platform to continue their education at colleges and universities.

Even so, the school still recognized that many of its female students would not seek further education beyond secondary schooling. Rather than advertising the success of its high school graduates in colleges or universities, the 1950 catalogue stated, "Although thorough college preparation is *one* of the chief aims of the Ward-Belmont Preparatory School, the course of study is flexible enough to assure a sound and well-rounded education to a girl who may not plan to continue her formal education at a senior college or university."[265] Compared to twenty-first-century standards, Ward-Belmont prep students took far fewer academic courses. A high school diploma required only nine units of academic classes: English (three), foreign language (two), mathematics (two, algebra and geometry), and one unit each of history and science (either biology or chemistry). The additional seven units were made up of electives.[266] These requirements would remain the same through Harpeth Hall's first decade from 1951 to 1963.

As girls' schools struggled to find their place in the world of secondary and higher education in the first half of the twentieth century, many continued to follow the finishing school model. Others, such as Ward-Belmont, developed their curricula in ways that served those who did not desire further collegiate training while also providing opportunities for those who sought to continue at traditional four-year universities. This was true for both the junior college and the college preparatory school. One legacy from this era "was a historic neglect of 'male' subjects like math and science."[267] This propensity remained prevalent in women's schools throughout the United States and Europe. Author Gillian Avery wrote of Great Britain, "In the privately owned schools there was on the whole a marked absence of science before the 1950s."[268] Ward-Belmont's Junior College did produce a few biology majors each year, and chemistry and biology classes were required at both the college preparatory and junior college levels. By 1935 Ward-Belmont offered courses in physical science, zoology, and organic chemistry but did not offer physics.

Only a handful of students emphasized math in their studies beyond the required algebra and geometry courses. Ward-Belmont did offer additional courses in analytic geometry, trigonometry, and differential calculus in 1939, but in 1942, calculus was dropped from the catalogue. The lack of math and science reflected a gender-biased curriculum that equated "soft" subjects with femininity and domesticity and difficult subjects with masculinity and the workplace. A lack of emphasis on math and science would continue to be problematic for girls' schools well after the 1950s.[269]

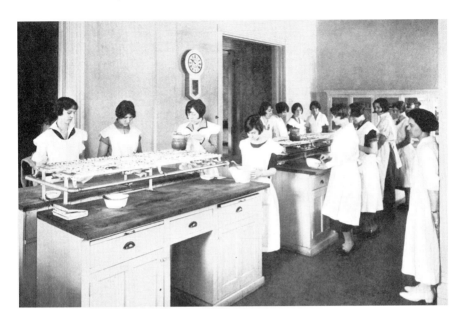

Domestic Science "laboratory," 1925.

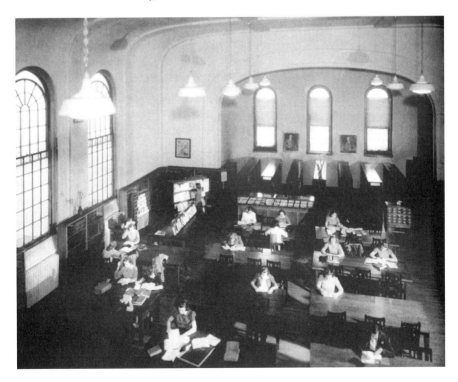

Students study in the Ward-Belmont School Library.

Domestic science, renamed home economics in the 1930s, seemed to emerge as the compromise. After receiving junior college accreditation, Ward-Belmont's catalogue read as follows:

> *The lifting of the homemaker's work to its proper place among the sciences is perhaps one of the most significant recent educational reforms. Domestic Science and Domestic Art are now regarded as essential in a well-rounded education for women. Responding to this progressive movement, Ward-Belmont maintains a thorough department for the study of the home and its varied problems.*[270]

In the boom and bust of the late 1920s, one *Hyphen* editor ended the Thanksgiving edition with an ominous quote: "There's only one letter difference between saving and having."[271] Ward-Belmont had certainly boomed in the 1920s. By the time of the Great Depression in 1929–30, enrollment had peaked to 1,200 students, including both part-time and full-time, and more than 80 faculty members.[272] But the economic depression took its toll on the school. By 1938 the student body had been reduced to approximately 700 students, with 109 diploma graduates; 94 earned a general diploma while the remaining 15 were awarded "diplomas" or certificates in expression, food and nutrition, textiles and clothing, postgraduate piano, harp, public school music, and dancing. In addition, 43 students earned special certificates in piano (4), voice (5), general art (3), costume design and commercial illustration (3), interior decoration (3), expression (13), secretarial training (6), dancing (1), and riding (5).[273]

By 1942 the Scholastic Aptitude Test (SAT) had become the benchmark for college admission. This change was not to the advantage of Ward-Belmont as a junior college, college preparatory school, or conservatory of music. Following the 1944 school term, Ward-Belmont reorganized some of its departments and majors, developing "pre" majors to replace many of the previously bestowed certificates and nontraditional majors. For example, in 1947, majors included general liberal arts and sciences, pre-business, pre-journalism, pre-medical, pre–physical education, and pre–social science. The final catalogue in 1950 reiterated Ward-Belmont's attempt to conform to a new wave of higher education: "There are two ways of earning the general diploma: first, by way of the general liberal arts and science curriculum and, second, by way of the more specialized [pre-professional] curricula."[274]

After the death of Dr. Blanton in 1933, John W. Barton, who had been vice president since 1927, became Ward-Belmont's third president.

Barton died after a short illness at the start of the school year on September 2, 1936, and the school did not name a president from 1936 to 1938. Instead, Andrew Benedict, vice president from 1934 to 1938, and Emma Sisson were listed together as top administrators. Other than Eliza Ward (tenure, 1865–87), wife of Dr. W.E. Ward, and Anna Hawes Blanton (tenure, 1892–1932), wife of Dr. John Blanton, Emma Sisson remains the only woman to have held an administrative position equal to that of co-president. Sisson began as a physical education teacher, assuming first the role of director of the physical education program in 1915. In 1931 she succeeded Leila Mills as dean of women, and in 1932 the title changed to dean of residence. Dr. Joseph Burke was hired in 1938 as the dean of academics and was appointed president in 1939, a position he would hold until 1945. Emma Sisson left Ward-Belmont in 1940 after twenty-five years of service. Some suggest that Sisson resigned because she was passed over for the presidency when the board promoted Burke to this office after one year on the faculty.[275]

Following World War II, Ward-Belmont hoped to rebound from the Great Depression, but the changing college landscape and accumulated debt cast doubt that the school would continue to operate. While enrollment dropped substantially from its peak in 1929, the budget had not proportionally tightened to reflect smaller revenues. The 1948 faculty still stood at eighty-one, approximately the same number as a decade prior when the student body was nearly twice as large. Perhaps the culture of loyalty at Ward-Belmont and the hardships of losing one's employment during the economic depression prevented the administration from releasing faculty in order to cut expenditures. Tuition was raised to $1,200 for room and board, but the school was more than $500,000 in debt and had no endowment.[276] Dr. Robert Provine, who was appointed president in 1945 following the six-year tenure of Dr. Joseph Burke, attempted to salvage the school's finances. However, over the next few years, Provine and the Board of Trustees would come to believe that the school's greatest asset was its campus and location. They approached Vanderbilt and Peabody to see if a deal might be reached that would allow a merger. Unfortunately, neither school was in a position to acquire additional debt and a financially troubled school with an uncertain future. In 1950 Dr. Provine and the Board of Trustees entered talks with the Tennessee Baptist Convention.

In February 1951, ownership of Ward-Belmont was transferred to the Tennessee Baptist Convention (TBC). Efforts to assume control of the schools were led by Executive Secretary Dr. C.W. Pope of the TBC.

The Baptists hoped to develop an academically strong Christian college to further the denomination's educational mission and to serve as an anchor of faith and learning for the local and regional community. While no longer under Baptist control, today's Belmont University serves as a Christian-based institution of higher education that continues to grow and garner national recognition.

In the spring of 1951, the TBC moved to take control of the Ward-Belmont School. It originally hoped to relocate Cumberland University's undergraduate school, which was also under Baptist control, to the Ward-Belmont campus in Nashville. The Baptists also sought to move their administrative headquarters, located downtown, to the Ward-Belmont campus. Milton Randolph of the *Nashville Banner* wrote on March 16, 1951, "Considerable confusion seems to be rampant over what is to be the ultimate fate of Ward-Belmont School and Cumberland University."[277] Six years earlier, in 1945, the TBC had acquired Cumberland University, located in nearby Lebanon, Tennessee, and previously operated by the Cumberland Presbyterians. Coincidentally, Dr. W.E. Ward, founder of Ward Seminary, earned his law degree and later returned for graduate training in divinity at Cumberland University in the mid-1800s. The Cumberland University Board of Trustees ultimately defeated efforts by the Baptists to move the school to Nashville, as it "voted not to move any part of the Cumberland University away from Lebanon."[278]

Unlike Cumberland University, the Ward-Belmont School would be unable to wrestle control back from the TBC, which legally gained control of Ward-Belmont on February 28, 1951. The TBC did not purchase the school but rather absorbed the "assets and liabilities of the school consisting of bonds and bank indebtedness amounting to approximately $600,000."[279] The campus and school's assets were later valued at more than $4 million.

Consternation abounded during the spring of 1951, especially for those concerned about the fate of the college preparatory school. Dr. Pope had originally stated, "It is the plan of the new Board of Trustees, elected this morning, to continue high school operations at Ward-Belmont."[280] Patty Chadwell, alumna and faculty member, rallied the Ward-Belmont Alumnae Association, which had previously been minimally active, and attempted to "buy back" the school. Monies were raised, and the Ward-Belmont Alumnae Club of Nashville passed several resolutions, including the following:

1. *Ward-Belmont School is a top girls' college preparatory school and junior college needed in the past, present, and future.*

2. *Tennessee Baptist Convention assumed control of the school with plans to change the existing mission of the school.*

3. *Whereas, no notice of such arrangements was given to the alumnae of said school prior to consummation thereof;*

4. *Whereas, the alumnae of said school have never been called upon to contribute to its expenses and endowment; and,*

5. *Whereas, said alumnae are vitally interested in contributing to said school and to its endowment and in continuing it as the same Ward-Belmont...*

8. *Whereas, competent investigation indicates that the funds incident thereto can be raised from friends of Ward-Belmont and over twenty thousand alumnae, now therefore,*

9. *Be it Resolved, that the Executive Board of the Tennessee Baptist Convention be benevolently requested to negotiate with representatives of this alumnae group, and,*

10. *Be it Further Resolved, that the Executive Board of the Tennessee Baptist Convention be earnestly requested to cooperate to the end that Ward-Belmont be restored to its former status.*[281]

Furthermore, $1,000 was raised by Club Village to help with legal expenses. Despite the valiant efforts of Chadwell and others, by late spring, it was decided that the college preparatory division would not be a part of the new Belmont College landscape.

Ultimately the events that began in early 1951 would result in the creation of a coeducational liberal arts college offering full bachelor's degree programs and end Ward-Belmont's College Preparatory School and Junior College. Belmont College did retain the Ward-Belmont Conservatory of Music, leading in part to today's stellar music programs at Belmont University. The local community rallied to preserve the legacy of an all-girls institution designed to educate young women for college. Because the majority of day students in the college preparatory division were daughters of local families, a new high school named the Harpeth Hall School was established on a suburban estate on the edge of Belle Meade, four miles west of Ward-Belmont's campus.[282] The Harpeth Hall School reopened in September 1951 under the leadership of Susan Souby, principal of the Ward-Belmont college preparatory division, alongside former Ward-Belmont faculty members and students.

Nationally, women's education, and specifically higher education, had greatly expanded and evolved from the time of U.S. entrance into World

War I (1917) to the end of World War II (1945). Ward-Belmont was a part of this expansion and a reflection of trends associated with urbanization and the Progressive Era. While the number of women's institutions of higher education grew from 142 in 1917 to 270 in 1935, the historic and social appeal of single-gender education as a viable alternative to traditional four-year universities began to wane in the years following World War II.[283]

The ideal of the southern lady did not disappear but rather transformed into a model of womanhood that did not require the prototypical, albeit seemingly antiquated, finishing school. Louise Lasseter LeQuire, a Ward-Belmont alumna, wrote, "Tradition involves an appreciation for the best which we inherit from the past…and a rejection of that which we have found to be of no value in the present situation…. [Ward-Belmont] may have found it difficult to weather the strain of economic upheaval but her ideals have never moved."[284] But *tradition*, if it was to survive, would require some degree of transformation if girls' schools, such as Ward-Belmont, were to remain economically feasible and educationally viable.

Private all-female schools experienced their cultural halcyon days from 1920 to 1950; however, accreditation, changing workforce demands, and economic depression led to the decline of single-gender institutions following World War II. Ward-Belmont was no exception. By 1955 the number of women's colleges had fallen to 248 and would steadily decline throughout the 1960s and 1970s. As some women's colleges closed, others, such as Agnes Scott College, adapted to become accredited four-year liberal arts colleges. A number of schools, such as Sophie Newcomb College, joined forces with all-male schools or began admitting men in an effort to redefine their mission as coeducational. Others ultimately embraced their role as college preparatory schools, which many had been all along, despite claiming at least some collegiate work or awarding diplomas. In perhaps a twist of historic fate, the closing of Ward-Belmont opened the door for a more sustainable model of single-gender education in the form of the Harpeth Hall School. The shift from a high school and junior college with a majority of boarding students to a day school for grades nine through twelve would represent a historical and institutional transition. This transition would set the stage for a reimagined single-sex educational model: the modern, independent all-girls college prep school.

Chapter 4

A NEW VISION

The Harpeth Hall School, 1951–1980

Mentem Spiritumque Tollamus, *"Let us lift up the mind and the spirit."*
–Harpeth Hall School Motto[285]

T he historic bonds between the Ward-Belmont School and the Harpeth Hall School continued long after 1951. In 1968 nearly nine hundred Ward-Belmont alumnae gathered on the campus of Harpeth Hall for a fried chicken lunch. Sarah Colley Cannon ("Minnie Pearl") hosted the luncheon, along with Head of School Idanelle McMurry, and performed a routine based on her Grand Ole Opry character from Grinder's Switch. Cannon, class of 1932, had remained an active alumna of Ward-Belmont and helped to organize the reunion.[286] While the weekend was full of exciting events, perhaps the most memorable came courtesy of former longtime faculty member Catherine Morrison, representing the "old guard" of female educators. For forty years she had whipped students into shape with a heart of gold and the command of a drill sergeant.

As an honored guest of the 1968 reunion, Morrison gave a special performance—providing a nostalgic journey that harkened back to a time of gaiety and youthfulness. At the reunion's main event, she appeared on stage dressed in a Ward-Belmont PE uniform, complete with navy wool bloomers, a middy blouse, and dark stockings. Morrison "gave a resounding blow from the old gym whistle…and the entire building shook from the laughter" as she proceeded to run them all through a

gym routine.[287] Morrison embodied and exemplified the ladylike order, propriety, and decorum of Ward-Belmont's traditional values. While she represented the golden age of the school, its 1951 closure marked a watershed moment as women's education experienced a transitional shift and a changing of the guard.

The strength of the community's response following the closure of the Ward-Belmont School reflected the value Nashville placed on quality education for the city's young women. Ironically, the unexpected closure of the Ward-Belmont School likely ensured that its single-sex model would endure. Harpeth Hall was the phoenix that rose from the ashes of Ward-Belmont.

Such institutional transitions were not uncommon for girls' schools in the 1950s and 1960s. Author Ilana DeBare articulated this educational and cultural development:

> By the 1950s, virtually all girls' schools had become college-preparatory schools, although that meant different things at different schools. Some girls' schools pushed their graduates toward academically elite Seven Sister colleges, such as Wellesley and Radcliffe, while others were content to send them off to two-year junior colleges. The social curriculum lingered on even after the end of the finishing school.[288]

The timing of Ward-Belmont's closing mirrored this national pattern. Whether or not Harpeth Hall could create an academic program that prepared and promoted its graduates to attend top-tier colleges and universities remained an unknown.

The sudden sale of Ward-Belmont in the spring of 1951 and the Tennessee Baptist Convention's decision to reopen a new four-year coeducational institution on the Ward-Belmont campus without a college preparatory division left Nashvillians little time to react. While the junior college could not be saved, local community leaders and alumnae rallied quickly and urgently to pull off a seemingly improbable feat. Astonishingly, in less than six months, prominent members of the Nashville community secured a new campus and faculty and reopened Ward-Belmont's college preparatory division as the Harpeth Hall School in September 1951.

The founders and first Board of Trustees for Harpeth Hall included Chairman William Waller, George N. Bullard, Daugh W. Smith, Hortense Bigelow Ingram, Katherine Early Russell, Frances Dudley

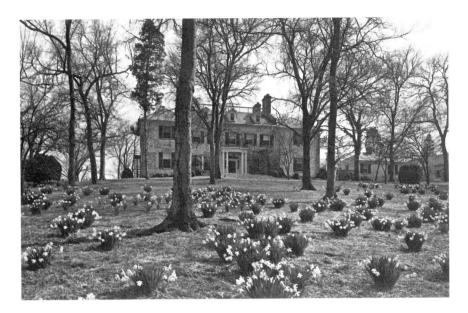

Souby Hall was formerly the main home located on the P.M. Estes estate. It was named in honor of Susan Souby. Originally, the building provided classroom space, the school's library, and administrative offices. Souby Hall and the Senior House remain the only two original buildings on campus.

Original gate for Harpeth Hall's new campus, located on the former P.M. Estes estate.

Brown, Mary Elizabeth Cayce, Ellen Bowers Hofstead (Ward-Belmont, class of 1936), Sara Sudekum Stengel (Ward-Belmont, class of 1929), Helen Dickinson Bransford (Ward-Belmont, class of 1928), Edith Caldwell Hill, Neely Stevens, Lulu Hampton Owen, Louise Barry, and Katherine Henry. While all of these community leaders were integral to the school's creation and initial success, Mary Elizabeth Cayce was an especially strong and steady force in the conception and transition from Ward-Belmont to Harpeth Hall. An alumna, Cayce had returned to teach physical education at Ward-Belmont from 1930 to 1945. While she never served on the faculty at Harpeth Hall, she was an integral part of the formation of the school. Cayce not only served as an original member on the Board of Trustees but also helped to secure funding for the school and conceived the school's new name. Harpeth Hall was chosen as the name because it "combine[d] euphonious sound with locale," based on its proximity to the Harpeth River and Harpeth Valley.

Founding Harpeth Hall Board of Trustees members. *Left to right*: Kathryn Craig Henry, Kay Early Russell, Daugh W. Smith, Lulu Hampton Owen, Idanelle McMurry (Head of School), and Hortense Bigelow Ingram, circa 1970.

Many of Ward-Belmont's faculty continued on at Harpeth Hall, as they remained dedicated to the school and its model of single-gender education. In fact, all of the full-time teaching faculty were former members of the Ward-Belmont faculty. Susan Souby began as an English teacher at Ward-Belmont in 1925, having graduated with a BA from George Peabody College for Teachers. After twenty years in the classroom, Souby succeeded longtime and beloved high school principal Annie Allison in 1946. After five years as principal at Ward-Belmont, Souby was the natural choice to serve as the first headmistress of Harpeth Hall. She was the widowed mother of two sons, and despite the challenge of single motherhood, she was fully committed to this new educational

Susan Souby, Ward-Belmont Preparatory School principal, 1946–51, and Harpeth Hall's first head of school, 1951–63.

venture—full of both opportunity and uncertainty. Susan Souby was asked to head the new school by William Waller, president of the committee determined to reopen Ward-Belmont's high school division.

Susan Souby accepted the position in April, provided that "she could choose her faculty from people she had under her at Ward-Belmont." She immediately set about hiring new teachers and turned to trusted Ward-Belmont colleague Patty Chadwell to teach physical education.[289] Chadwell had graduated from Ward-Belmont in 1935 and earned bachelor's and master's degrees at George Peabody College for Teachers before returning to her alma mater in 1947. "Miss Patty," as she was endearingly known to students, established Harpeth Hall's physical education program—a daunting prospect given that there were no facilities, no money, and only basic equipment transferred from Ward-Belmont College or donated by local businesses. Her teaching tenure would ultimately span five decades.[290] Other founding faculty members included Mary Rasmussen, Billie Kuykendall, and Martha Gregory

(English); Ruth Mann and Frances Ewing (math); Penelope Mountfort (science); Margaret Ottarson, Lucy Fountain, and Ella Puryear Mims (languages); Sophronia Eggleston and Vera Brooks (history); and Lucille McLean (business manager). The total budget for administrative, faculty, and staff salaries was $45,000 in the school's first year, with an average annual salary of $2,787 for a full-time faculty member.[291]

The founding Board of Trustees initially wanted to hold the school's enrollment to 150 students in order to maintain a manageable number of

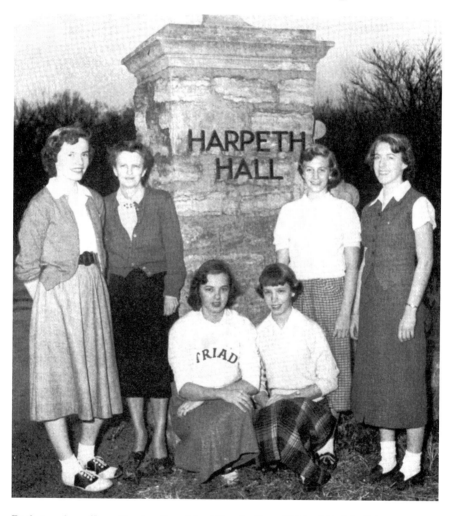

Freshmen class officers Carolyn Carmichael Buntin, Betsy Caldwell Parish, Celeste Morrison Johnson, Pam Parker Helms, Nancy Hardison Williams, and faculty sponsor Martha Gregory stand in front of the new Harpeth Hall sign on the edge of campus, 1953. These students were members of the class of 1956.

faculty and students. However, student demand rose above 150, resulting in a letter to "Patrons of The Harpeth Hall School" from Board of Trustees President William Waller and Head of School Susan Souby, who wrote, "[I]t was felt that it would be unfair not to accept former Ward-Belmont students who wished to complete their course of study with the same faculty."[292] As a result, Harpeth Hall opened in September 1951 with 161 students, almost all of whom were former students at Ward-Belmont's college preparatory school. Harpeth Hall's campus consisted of twenty-six acres on the former P.M. Estes estate, located approximately four miles west of the former Ward-Belmont campus, on the edge of the affluent suburb known as Belle Meade. The property was purchased for $75,582 in 1951.[293]

The original curriculum was also an extension of Ward-Belmont's high school curriculum, which required three compulsory units of English, two required units each of foreign language and math, and one mandatory unit in both history and science, as well as seven electives—for a total of sixteen credits.[294] Such curricular requirements were typical of high schools, particularly girls' schools, in the 1950s and early 1960s. The first senior class would be the only class at Harpeth Hall to graduate from an unaccredited school. Due to the determined efforts of Susan Souby and her staff, Harpeth Hall opened its second year as an accredited member of the Southern Association of Colleges and Schools (SACS).[295]

Lucille McLean, Penelope Mountfort, Patty Chadwell, and Martha Gregory would all remain an integral part of the faculty for thirty or more years. One of Susan Souby's most important academic hires was Penny Mountfort, a young science teacher who had just begun at Ward-Belmont before its closure. Souby convinced Mountfort to delay the start of her master's program at Peabody College for Teachers and "stay on a few weeks" at the beginning of the 1951 fall term. A few weeks turned into a twenty-two-year tenure, and "Miss Penny" served as the lone member of the Science Department from 1951 until 1964, teaching all chemistry, biology, anatomy, and general science classes. She later reflected on her first years at Harpeth Hall, noting that "I was too young to realize that the schedule was impossible."[296] While all faculty departments were small at Harpeth Hall in the 1950s, Mountfort's solitary status in the Science Department for twelve years reflected the lack of emphasis on science and the persistent, though misguided, notion that women had little use for instensive STEM-related study.

Early Harpeth Hall catalogues reveal an educational curriculum still largely focused on the classical liberal arts until the 1970s. For example, in the late 1960s, Harpeth Hall students traveled to the nearby all-boys school,

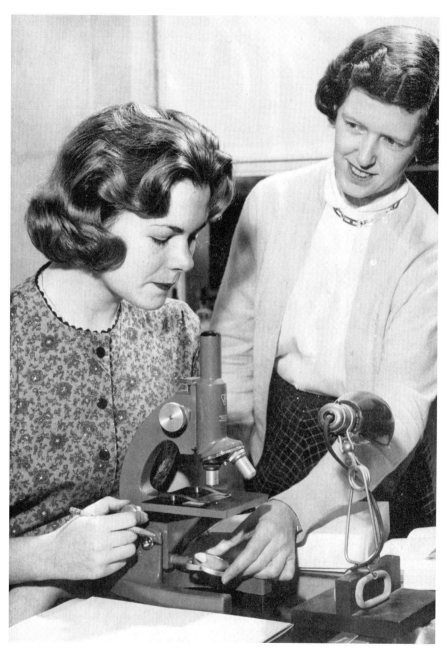

Penny Mountfort began her career as a science teacher at Ward-Belmont. During her nearly forty-year tenure at Ward-Belmont and Harpeth Hall, she served as a teacher, department chair, counselor, college counselor, and dean of faculty.

Students taking final exams in the original auditorium located in the Wallace Building, circa 1968.

Montgomery Bell Academy (MBA), to study physics, and MBA students came to Harpeth Hall to take molecular biology. Until the early 1980s, girls at Harpeth Hall continued to take some upper-level advanced science classes at MBA. It was not just the lack of math and science courses that contributed to the finishing school perception; it was also the overall school culture, including mother-daughter "teas," dinner dances, lack of athletic competition, and focus on traditional gender roles. Despite appearances, Harpeth Hall continued to prepare young women for college and boasted a near 100 percent college matriculation rate by 1968.[297] Shifting gender roles and expectations would continue into the 1980s as the next generation of young women passed through the halls of Harpeth Hall.

Many traditions carried over from Ward-Belmont, shaping school culture in the early days, but Harpeth Hall also worked to create its own identity. Harpeth Hall English teacher Martha Corwin Gregory wrote the alma mater with "help from her students, who also insisted that the school colors be magnolia green and silver gray, not just ordinary green and gray."[298]

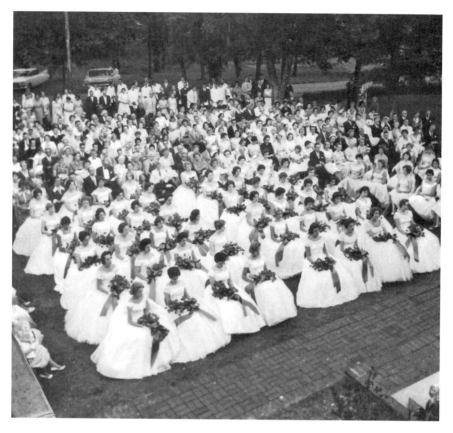

Graduation held behind Souby Hall, circa 1953.

Gregory would remain on the faculty as an English teacher, and later a librarian, until 1984. Ward-Belmont's traditions were modified in order to reflect a shifted sense of women's roles and expectations following World War II. With a younger student body, Harpeth Hall also modernized and reevaluated certain rituals based on age-appropriateness. The crowning of a May Queen was adapted to celebrate the Lady of the Hall (although underclass representatives were still referred to as "her court"). Additionally, Step Singing would continue as a ceremony at which seniors passed the torch of leadership to juniors as they pledged to "[t]ransmit this school not less, but greater, better, and more beautiful than it was transmitted to us."[299] Harpeth Hall continued this tradition, and Step Singing, which still includes singing and the wearing of white dresses remains largely unchanged from its Ward-Belmont days. While Ward-Belmont and Harpeth Hall also held annual

baccalaureate services, in the 1970s, Harpeth Hall combined baccalaureate and Step Singing into one ceremony.

Other shared rites and rituals included social clubs, tea dances, and the annual George Washington Day Celebration.[300] This tradition was nearly lost, but Patty Chadwell revived the performance in 1954, with Liz Smith Bass as Martha Washington and Florence Stumb Davis as George Washington.[301] The performance, held on George Washington's birthday each February 22, remains reminiscent of a bygone era of costumes and man-less dances, despite some modifications to the literal song and dance. The student council sponsored an annual tea dance for the first few years, but by the late 1960s, "gone [were] the days of the annual tea dance" where

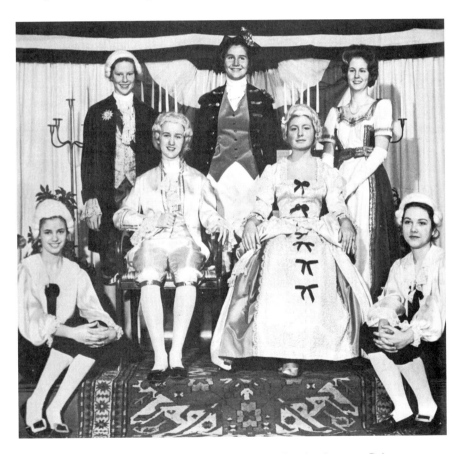

The George Washington Day Celebration was a tradition that began at Belmont College for Young Women, developed into a costume ball and dance at Ward-Belmont, and was transferred to Harpeth Hall, where it continues as a special all-school program performed by Middle School students.

girls at Harpeth Hall wore gowns and long white gloves and presented their dates to teachers.[302]

Author Ilana DeBare affirmed this post–World War II trend for girls' schools across the nation: "The social curriculum lingered on even after the end of the finishing school. Most schools stopped holding formal dinners and afternoon teas during the cultural upheavals of the 1960s. But here and there, schools continued to offer instruction in ladylike deportment."[303] For example, Harpeth Hall's Patty Chadwell taught students how to walk, stand straight, and cross their legs. The school also had a strict policy regarding boys on campus in the 1950s. This rule arose from an incident involving a male student from Montgomery Bell Academy, Harpeth Hall's "brother school." The MBA student, driving a car full of classmates, cruised through campus in his Green Hornet. Harpeth Hall students waved and yelled at the young men as they passed by, which promptly led to the rule that "no student was allowed to speak to a boy on campus." Likewise, sunbathing was strictly forbidden, even though seniors were allowed to smoke in the Senior House. Still, such rules were minimal compared to the rigidly regimental process of dating and courtship for students at Ward Seminary, Belmont College, or the Ward-Belmont School. Rules regarding women's behavior had relaxed somewhat by the 1950s, but it remained a period of transition.

The four-day school clubs, which began at Ward-Belmont in 1927, transferred to Harpeth Hall. According to documentation from Ward-Belmont, Angkor was named for the Cambodian city; Ariston was a Greek translation meaning "the best"; Eccowasin was an Indian name whose meaning was interpreted as "give all and be all"; and Triad was based on the number three, as red was the third color drawn when the clubs were established. Ward-Belmont's social clubs had served as sororities around which a student's life, activities, dances, and athletics revolved. While still an important source of competition, pride, and school spirit, the purpose and scope of the "club system" was modified at Harpeth Hall. No longer did clubs sponsor dances, luncheons, teas, or parties resembling Ward-Belmont's Club Village.

Nationally, women's sports remained largely intramural, and girls' athletic teams would not compete with other schools' teams until the late 1960s and early 1970s. As such, girls' teams at Harpeth Hall were designated by clubs. Sports and field day competitions took on the feel of Olympic competition as Eccowasin, Triad, Angkor, and Ariston fought to win annual titles in archery, tennis, bowling, basketball, field hockey, and non-athletic categories such as citizenship. The highest prize bestowed

each year was the coveted "Club Cup," awarded to the club with the most total points for the year. A grand silver cup, the trophy was annually inscribed with the winning club's name and passed down each year to the new champion.

While Gregory, Mountfort, and Chadwell guided the educational experience of students, Lucille McLean was instrumental in ensuring the financial success of the school. She dutifully served as Harpeth Hall's top financial officer for thirty-four years. McLean's official title was business manager, but in reality, she was an invaluable worker behind the scenes. She helped manage the administrative office in the 1950s, received and processed applications and tuition, served as registrar, sold textbooks, managed the budget, and even stuffed envelopes when needed. Overall, the core faculty who began a new professional chapter at Harpeth Hall remained through the 1950s. For more than a decade, the same dedicated twenty or so teachers returned to "Little Harpeth," a nickname assigned the first classroom building by many of the school's early students. In fact, very few faculty positions were added until the mid- to late 1960s. As Harpeth Hall's enrollment grew, particularly with the opening of middle grades in 1968, faculty numbers also increased.

Harpeth Hall had begun with nearly two hundred students, faculty, and administrators, all of whom operated out of the original Estes estate home.[304] The school's early success was due in large part to the resilience and versatility of students and faculty. Students regularly ate lunch and had classes outside to escape the cramped quarters. Alumna Lissa Luton Bradford, class

First classroom building, known as "Little Harpeth," circa 1975.

Students between classes, circa 1955.

of 1955, recalled uncomfortable math classes held "in the kitchen with the pots and pans."[305] There was only one telephone for the entire campus. Mrs. Souby had no administrative staff and regularly tutored girls in study hall who needed help with any subject—"except biology," as she was quick to say. Teachers doubled as college and guidance counselors and, at times, assistant principals. Situated in the former parlor of the administrative building, the library had only twenty chairs, and with no dining hall students brought packed lunches.[306] Students and faculty borrowed tools from home and groomed the campus's landscape with little to no budget. But even with such humble beginnings, efforts spearheaded by Susan Souby, a determined board, and a resourceful and academically driven faculty led to incremental growth built on a solid foundation of community support.

From 1950 to 1963, Harpeth Hall transformed from a "one-house" schoolhouse to an accredited and respected high school complete with a beautiful campus and well-appointed facilities. While some classes were still held in Souby Hall, a dedicated academic building with classrooms and a dining hall was completed by 1952, and Bullard Gymnasium, named for

George N. Bullard, was completed in 1953. In 1954 a large classroom building and auditorium was added to the north end of the gymnasium and named the Louise Bullard Wallace Educational Building in honor of George Bullard's daughter Louise, a member of the class of 1953. Athletic fields and tennis courts were also constructed in the 1950s. While the school had not continued a music program with the size and scope of Ward-Belmont's Music Conservatory, the first senior class presented Mrs. Souby with a check designated for the purpose of purchasing a piano.[307]

When Souby announced her retirement in the summer of 1963, she was named "Headmistress Emerita," and the original estate home was renamed Souby Hall. She was also given a new car and a trip to Europe, as she had not taken a vacation in thirteen years. Souby was described as loyal, caring, revered, even-tempered, dedicated, "old school," and a "true lady."[308] It was this "true lady" who bridged the gap between Ward-Belmont and Harpeth Hall, carving out a new niche in Nashville for single-gender education.

Following Susan Souby's retirement, the search committee commenced the task of finding a new head of school, interviewing candidates from Connecticut to California. With no clear choice, the chair of the committee, Sue Ivie, was given the name of a Ward-Belmont alumna: Idanelle McMurry. Ivie was perplexed by the suggestion because she did not recall an alumna with that name. It was later revealed that while her given name was Idanelle, everyone called her "Sam." Instantly, Ivie remembered Sam McMurry, from nearby Cookeville, who graduated from Ward-Belmont in 1943. By 1963 McMurry was teaching English and serving as an administrative dean at the Kinkaid School, an independent coeducational school in Houston, Texas. McMurry was the perfect fit, a progressive educator with an appreciation and understanding of the tradition of Ward-Belmont and Harpeth Hall. Mary Elizabeth Cayce remarked, "Sam was to put Harpeth Hall on the educational map."[309]

Harpeth Hall's founding trustees, parents, and faculty had saved the city's only independent (non-parochial) all-girls school. However, they did so based on their own experiences and expectations of education for women in 1951. These men and women had lived in an era that celebrated expanded opportunities for work outside the home but still expected women to ultimately find satisfaction in the private sphere. Such overtones were apparent even in the early organization of the school, as married female trustees were listed by their husbands' names and, as a whole, contributed to their families and community through nonpaid labor. This was common not only in Nashville but also in towns and

Idanelle McMurry, head of school, 1963–79.

cities across the nation. As the 1950s gave way to the 1960s, the winds of change began to blow, even in the South. While Harpeth Hall still supported, if not encouraged, the idea of its graduates seeking ultimate success through family and civic life, attitudes had begun to shift by the mid-1960s. Sparked by Betty Friedan's *Feminine Mystique*, published in 1963, and a second wave of feminism, women were no longer expected to choose between work and family. Increasingly, women's schools began affirming the capability of women to prosper as professionals as well as wives and mothers.

In 1963 Idanelle McMurry would seize these winds of change to modernize the mission and purpose of Harpeth Hall. In an interview, McMurry noted that "[t]here was perhaps a time when the education of girls revolved around morals, manners, and preparation for college." But more importantly, McMurry recognized and embraced the changing roles of women occurring in the 1960s and 1970s. In 1975 she stated, "An added dimension to our purpose has grown out of the recognition that *women want and can have significant careers* before, during, after, or instead of marriage and motherhood." She concluded with an articulate expression reflective of the delicate balance between southern definitions of traditional femininity and fears of modern feminism: "Thus our school needs to offer counseling and practical exposure in all areas, not to replace, but to supplement our continuing purpose in the education of young women."[310]

McMurry understood that opportunities for and expectations of students must evolve if Harpeth Hall was to survive trends toward coeducation in the 1960s and 1970s. She also realized that Harpeth Hall would have to expand in a way that reflected changing gender roles if the school hoped to establish its presence as an elite girls' school with a national reputation. According to a 1997 U.S. Department of Education study, *Women's Colleges in the United States*, "Beginning in the 1960s, the conversation was not simply about women's colleges, but about the nature of women's participation overall in higher education."[311] The number of young women seeking and obtaining bachelor's degrees at four-year colleges and universities increased dramatically in the 1960s. McMurry recognized that in order for Harpeth Hall to stay competitive as a college-preparatory school, the school would have to make college acceptance and attendance the main curricular goal. As such, she transformed Harpeth Hall's curriculum and status without abandoning the school's rich history and tradition. McMurry sought to make Harpeth Hall a trendsetter in independent education.

McMurry continued the work begun by Souby while also increasing the school's standing and visibility. Under her leadership, maximum enrollment was raised to 320 students and the faculty increased to 31 members.[312] This allowed for a natural expansion of course offerings while keeping class sizes below 17 students. In addition, several new positions were created to better serve the school and its students, including two administrative assistants; two counselors, who assisted in the college application process; a dean of faculty; a dean of students; department chairs; and an alumnae office.[313] Tuition was raised from $625 per year in 1963 to more than $1,000 by 1970—an overall increase of nearly 40 percent.[314]

Another key part of the school's successful growth was McMurry's desire to make Harpeth Hall more competitive and visible within the national network of independent schools. She was a member of several national organizations and attended conferences each year to keep abreast of educational and independent school trends, recruit faculty, and promote Harpeth Hall. During her tenure from 1963 to 1979, McMurry served as the president of the Southern Association of Independent Schools (SAIS), member of the board of directors for the National Association of Independent Schools (NAIS), and president of the National Association of Principals of Schools for Girls (NAPSG), which represented more than four hundred girls' schools in 1975. She had the added distinction of being the first administrator from the South to be named president of the NAPSG.[315] Her leadership in these organizations contributed to Harpeth Hall's ascension to the national stage as a reputable and recognizable all-girls college preparatory school.

Sam McMurry exemplified the professional woman. Often dressed in suits with straight skirts and high-heeled shoes, she was both sophisticated and businesslike. She was compassionate while also commanding the attention of anyone in her presence. Her dachshund, Heidi, was a fixture on campus and accompanied McMurry virtually everywhere. One alumna noted, "Her dignified presence and demeanor brought a sense of importance to the work we were doing. Miss McMurry had a firm, smiling grace for the evolving and occasionally silly young women that we were."[316] Kate Cooper Leupin, class of 1968, recalled an incident where she was closed into a closet by a fellow classmate. The door was difficult to open from the inside, and when she "frantically shoved the door open, it was right into Miss McMurry's face!" Instead of irritation or anger, McMurry laughed—immediately putting everyone at ease. She allowed the girls to be teenagers but also made sure that she was providing the best educational preparation and instruction possible.

While alumnae from the 1960s and 1970s respected the leadership of Sam McMurry, they also held their teachers in high regard. A handful of teachers who began their careers at Ward-Belmont remained on the Harpeth Hall faculty through the 1960s—including Latin teacher Margaret Henry Ottarson and French teacher Ella Puryear Mims. However, a new cadre of teachers had arrived by the late 1960s. Students in 1967 "tittered over the first male Spanish teacher, Señor German A. Pavia, in his suits and ties. There was a little nervousness over the novelty of a male teacher."[317]

Martha Overholser, an English teacher, had perhaps the greatest impact on students at Harpeth Hall during her tenure from 1963 to 1979.

Overholser earned her PhD in English at Vanderbilt University while teaching at Harpeth Hall. Certain teachers leave lasting impressions on their students, and Martha Overholser was undoubtedly one of those teachers. Members of the class of 1968 recalled the following:

> *Most of us would agree that Dr. Martha Overholser was one of the best teachers we ever had, including in college and graduate school. Our class upstairs in Souby Hall was such a revelation: when Dr. Overholser closed the door and turned to us with her lovely smile and her brilliance and love for literature (which she did everything in her power to impart to us), we were hooked.*[318]

Dr. Overholser demanded perfection and inspired passion. Her world literature classes studied the biblical Book of Job as a Greek tragedy; Shakespeare's *Macbeth* or *Hamlet*; and the poetry of Elliott, Auden, Yeats, Hopkins, and Cummings. Alumnae recalled, "Somehow she managed to pull from us the most sophisticated of ideas and insights. At the beginning of the year she said, 'I'll do anything I can to help you make a good grade in this class, but I will not water down the material.'" Their senior year culminated in a rigorous and demanding research paper for which students spent weeks meticulously researching and making note cards and outlines, as well as revising multiple drafts that required precise citation and well-crafted and supported arguments. Alumna Margaret Hylton Jones wrote, "College and graduate papers after that seemed like a breeze. Martha Overholser made me a writer."[319] She graded with a toughness that demanded excellence, but beyond grades, Dr. Overholser captivated students with her love of language and the "beautiful sound of her voice and her serene smile as she shared passages she loved with us."[320] Harpeth Hall's faculty continued to set it apart from its competitors, and by the mid-1960s, the campus also saw improvements.

The fall term of 1966 opened with a new biology lab and a new library. For thirteen years, the library had been located in Souby Hall. Harpeth Hall desperately needed a library if the school were to compete with other independent schools and provide the necessary research skills and resources for students to prepare for college-level work. This need was augmented by a conversation between Dr. Daugh W. Smith, then chair of the board, and Miss McMurry. Dr. Smith had arrived on campus one day and found girls sitting on the floor of the entrance hall of the administration building. When asked why girls were sprawled all over Souby Hall, McMurry replied,

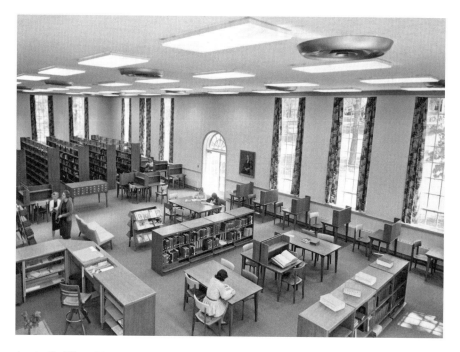

Annie C. Allison Library, circa 1968.

"There's no place in the library for them. All twenty seats are taken... They're waiting to do their homework."[321] To which Smith replied, "Then we've got to have a library. There's no question about it."[322] The Annie C. Allison Library opened in November 1966, housing over fourteen thousand volumes and providing media, classroom, and studio space.[323]

Annie C. Allison was a legend in the world of girls' education in Nashville, and the library was appropriately named in her memory. She had operated a preparatory school, called simply Miss Allison's School, until 1923, and she was hired by Dr. J.D. Blanton to teach Latin at Ward-Belmont in 1925. Two years later, she became the high school division principal. Many former students and faculty of Ward-Belmont considered Miss Allison to be Susan Souby's mentor, and few were surprised when Souby succeeded Allison when she retired in 1945. Allison was the consummate southern lady but did maintain progressive ideals for her day. Fellow Ward-Belmont colleague Dr. Ivarlou Duncan stated, "Miss Annie was actively pursuing better recognition for women. Oh, she was not a woman's rights advocate in today's terms... [but] she felt that academically and politically women were not respected for their [academic] capabilities."[324]

From 1966 to 1970, Harpeth Hall matured as an institution and crafted a more modern identity while still relishing its educational and traditional foundations. Because of Harpeth Hall's emergence as a leading preparatory school, Sam McMurry began talking to board chair Daugh Smith about the possibility of starting a middle school, which ironically reconnected Harpeth Hall with its roots. Ward Seminary and Belmont College for Young Women had maintained active "Intermediate Departments," or a Junior School, that represented modern grades five through eight. Susan Souby had remarked in the early 1960s that it took "three to six months for ninth graders to learn how to study." Sam McMurry also believed in the need to "have students better prepared when they entered as freshman."[325] Dr. Smith appointed a committee to explore the possibility, and in 1967, it came to a conclusion: "The addition of grades 7–8 would strengthen the school's program of college preparation through established sequential courses of study and expansion of curricular offerings."[326]

Dr. Daugh W. Smith was a prominent Nashville surgeon who also had a passion for promoting excellence in girls' education. He was a founding board member and served as the chair of the Board of Trustees for an incomparable twenty-one years. He was instrumental in raising funds and organizing building campaigns for Bullard Gym, the Annie C. Allison Library, the Middle School and, in 1976, the McMurry Arts and Athletics Center.[327] Longtime physical education teacher Patty Chadwell remarked, "Dr. Smith is the one person with a sustained interest in the school. He has been here the whole time…. No one has worked harder or cared more."[328]

As a tribute to Dr. Smith's long service, the Daugh W. Smith Middle School opened in the fall of 1968 with 140 students and 15 faculty members, headed by Ward-Belmont alumna (class of 1943) Polly Fessey. Fessey had completed her bachelor's degree at Vanderbilt University and taught business law and accounting at Ward-Belmont from 1945 to 1951. The day the Middle School opened in 1968, "Miss McMurry and Miss Fessey were carrying in furniture so the students would have some place to sit."[329] In addition to Middle School classroom facilities, the building also housed a new cafeteria and dining hall for the school. In 1971 following the lead of other independent and public schools, grade six was added.[330] McMurry later noted that the opening of the Middle School "seemed the best way to stabilize the backgrounds of all the students entering high school. And it worked."[331] It also worked to boost student enrollment; by 1971, the student population had risen to 535 students and 56 faculty/staff members.[332]

The cultural landscape of the late 1960s and early 1970s brought much change to the United States, and the South in particular. Civil rights, antiwar demonstrations, and a reinvigorated women's movement led to a new political agenda. While women were included in Title VII of the Civil Rights Act of 1964, the Equal Employment Opportunity Commission assigned to enforce the 1964 legislation "refused to consider cases of economic discrimination against women."[333] This led to the formation of the National Organization of Women and ultimately the inclusion of a provision known as Title IX to the Educational Amendments, a series of federal laws passed in 1972 as an extension of the Civil Rights Act of 1964. The Title IX clause reads, "No person in the United States shall, on the basis of sex, be excluded from participation in, or denied the benefits of, or be subjected to discrimination under any educational program or activity receiving federal assistance."[334] In short, Title IX ensured that male and female students were treated equally and that gender discrimination was illegal in educational settings. Legislators and educators would debate and shape the scope and implementation of Title IX throughout the 1970s. The long-term impact of Title IX on public as well as private education would ultimately change the trajectory of women's education and sports and specifically affect girls' schools beginning in the 1980s (see chapter 5).

The social upheaval experienced throughout much of the country in the 1960s and early 1970s did not affect students at the Harpeth Hall School directly. Likewise, events associated with the Cold War and Vietnam did not greatly influence daily school life or conversation. Ann Beach Was, class of 1968, recalled her high school years:

> *I was awfully naïve then and not one to rock the boat. It seemed as if the boat was still pretty steady and calm in those days, in spite of the social revolutions storming the rest of the country.... We were sheltered from controversy and the terrible injustices of the outside world. Not many of us dared to be different.... I think we were true products of our transition-era, post-'50s southern heritage. We were not quite as career-minded at that tender age as our successors would be.... We did not yet imagine the dazzling array of possibilities for our lives that would soon exist for us.*[335]

Many alumnae from this period felt removed from what was happening throughout the rest of the country and the world. One alumna noted, "We did not discuss politics or what was going on in the world; we were there to learn. There was a culture of academic excellence; you were expected

to work hard…. It was also an important honor to be an athlete…. We looked up to everyone who was outstanding in any area."[336] Harpeth Hall may not have fostered social or political activism, but it did provide a superb education, as well as regular chapels and assemblies. Chapel services were held in the auditorium, and "speakers from all faiths came—Protestant ministers, Catholic priests, and Jewish rabbis." As one alumna from the 1960s recalled, "It [chapel] never felt 'evangelical' in any way. Speakers told stories, communicated values and challenged us to think in different ways."[337] Designated chapel services had faded by the 1970s, but messages that inspired reflection and character would continue in the form of assembly speakers and performances.

At Harpeth Hall, the mid- to late 1970s was a period of continued development as an all-girls college preparatory school. Idanelle McMurry capitalized on the growth of the new Middle School by adding a new academic program to the high school that would keep Harpeth Hall on the cutting edge of independent education. The program, known as Winterim, built on the tradition of community involvement and travel established by Ward-Belmont. It would become a signature program at Harpeth Hall. Winterim exposed students to new electives, professional opportunities, independent study, and domestic and international academic travel. This trailblazing program was modeled after college mini-semesters typically held in January or May. At Harpeth Hall, this mini-term lasted a month (later reduced to three weeks) and provided on-campus elective offerings for freshman and sophomores and off-campus internships or travel for juniors and seniors. Winterim debuted in January 1973, and its purpose was clearly articulated in 1974:

> *The basic purpose of any "interim-type" program is to provide for students a worthwhile learning experience in an atmosphere significantly different from the traditional classroom. We agree with this purpose but add to it the aspect of strengthening academic weaknesses which have become apparent in the first term.*[338]

Initial elective offerings included political science, music, astronomy, etymology, contemporary poetry, needlework, birds and flowers of Tennessee, and forensics. As a sign of changing times, Harpeth Hall also offered its first computer course with the following description: "The computer has come to be a major factor in our society. For this reason we are offering a course designed to introduce the girls to the

various uses of the machine and skills needed to operate it."[339] Early travel offerings included student trips focusing on culture, language, and history to England, France, Spain, and Greece. The Winterim concept was groundbreaking in 1974 and would continue to evolve over the next forty years into one of the school's most defining programs.

Idanelle McMurry's success in elevating Harpeth Hall to national status did not go unnoticed. Other prominent independent schools began to show interest in her talents. In early 1979, she resigned from Harpeth Hall to become head of school at the Hockaday School in Dallas, one of the country's most prestigious and largest schools for girls. Hockaday offered pre-kindergarten through grade twelve for both day and boarding students. McMurry guided Harpeth Hall through a tumultuous period for the nation, for education, and for single-gender schools. She had done so by expanding the physical campus, opening the Middle School to better serve the academic rigor of the Upper School, creating the innovative new Winterim program, promoting Harpeth Hall through professional associations, and strengthening community/alumnae relations. McMurry's final building campaign was a facility that provided theatre and music rehearsal space, dance studios, a seven-hundred-seat auditorium, a six-hundred-seat gymnasium, a chapel room, and an art gallery.[340] Upon recommendation by the Board of Trustees and school community, the building was dedicated as the McMurry Center for Arts and Athletics in 1977, a fitting tribute to her tenure at Harpeth Hall.

The construction of the Arts and Athletics Center signaled a post–Title IX era; however, it also contained elements representative of the school's rich history. The original doors of Ward Seminary from Eighth Avenue were donated to Harpeth Hall in 1977 and used on the entrances to the chapel and faculty offices. William Ward III and his son, Bill Ward, had originally reclaimed the doors prior to the demolition of the old Ward Seminary building in downtown Nashville. The doors were added to the Ward's private residence; however, upon the sale of their home, the stately solid wood doors were given to Harpeth Hall as a gift.[341]

Harpeth Hall had begun in the 1960s as most girls' high schools and colleges, seeking to bridge an era representing two very different generations. Ilana DeBare argued:

> *Although they never would have admitted it, many private girls' schools had calcified by the early 1960s…. Most schools had been around long enough to have legions of loyal alumnae, who provided a useful base of support but also a strong lobby against change. With the baby boom and economic*

The original doors of Ward Seminary on Eighth Avenue North, now Rosa L. Parks Boulevard, are now part of the Idanelle McMurry Center for Arts and Athletics.

prosperity of postwar America, schools could pick and choose the students from a growing population of well-off families who didn't see anything wrong with doing things the way they'd always been done—who in fact, often chose private schools precisely for their conservatism....Rather than blazing new trails for women, they were following in the wake of society as a whole.[342]

Harpeth Hall avoided such cultural stagnation with the change in leadership that occurred in 1963 with Souby's retirement and McMurry's hiring.

McMurry was an alumna who understood and respected the tradition behind Harpeth Hall but was also a motivated administrator who realized that if Harpeth Hall was to survive and thrive, the school's curriculum and campus needed to grow and change.

The 1960s and early 1970s brought with it a generation of students more likely to challenge authority and push the limits of school rules and social norms previously thought nonnegotiable. Moreover, the passage of Title IX greatly reduced the number of girls' schools in the country, as many merged with boys' schools or became coeducational—affecting single-sex public and private schools. At the beginning of McMurry's tenure, there were approximately 1,132 private girls' high schools; by the end of her tenure, only 561 girls' high schools were still in operation.[343] Single-sex colleges also moved to a coeducation model; even Ivy League Schools such as Princeton and Harvard Universities began admitting women in 1969 and 1976, respectively. The closure or merger of women's colleges trickled down to single-gender high schools. Many all-boys high schools began to admit girls with far greater success than girls' schools who decided to admit young men. As such, remaining private girls' college preparatory schools struggled to find their identity and niche in the 1970s.

Harpeth Hall survived this period, to a great extent, because of its Board of Trustees and administration. These groups kept enrollment and finances steady, in part, by adding the Middle School and fundraising. Moreover, the school's academic reputation was enhanced by Winterim and the addition of new faculty, staff, courses, and induction as a chapter of the Cum Laude Society.[344] Applicants increased and admission to Harpeth Hall remained competitive. A school newsletter reported in 1975: "The school operates at its maximum enrollment of 570 students, and each year there are approximately 25 percent more applicants than the school has space to accept. Students come from a wide area of the city and county, and several commute from nearby towns. There has been an addition of a wide variety of courses."[345] McMurry's foresight in forming an official alumnae organization also supported the school in various ways. The Alumnae Association reaffirmed the bonds between Ward-Belmont and Harpeth Hall while also organizing the school's growing base of young alumnae.

Harpeth Hall students in the 1970s reflected national trends as participants of a changing cultural and political scene. However, the school and its students remained insulated from the topsy-turvy world beyond campus. The school did react to certain trends that it found in violation of a southern girls' prep school, though it modified other rules

Ali Russell Ferrell and Laura Watson Davenport, class of 1983, in newly adopted uniforms and blazers. The uniform was introduced in 1973 at Harpeth Hall. The uniform included a plaid skirt, a white blouse, and saddle shoes. Ward Seminary and Belmont College students had also worn uniforms. Ward-Belmont students were only required to wear uniforms for physical education.

in order to abide by changing gender roles. For example, sunbathing was expressly forbidden, but girls were allowed to ask boys to dances held on campus. Gone were the days of man-less dancing, strict chaperonage, and white gloves. As long hems, bobby socks, and collared shirts gave way to pant suits, jeans, short polyester skirts, and tank tops, Harpeth Hall adopted a school uniform in 1973. A policy fully implemented by 1975, the uniform reinforced Harpeth Hall's mission as an elite college preparatory school, with wool plaid skirts, oxford shoes, button-down white shirts, and blazers embossed with the school's emblem.

Polly Fessey, the director of the Middle School, was appointed interim headmistress for the 1979–80 academic year as the school searched for a permanent head of school. The committee chose David Ernest Wood, a graduate of Battle Ground Academy (BGA) in nearby Franklin, Tennessee. Following Wood's appointment, Fessey returned to her position as director of the Daugh W. Smith Middle School, where she would serve until her retirement in 1989. Prior to 1980, David Wood had served on the faculty at BGA and University Military School (UMS) in Mobile, Alabama, as well as the admissions director at Vanderbilt University.[346] While Wood was the first headmaster of Harpeth Hall, he was certainly not the first man to lead the then 115-year-old institution; Wood followed in the footsteps of men such as Dr. William Ward and Dr. John Blanton. Wood's appointment also reflected national trends experienced by girls' college preparatory schools throughout the 1970s and early 1980s. Beginning in the late 1960s, "private girls' schools embarked on a wave of hiring men as heads for the first time."[347] Notably, Abbot Academy in Massachusetts and the Emma Willard School in New York, two of the oldest and most elite women's schools in the United States, hired male heads in 1967 and 1970, respectively.

At the 1968 Ward-Belmont reunion, "Minnie Pearl" had delighted the crowd with a performance that personified the good ol' days. A decade later, a new voice enthralled and captivated the Harpeth Hall community. Amy Grant, class of 1978, personified all that was good at Harpeth Hall. She reflected a new generation of graduates from all-female educational institutions—young women who embodied Idanelle McMurry's affirmation that "women want and can have significant careers before, during, after, or instead of marriage and motherhood."[348] A native Nashvillian, Grant embraced the school's traditions as Martha Washington in the annual George Washington Day Celebration, MBA Homecoming Queen, and the Lady of the Hall. Grant earned distinction

Amy Grant was elected Lady of the Hall in 1978. Here she is pictured on the steps of Souby Hall with other elected representatives, heralds, crown bearers, and flower girls.

as a National Merit Scholar and also served in leadership positions as a class officer and student council representative during her time at Harpeth Hall.[349] Alumna Beth Richardson Trescott, class of 1979, recalled Grant's help during a Winterim trip to the United Kingdom. While in Cambridge, Trescott experienced quite a fright:

> *I wanted to get a photograph of a beautiful flag at the end of what appeared to be a snow-covered walkway. Well, the walkway was actually part of a larger water feature that was frozen, and* kerplunk—*I went down into the cold January water. Everyone was shocked and rushed over, but Amy was one of the first to reach me and extended her hands to rescue me. You see, I was really weighted down with my cashmere winter coat. I was mortified and cold. Afterward, I was given the "Best Swimmer Award" for the trip. That's just the kind of person Amy is—always willing to lend a hand, literally.*[350]

While still a student at Harpeth Hall, Amy Grant was already pursuing a professional music career. Grant released her first album in 1978, and her success would lead to national prominence as an inspirational voice in a time of social change and upheaval. Amy represented the new ideal of southern womanhood in the 1970s—smart and talented,

127

compassionate and engaged, and capable of leadership and success in any arena. As Harpeth Hall entered the last quarter of the twentieth century, the precedent set by Grant and her classmates would remain vitally important as the school faced new challenges. Single-gender education would need to survive the 1980s before experiencing a renewal and revival of purpose in the 1990s.

Chapter 5

DEFINING MOMENTS

The Harpeth Hall School, 1980–1998

The education I received at Harpeth Hall gave me the confidence to go into the world as a young professional, completely prepared academically and socially for the many challenges I would face. I had an incredible time at Harpeth Hall.
—Reese Witherspoon, class of 1994

In 1980 a group of juniors and seniors traveled to Austria, Switzerland, and Germany for Winterim. On January 7, students visited arguably the most tenuous site in Berlin, known as "Checkpoint Charlie." This border crossing between West Berlin and East Berlin represented an iconic symbol of the Cold War and signified the division between capitalism and communism, freedom and repression. As the Harpeth Hall group arrived, students realized perhaps for the first time that they were part of something larger—an experience beyond the simple joys of a high school trip. Their merriment quickly abated as Soviet guards boarded the bus with automatic weapons, and guards outside used mirrors to check underneath the bus for suspicious items. Their chaperone, Patty Chadwell, was solemn and quiet, and the girls followed her lead. The visit proceeded without incident, but "Checkpoint Charlie," a serious moment in an otherwise high-spirited trip, left a lasting impression for all who experienced it.[351]

Winterim was one of several advantages that Harpeth Hall offered families interested in independent education for their daughters.[352] In the 1980s, students not only traveled to Berlin but also participated in archaeological digs in Egypt with Joyce Ward and literature studies in

Louisa Gibbs Bassarate, Frannie Douglas Corzine, and Julia Sawyers Triplett stand in front of the Berlin Wall in January 1981. This Winterim trip also included a memorable visit to "Checkpoint Charlie." *Courtesy of Capell Teas Simmons.*

Greece and Italy with Dr. Derah Myers. One alumna noted, "I can't overstate how invaluable Winterim was to my learning experience."[353] Leading and molding the Winterim program through the years was Emily Fuller, who served as director of Winterim (and later special programs) from 1986 until 1998.[354] The program not only provided unique learning opportunities but also created lasting connections that benefited many graduates in college and in the professional world. As a signature program, Winterim helped to sustain Harpeth Hall through the 1980s and early 1990s as single-gender schools reacted to the shifting sands of educational thought and pedagogy.

The 1980s was, in America, a decade of renewed national prosperity and pride, but girls' schools had yet to put their finger on the best way to articulate and sell their model of education in a postmodern world. Illana DeBare, author of *Where Girls Come First*, noted, "[G]irls' schools had to contend with the allure of coeducation, in particular, the allure of prestigious boys' schools that

had recently started admitting girls."[355] On the local level, fellow private school Battle Ground Academy (BGA) began to admit girls in 1979. Nine years earlier, Father Ryan High School (all-male) had merged with the all-female Cathedral High School. After Father Ryan and BGA adopted the coeducational model, Montgomery Bell Academy remained the only all-boys preparatory school in Nashville. Other private high schools included St. Cecilia Academy, a local all-female Catholic secondary school, and University School of Nashville (USN), formerly Peabody Demonstration School, which had admitted young men and women from its inception in 1915.[356]

Despite national and local trends, the early 1980s was a time of great learning and exuberance at Harpeth Hall. As alumnae from the class of 1982 fondly recalled:

> *The 1980s were a carefree, happy time with great teachers. Looking back, it was a time of balance and fun, even though the classes were demanding. We still had to write our papers by hand or occasionally use a typewriter. Our teachers were the total package and served as role models outside of the home. We had the freedom to learn, but we didn't use the word* stress. *We were busy but not as pressured as teens today.*[357]

Harpeth Hall prom, circa 1985.

Harpeth Hall's young graduates in the 1980s and early 1990s emerged with greater confidence, intellectualism, and life experience. Despite challenges to single-gender education across the nation, Harpeth Hall students felt an overwhelming sense of loyalty and community. One alumna noted, "Harpeth Hall's greatest assets include the school's dedication to its mission for educational excellence for young women and the multigenerational ties formed over the past century."[358] As high school students, many did not realize that they were benefiting from pedagogy and curricular instruction based on the ways in which girls learned best. By the mid-1990s, educational experts, psychologists, and parents were beginning to see girls' schools in a new light. Educating girls in a single-gender environment could be advantageous in its own right, and the learning outcomes of girls should be measured differently than those of boys.

The 1970s and 1980s brought many male heads of school to independent girls' schools, and Harpeth Hall followed this national pattern with the hiring of David Wood in 1980. One visible product of Wood's tenure was the dramatic increase in the number of men on the faculty. This increase reflected a larger trend experienced nationwide in many girls' schools and was perhaps a byproduct of more male heads of schools. Consciously or not, the

The class of 1982 in front of the designated Senior House located between today's Jack C. Massey Center and Souby Hall. The class theme, "We Made It Through in '82," is featured on the Senior House. *Courtesy of Capell Teas Simmons.*

Harpeth Hall students pictured in the Leigh Horton Garden. The garden was dedicated in memory of Leigh Horton, class of 1985, who passed away from cancer in 1984.

decision to add men to teach and coach contributed to the larger rebranding effort of girls' schools in the 1990s. In 1979–80, only four men served on the teaching faculty at Harpeth Hall. By 1985 every Upper School department had at least one male faculty member (except for physical education), and surprisingly, four of the eight members of the English Department were men. While the Middle School still maintained a virtually all-female faculty, by 1989 the number of male teachers in the Upper School had expanded to eleven. The administration certainly hired well. Several men who joined the faculty during the 1980s began long and respected tenures, lasting an average of thirty years, and included Peter Goodwin, Paul Tuzeneu, Dr. Art Echerd, Tony Springman, Tad Wert, and Dr. Jim Cooper.[359]

Ward Seminary and Ward-Belmont certainly had men on the faculty, in addition to an all-male slate of chief administrators, but Harpeth Hall had only one or two men on the faculty at any given time before the 1980s. Having more male faculty helped Harpeth Hall overcome some of the misperceptions about girls' high schools. While single-gender schools had

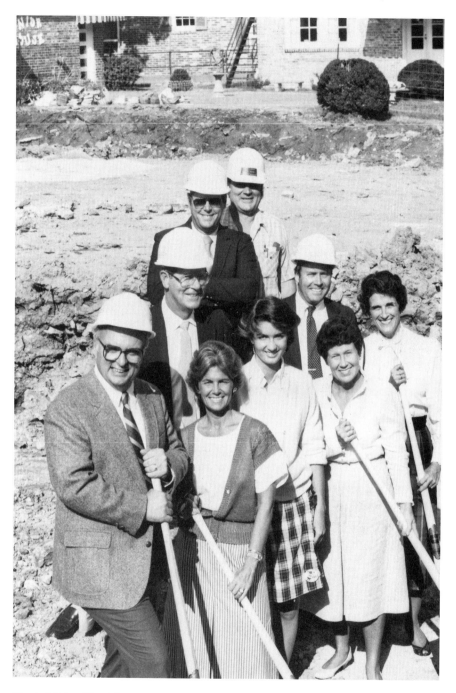

Head of School David Wood with trustees Patricia Frist; Mary Schlater Stumb, class of 1953; Robert Kitchel; student Elizabeth Hightower, class of 1985; Director of Development Polly Jordan Nichols, class of 1953; and representatives from Shaub Construction Company break ground for the Jack C. Massey Center for Mathematics and Science in 1984.

modernized and implemented progressive academic and athletic reform, all-female schools in the 1980s still faced public misperceptions of strict rules and "school marms." In 1987 a group of thirty girls' boarding schools commissioned a study to explore future marketing strategies. One consultant and former admission director noted, "The reality of how we'd changed was not as well documented as the image of double strand pearls, riding horses, and pouring tea."[360] Adding men to the faculty at Harpeth Hall helped to give the school a certain legitimacy and broader appeal.

David Wood was very popular with students; he annually dressed as Santa Claus and occasionally canceled classes for special events, to the students' delight. Many faculty members were also loyal to Wood; however, the latter part of his eleven-year tenure brought tough decisions with bittersweet consequences. From 1984 to 1989, Harpeth Hall confronted its greatest staffing and administrative challenges. In 1984 there were approximately forty full-time members of the teaching faculty. In the spring of 1985, three teachers' contracts were not renewed for the following year. The move was both bold and controversial; Wood believed that a reduction in full-time faculty was necessary to keep the school financially viable. Many teachers felt that the decision was more politically motivated and based on the partiality and preference of the administration and the Board of Trustees. Historically, both Ward-Belmont and Harpeth Hall had maintained a reputation for the retention of a dedicated core of faculty, with low turnover and long tenure. The events of 1984–85 marked a temporary departure from precedent.

Regardless of the complicated decision to eliminate teaching positions, Wood's decision set in motion a chain of events that compounded growing uncertainty about the school's direction and course. In addition to the three teachers who were not offered contracts, thirteen faculty members resigned as a sign of solidarity and protest in 1985. Many believed that the Board of Trustees would not accept the resignations and instead address teacher concerns with the administration. To the dismay of many students and faculty, the resignations were accepted, and David Wood sought to bring some measure of stability back to the school. Unfortunately, over the next three years, Harpeth Hall would experience its greatest challenges with a decreasing enrollment, an increase in campus maintenance costs with aging buildings, and turnover in the faculty. Ten additional Upper School faculty members would retire or resign before 1988.[361]

Despite some dissension between the faculty and administration, teachers continued to inspire students in the classroom. Alumnae from the 1980s remember their teachers with fondness and admiration. Female teachers, in

particular, served as role models and inspired students with their confidence, wit, and thoughtfulness. Capell Teas Simmons, class of 1982, stated, "I bet they had more fun in the teachers' lounge than we did in the Senior House. These women showed us that women could do anything—that was the essence of Harpeth Hall."[362] Students from the early 1980s recall a particular skit in which English teachers Dr. Dona Gower, Dr. Betty Marney, and Sarah Stamps performed a *Macbeth* scene in full costume. They chanted, "Double, double toil and trouble; Fire burn, and cauldron bubble," to roars from the audience.[363]

While the teaching faculty endured a period of change, administrative departments were expanded in order to keep Harpeth Hall competitive with other private schools and to help with the school's financial solvency. Wood created a Department of Development in 1981, naming Harpeth Hall graduate Polly Jordan Nichols, class of 1953, as director. Within two years, a Department for Admissions and Alumnae was created, with Susan Glasgow Brown, class of 1960, appointed its first director. Penny Mountfort had served as counselor, college counselor, and dean of faculty before her retirement in 1985. When she left, the dean of faculty position was not filled, and the counseling office was divided into two separate offices as the College Counseling Department and the Counseling Department.

Several members of the faculty and staff wore multiple hats, and titled positions fluctuated as the school attempted to keep its balance during the 1980s. Bill Hayward, named the new head of the business office in 1986, also taught economics. Emily Fuller began teaching mathematics in 1981 and eight years later was named director of special programs, which included Winterim, summer programs, Leadership Conference, and the bookstore. For the 1984–85 school year, one of the two counselors, Jane Berry Jacques, class of 1972, also served as dean of students. The first appointed Upper School director was Joanna Rutter in 1984. When Rutter departed after one year, Betsy Turnbull, who taught business and history, assumed the role of lead administrator, alongside David Wood, from 1985 to 1988. Turnbull, who had come to Harpeth Hall with her husband, Gordon, an English teacher, approached Wood after the 1985 school year. Her timing was impeccable. She desired a transfer to teach in the Social Science Department full time, but when she proposed such a change, Wood replied, "What would you think about being my assistant?"[364] Betsy accepted, and the Turnbulls remained a popular young duo until they moved to Virginia in 1988. Alumna Susan McKeand Baughman, class of 1956 and Harpeth Hall's college counselor since 1986, was promoted to

director of the Upper School, a permanent position beginning in 1989.[365] When Baughman transitioned from college counselor to Upper School director, Wood named himself college counselor in her place.

David Wood provided leadership in areas involving student culture, service, and curriculum from 1980 to 1991. In 1982 Harpeth Hall formalized its Honor System, which included both an Honor Council and Honor Code. The purpose of the Honor System was "to instill trust and responsibility in every student."[366] A new assembly held at the beginning of each year administered the oath to all students, who then signed an annual pledge. The Honor Council, composed of students elected by grade level without nomination, was charged with the confidential task of hearing offenses to "insure that a spirit of integrity would remain in each student's mind throughout the school year."[367] Moreover, Wood inaugurated the Father-Daughter Dinner, created a new student hangout nicknamed the Bear Lair, and formed the Key Club to "increase student involvement in community service."[368] He was also "instrumental in obtaining the Morehead Scholarship to the University of North Carolina, open to two schools in Tennessee at that time."[369]

On a curricular level, Harpeth Hall expanded its fine arts program, creating separate departments for music, theatre, and dance. While fine arts programs had been a staple of women's schools since the late 1800s, Wood recognized their importance and embraced these traditional subjects of study. As girls' schools sought to find their place and define themselves in a post–Title IX world, Wood's decision would prove to be a good one. The 1990s and 2000s brought continued success and growth to Harpeth Hall's choral, instrumental, and theatre programs, producing highly anticipated concerts, plays, and musicals throughout the school year. Building on a tradition of excellence in musical and artistic expression from its predecessor schools, the fine arts program continues to showcase the many acting, musical, and technical talents of Harpeth Hall students.

Harpeth Hall's decision to focus equally on fine arts, particularly dance, would provide the school with an advantage over other independent and public schools. The move to create a modern dance program actually began in 1977 when Idanelle McMurry hired Leslie Matthews, a graduate from New Mexico State University. Matthews was appointed to charter a dance program at Harpeth Hall, bringing dance back to the school for the first time since Ward-Belmont. In her first year, Matthews taught both dance and rhythmics. Rhythmics

Physical Education Department, 1981. *Left to right*: Pat Moran, Susan Russ, Patty Chadwell, and Leslie Matthews.

was a combination course reminiscent of callisthenics and early physical education—courses that included gymnastics and dance and sometimes incorporated hoops, ribbons, and batons. Patty Chadwell taught rhythmics at Harpeth Hall, but in 1979, the course was phased out. In the late 1970s, Matthews worked to develop a legitimate dance program with ballet and modern dance companies. In 1980 Stephanie Hamilton was added to the faculty to assist with dance, specifically with ballet, tap, and jazz. Matthews and Hamilton formed a dynamic team, producing sophisticated and intricately choreographed dance concerts—the highlights of the year. In the 1990s, the dance program included both curricular classes and extracurricular dance companies. In 2000 a Middle School after-school dance program was established, led by Hamilton, and in 2004 Matthews established a yoga physical education course.[370] Matthews and Hamilton would become fixtures at Harpeth Hall and remain two of the longest-tenured faculty members at the school.

Dance as a discipline reflected traditional notions of femininity dating back to the late nineteenth century with an emphasis on womanly grace and poise. The study of dance experienced a resurgence in the 1970s and 1980s, with some modern variations. The year 1981 was dubbed "The Year of the Dancer," as the Ballet Club performed *Papillon*, and the Jazz Club did a rendition of *David's Suite*. The show ended with a dance extravaganza entitled *The Greatest Show on Earth*, featuring a ringmaster, tightrope walkers, aerialists, and acrobatics.[371] Since the dance program's modern inception nearly forty years ago, participation in dance has increased substantially. Holly Whetsell Coltea, class of 1994, recalled in 2012 that Leslie Matthews had instilled in her a love of dance: "She was one of my biggest supporters…The physical efforts coupled with the daily structure pushed me to be my best self…. I made incredible strides with my flexibility, agility, and as a by-product, my self-confidence."[372] Alumnae from the 1980s to the 2000s continue to highlight the role of the performing arts, including music, theatre, and dance as equally important to the growth of athletics.

Athletics at Harpeth Hall expanded after Title IX was signed into law in 1972, but by the 1980s the new federal legislation had affected secondary education in a multitude of ways that extended beyond girls' sports. By law, schools receiving federal funding nationwide were obligated to invest equally in the education of female and male students. Public schools for girls were increasingly seen as antiquated and inequitable when compared to boys' schools. As a result, Title IX created a dynamic in which nearly all public single-gender schools had merged by 1980 in order to create equal educational opportunity.

Girls in private single-gender schools had always maintained certain advantages over their all-girl public school counterparts. However, the coeducational wave in public education trickled down to independent schools in the 1980s. In fact, by 1990 only two public girls' schools remained in operation in the United States.[373] This shift served as an undermining force for private schools, unable to shake lingering reputations as finishing schools that catered to wealthy white families and produced southern "ladies." Perhaps ironically, Title IX initially did more harm than good for all-girls schools. Girls' schools would have to prove their educational value—not as institutions with rich histories but as educational launching pads designed specifically to maximize the full potential of young women. This would be accomplished through gender-specific opportunities in academic, artistic, and athletic realms.

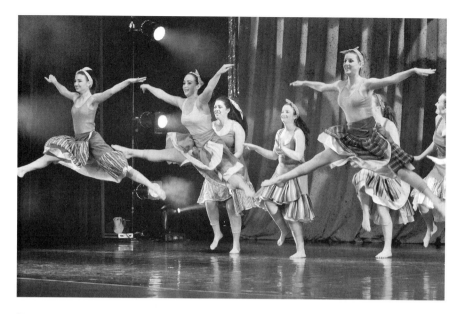

Dance concert, 2012. Stephanie Hamilton has served as the director of the Upper and Middle School Dance Program since 1999 and has served on the faculty since 1980.

While the short-term effects of Title IX challenged the validity of the single-gender model, long-term results of the legislation served to jumpstart a new pattern of empowerment for young women. The expansion of funding for girls in public education, and in particular girls' sports, led to a more visible and confident generation of young women. Title IX added momentum to sweeping changes taking place in secondary and collegiate coeducational institutions. As a result, all-girls schools benefited from the enhancement of athletic competition and the expansion of women's sports between 1972 and the mid-1990s. As an independent all-girls school not eligible for federal funding, Harpeth Hall was not directly affected by Title IX. However, as "a rising tide lifts all boats," the additional funding and expansion of women's sports for public schools also elevated athletics at Harpeth Hall. In turn, the growth of Harpeth Hall's athletic program helped to boost the school's reputation beyond academics. It was precisely the type of gender-specific opportunity that the school needed to set it apart from other public and private high schools. Harpeth Hall's early sporting success was also due to dedicated coaches and exceptional athletes who emerged in the late 1970s and 1980s.

In 1973 and 1974, Harpeth Hall's intramural teams (based on clubs) transitioned into organized competitive varsity teams. Basketball was the first girls' sport at Harpeth Hall to join the Tennessee Secondary School Athletic Association (TSSAA) in 1973.[374] Additional varsity teams were added to TSSAA in 1974 and 1975, achieving early athletic success in track, cross-country, tennis, and swimming. Steve Kramer, former history teacher and department chair, coached both the track and cross-country teams to state championships in 1975. The team was led by Susan Thornton, Harpeth Hall class of 1976 and University of Tennessee track and field standout, as well as future Olympian Margaret Groos Sloan, class of 1977. The track team's success was particularly impressive considering that practices were held at either nearby Overton High School or Hillsboro High School, as Harpeth Hall did not yet have a regulation track or field.

From 1975 to 1978 the cross-country team captured four consecutive state titles. In 1977 Harpeth Hall garnered its first state championship in doubles tennis, with Kathy Denton Stumb and Liz Jamison Young,

Olympic marathoner Margaret Groos Sloan, class of 1977, and University of Tennessee track and field standout Susan Thornton, Harpeth Hall class of 1976.

both class of 1979.[375] English teacher Dugan Davis established a soccer team in 1980 that played against college and club teams until TSSAA added soccer. A rifle team was formed in 1984 by Emmons Woolwine and competed against boys' teams because of the lack of local or state competition.[376] And in 1987, teacher and coach Tony Springman formally organized Harpeth Hall's first softball team with the assistance of Dr. Art Echerd, a fellow colleague in the Social Science Department. The softball team did not have a home game for two years until a regulation softball field was completed in 1989.

Harpeth Hall did not have a school-sponsored swim team until students who swam for local club teams organized and represented Harpeth Hall starting in 1978. In 1979 the swim team captured its first state title, led by future Olympic star Tracy Caulkins Stockwell, class of 1981. Unlike swimmers who specialize in a single stroke, Caulkins's unparalleled athletic ability allowed her to dominate all four swimming strokes. As a freshman at Harpeth Hall, she won five gold medals and one silver medal at the 1978 World Championships in Berlin and the James E. Sullivan Award, which honors the nation's top amateur athlete.[377] Caulkins competed in the 1984 Los Angeles Olympic Games, with her family, friends, and high school PE teacher Patty Chadwell watching from the stands. She won gold medals in the 400-meter individual relay (United States record), 200-meter individual relay (Olympic record), and the 4x100-meter medley relay team. At the end of 1984, Caulkins was named the U.S. Olympic Committee's Sportswoman of the Year.[378]

As women's varsity athletic programs developed nationwide, schools invested in better facilities to accommodate competitive extracurricular activities. At Harpeth Hall, the Idanelle McMurry Arts and Athletics Center (1977) remains a prime example of the ways in which Title IX raised the educational and athletic bar for girls. Additionally, from 1977 to 1989, the school constructed its first field house, an eight-lane track, and two softball fields. Another example of Title IX's impact on women's sports was Harpeth Hall's hiring of Susan Russ from Memphis State University. A pioneer in women's athletics, Russ initiated the track and cross-country programs at the university in 1969 with no additional pay. After eleven years in Memphis, Russ joined the faculty at Harpeth Hall in 1980 and continued building on the school's early athletic success. She began as a physical education teacher and volleyball coach. In 1986 Russ was named the school's athletic director—a dedicated position created during Wood's tenure.[379] Over her thirty-year career at Harpeth Hall,

Russ won more than twenty state championships in cross-country and track and field. She remains the winningest coach in Tennessee high school history.[380]

The post–Title IX era led to a new golden age of women's sports not seen since the early 1900s. From 1974 to 1990, Harpeth Hall transitioned from a club intramural system to an athletic powerhouse within the Tennessee Secondary School Athletic Association (TSSAA) and Harpeth Valley Athletic Conference (middle school). Although it first appeared that Title IX had endangered the very existence of single-gender schools, over the course of time, young women in all-female schools emerged as the legislation's greatest beneficiaries. The emphasis on

Tracy Caulkins Stockwell, class of 1981, with her Olympic medals following the 1984 summer games in Los Angeles.

and the expansion of women's sports was part of a larger educational and cultural shift—a metamorphosis that would produce a new vision and mission for girls' schools in the 1990s and 2000s.

On the cusp of a new decade, Harpeth Hall's commitment to single-gender education continued to evolve as the school transitioned into an era marked by both continuity and change. The beloved song and dance for the George Washington Day Celebration continued, but its production was moved from the Upper School to the Middle School under the leadership of history teacher Dr. Merrie Morrissey Clark, class of 1969. The traditional beanie hats worn by seniors were discontinued in 1988 in favor of navy tennis visors.[381] In addition, several longtime teachers retired. The 1988 *Milestones* was dedicated to retiring science teacher Carolyn Felkel, faculty member since 1965, who sponsored the Triad club, chaperoned Winterim trips to Great Britain, and taught on-

campus Winterim pottery classes. Students noted that her "impeccable character and care for students complement her extensive knowledge."[382] She was also remembered for a tradition known as "Frog Day," during which her students buried frogs on campus grounds after class dissections. Mirroring the growth of the school, Felkel began her teaching career in Souby Hall, moved to the first classroom building known as "Little Harpeth," and ended her classroom experience in the newly completed Jack C. Massey Center for Mathematics and Science.[383] In 1989, Polly Fessey also retired after leading the Daugh W. Smith Middle School for twenty-two years. Finally, in 1991, David Wood left to accept a position at Pace Academy in Atlanta. Retiring teachers and administrators remained beloved, but a new generation of educators would sustain and carry Harpeth Hall's best ideals forward.

In the 1990s a younger generation of faculty members would rise to assume the mantle of leadership. Lindy Sayers, a young English teacher, succeeded Polly Fessey as Middle School director, and Dr. Heath Jones, a highly respected science and math teacher, was named dean of faculty. The 1989 and 1991 *Milestones* were dedicated to art/photography teacher Peter Goodwin and art history/English teacher Dr. Derah Myers, respectively. Goodwin challenged his students to think with originality, create with freedom, and learn about the world through learning first about themselves.[384] Myers, who joined the faculty in 1987, was compared to a "kaleidoscope by transforming the ordinary...with an her intense love of art and literature, candidly expressed in class, with contagion."[385]

Other teachers who would start their Harpeth Hall journey in the 1980s included Jess Hill, Tony Springman, Dr. Jim Cooper, Merrie Clark, Scottie Girgus, Tad Wert, Carol Oxley (1978), Paul Tuzenu, Dr. Art Echerd, Rosie Paschall, Ann Blackburn, and Janette Fox Klocko. Joyce Ward, beloved Latin teacher, began in 1970 and also added greatly to this core group of teachers. Nicknamed "Magistra," Ward hosted Roman banquets and delighted students with her passion for Latin until her retirement in 2007.[386] These educators continued to inspire academic and extracurricular excellence and treasured teacher-student relationships but also shaped a new era of single-gender education and school culture. Simultaneously, a generational shift occurred within the student body as the children of baby boomers, known as Generation X, entered their teenage years in the late 1980s and 1990s.

The Jack C. Massey Center for Mathematics and Science was built in 1985 and replaced "Little Harpeth." Today, it serves as the main point of entry for the Hortense Bigelow Ingram Upper School.

Kate Celauro, Lady of the Hall in 1998, and Head of School Leah Rhys in front of Souby Hall.

In 1991 Leah Rhys was appointed head of school, a title she preferred to headmistress, and she quickly set about ensuring that Harpeth Hall remained both relevant and revered as an all-girls preparatory school. In spite of the administration's best efforts, the size of the student body had declined from 1980 to 1991.[387] In 1984 student enrollment stood at 503, with 71 graduating seniors. In the last year of Wood's tenure, figures reveal 391 students (including grades six, seven, and eight) and only 59 graduates.[388] While David Wood remained a much-loved figure within the Harpeth Hall and Nashville communities, the business and educational model was at odds with demographic and cultural trends. As author Ilana DeBare noted:

> *The 1980s had been a tough decade for private girls' schools, many of which were suffering from a slump in application. Part of the problem was demographic. America's postwar baby boom ended in the early*

1960s, which meant that the total pool of high-school-aged kids in America started shrinking in 1976 and didn't begin growing again until 1991.[389]

Leah Rhys was recruited from the Laurel School, an all-girls school in Shaker Heights, Ohio. Rhys served as the head of school at Laurel for seven years prior to accepting the position at Harpeth Hall. Her support of women's education within the single-gender model went beyond her administrative duties at the Laurel School. She was keenly concerned with issues related to the psychological, emotional, and intellectual development of girls compared to boys. Opportunities for women had greatly increased from 1960 to 1990. As a result, many women's schools (both colleges and high schools) had closed or merged as cultural trends leaned toward educational equality through coeducation. All-girls schools, including Harpeth Hall, found themselves at a tipping point by 1991. The school could either re-energize and appeal to a broader base or continue with the traditional formula and appeal to a small niche of families.

With Rhys at the helm, and parents and alumnae on board, "the school slowly redefined its place in the world of education, [shaking] off its image as a place where only Nashville's wealthy sent their daughters."[390] Following the lead of the Emma Willard School, Harpeth Hall filmed its first commercial in 1993 and purchased a series of advertisements. Such promotional campaigns proclaimed the merits of single-gender education and helped to shed new light on public perceptions of all-female schools. Whitney "Whitty" Ransome, former co-executive of the National Coalition of Girls' Schools (NCGS) and director of admissions at Dana Hall in Wellesley, Massachusetts, argued that "[t]he myth out there was that girls did not love their high schools—that these places were ivory towers of girls in white gloves serving tea.... It was as much a misperception problem than anything else."[391] Harpeth Hall's commercial directly challenged this misperception as students repetitiously chanted, "Harpeth Hall, we love it!"

The tide began to turn in favor of single-gender education for the first time in nearly a century, and several events precipitated this seminal moment. In 1991 the NCGS unified two smaller organizations, and the new group hired the Howard Rubenstein agency. This public relations consulting agency made several recommendations that included the following broad goals: first, to develop more math and science courses; second, to improve diversity (religious, ethnic, socioeconomic); third, to

emphasize career education; fourth, to add more "women" to the content curriculum; fifth, to embrace competitive athletics; and sixth, to better promote the advantages of learning focused on girls.

Nearly twenty years after Title IX, the academic world would also revisit the issue of women's education and equity through the lens of gender studies and psychology. The American Association of University Women (AAUW) produced a report in 1992 that monumentally influenced public awareness about girls in coeducational institutions. The report concluded that "[g]irls and boys enter school roughly equal in measured ability.... Twelve years later, girls have fallen behind their male classmates in key areas such as higher-level mathematics and measures of self-esteem."[392] A book by Mary Pipher in 1994 entitled *Reviving Ophelia: Saving the Selves of Adolescent Girls* argued that "girls in the 1990s had a tougher time in adolescence than their mothers and grandmothers," affecting their IQ scores, confidence, intellectual curiosity, and emotional development.[393] The same year, psychologists Myra and David Sadker published *Failing at Fairness: How Our Schools Cheat Girls.* The Sadkers showed that beyond test score comparisons, many female students suffered in coeducational classrooms; girls received higher grades and needed less discipline than boys, but not to their betterment. They concluded that "girls' good behavior frees the teacher to work with the more-difficult-to manage boys. The result is that girls receive less time, less help, and fewer challenges."[394] In sum, girls learned to be quiet, conform, and behave in coeducational settings rather than learning to be critical thinkers and assertive young adults.

The leading voice for girls and their education was Carol Gilligan, a professor and expert in gender studies, psychology, and pedagogy. Several publications authored by Gilligan from 1982 to 1996 "opened the door for teachers to think about differences in boys' and girls' learning styles."[395] In the groundbreaking study *Making Connections: The Relational World of Girls at the Emma Willard School*, Gilligan concluded that the majority of educational and psychological research had "considered only the male perspective, and women's voices [had] been lost in the process of accommodating researchers' expectations."[396] In other words, the study of gender differences within educational settings remained essential to better understand and effectively teach girls in school—which, in turn, shaped women in adulthood.[397]

Following *Making Connections*, Carol Gilligan sought to expand on her research. Gilligan, who taught at that time in the Education Department

at Harvard University, joined forces with Lyn Brown of Colby College in 1986 to ask the question, "What, on the way to womanhood, does a girl give up?" The journey that would ultimately answer this question was "initiated by an invitation from Leah Rhys on behalf of the Laurel School" in Cleveland, Ohio.[398] Gilligan and Brown studied female students, ages seven to eighteen, at the Laurel School and published their work, *Meeting at the Crossroads: Women's Psychology and Girls' Development*, in 1992. Girls' schools had for decades believed that single-gender education was beneficial and created an environment whereby girls became young women—more confident in themselves, more curious about the world, and more engaged in their communities. But academic works published in the 1990s helped girls' schools to rediscover their "voice" and provided a renewed sense of purpose.

Leah Rhys arrived on the campus of Harpeth Hall in the summer of 1991 armed with a clear vision and the pedagogical research of Gilligan, Brown, Pipher, and the Sadkers. By the mid-1990s, Gilligan's books were considered both a "bible" and a blueprint for girls' schools going forward. In *Meeting at the Crossroads*, Gilligan and Brown stated, "Our journey into women's childhood—our joining women with girls rather than comparing women with men—led us to hear, as if for the first time, the clarity and strength of girls' voices and the extent of girls' relational knowledge."[399] Katie Moran Bostrom, class of 1994, echoed Gilligan's thesis. In her own "voice," Moran described her experience at Harpeth Hall: "[I] learned that not many things in the world are just black and white. The ability to recognize the beauty of a situation from different perspectives and angles allows one to truly appreciate the shades of gray that constantly surround us."[400]

Rhys sought to increase the school's visibility within the local community and raise the school's profile among other local independent schools, both single-gender and coeducational. She felt that the school was "little appreciated and ill-understood" by the Nashville community. Her efforts paid off in part because of her ability to connect with alumnae, local leaders, and the Board of Trustees. She was less involved in daily campus life outside the administration building, and school culture was quite different than it had been under David Wood. However, Rhys stirred enthusiasm and fidelity among alumnae and the greater Nashville community. She understood that the "future health of the school depended on women all around the country who had benefited from their education at Harpeth Hall." As head of school, Rhys "worked hard to

develop contacts, traveling to cities and giving receptions for women."[401] In the process, she gave the school "a push out of its comfort zone…and helped ensure that there would be a Harpeth Hall for years to come."[402]

One student, in particular, raised the school's profile and visibility single-handedly. Reese Witherspoon, class of 1994, landed her first major role in the film *Man in the Moon* in 1990 as a freshman, and by her senior year, she had appeared in seven movies (three made for television and four released at the box office), including *Jack the Bear* with Danny DeVito and *A Far Off Place*, both released in 1993. Witherspoon attended Harpeth Hall from 1990 to 1994 and enjoyed the all-girls environment: "Attending an all-girls' school taught me how to get along with women without the distraction…of boyfriends and relationships…It was really nice to have that part of my life be separate from my school experience."[403] She served as the student assistant director of a school play production and spent Winterim her junior year working on post-production editing for *A Far Off Place* in Los Angeles.

Although she was not on campus full time during her years at Harpeth Hall, Witherspoon remained a beloved classmate, and the school celebrated her success. Physics teacher Heath Jones and English teacher Margaret Renkl supported her with creative assignments, and "[w]hile on location, her tests and exams were sent back and forth by fax" from Souby Hall.[404] Witherspoon fondly recalled the encouragement given to her by theatre director Janette Fox Klocko: "She would always run lines with me before I would get on a plane for an audition…I always go see her in her basement office when I go back for a visit."[405] In fact, Witherspoon continues to speak highly of the faculty and the educational environment and preparation fostered at Harpeth Hall: "The teachers were extraordinary. They instilled in me a love of learning that has lasted a lifetime. In particular, my English, history, and language courses prepared me for not only Stanford University, but for a career in the arts as well."[406]

Following Witherspoon's high school career, her star continued to rise as an actor known for her humor, passion, and hard work. By the early 2000s, she was one of the most talented and popular actors in film. Witherspoon starred in movies that reached audiences across many generations and genres: *Cruel Intentions* (1999), *Election* (1999), *Legally Blonde* (2001, sequel 2003), *The Importance of Being Earnest* (2002), *Sweet Home Alabama* (2002), *Rendition* (2007), *Water for Elephants* (2011), and *Walk the Line* (2005), for which she won the Golden Globe, SAG Award, and the Academy Award

for Best Actress in 2006. In 2010 Reese Witherspoon was given a star on the famed Hollywood Boulevard, and two years later, she and Bruna Papandrea launched Pacific Standard, a new production company. Pacific Standard produced its first two major films in 2014, which received rave reviews from audiences and movie critics alike. *Gone Girl* (October) and *Wild* (December) were based on books and feature

Reese Witherspoon, class of 1994, and Janette Fox Klocko, theatre director.

strong female leads, including Witherspoon as Cheryl Strayed in *Wild*. Papandrea stated that she and Reese "share the same goal in terms of focusing primarily on developing roles for women." Witherspoon added, "We just want to see different, dynamic women on film."[407] Witherspoon's work with Pacific Standard reflects and reinforces the mission of Harpeth Hall and other all-girls schools. Women grow stronger when they see strength; women are leaders when they see others who lead.

Witherspoon noted that Harpeth Hall "had a great focus on feminism and [taught] that we could accomplish anything we wanted."[408] She remarked that while high school can be tough, her classmates at Harpeth Hall were special: "[E]verybody was appreciated for their individuality. We had some girls who were marathon runners and everyone was proud of them, and we had a beautiful painter in our class. People were good at different things." In May 2014 this group of distinctive and exceptional women from the class of 1994 reunited to celebrate their twentieth high school reunion. Witherspoon continues to cherish the bonds of timeless sisterhood shared by many alumnae of single-gender schools: "I am lucky to still have so many close relationships with other women that attended the school. It truly was a perfect learning experience."[409]

By the mid-1990s, the financial health of the school had recovered, with a marked increase in fundraising, annual giving, and an enrollment of more than five hundred students for the first time in a decade. Business manager

Anne King noted, "Things had really turned around by 1995. Leah was great at raising money, and she worked very well with the Board of Trustees." In 1991 there had been talk of going co-ed or merging with another school such as Montgomery Bell Academy (MBA) or Harding Academy (K-8). Rhys put such rumors to rest: "My role was to confirm Harpeth Hall's original mission of educating girls and young women. My commitment to girls' schools is how my feminism expressed itself."[410]

In 1996 Harpeth Hall hosted a symposium entitled "Today's Girl in Tomorrow's World" with the Girl Scouts as a corporate and community co-sponsor. In retrospect, the two-day event was Harpeth Hall's reintroduction to the Middle Tennessee region as a top-tier college preparatory school.[411] The symposium was a huge success and raised public visibility for a school tucked away in a suburban setting. The year 1996 also marked a watershed moment with the retirement of Pat Moran. As a member of Ward-Belmont's last graduating collegiate class of 1951, Patsy "Pat" Neblett Moran had studied at Ward-Belmont in the Physical Education Department under the legendary Catherine Morrison and Patty Chadwell. She completed her studies at Peabody College for Teachers (now part of Vanderbilt University) and joined the Harpeth Hall faculty in 1956 as a physical education and health teacher. Moran served as Physical Education Department chair from 1981 until her retirement in 1996. Not only was she the last remaining Ward-Belmont graduate to teach and coach at Harpeth Hall, but she also marked a generational shift in the life of the school and the evolution of single-gender education. After a trying decade, the school had emerged with a new identity by the late 1990s. It was a time of "renewal and recommitment for Harpeth Hall as it strived to stay current with the needs of…young women. Women not only desired to have the same education as men but to have one in which their differences were celebrated not compromised."[412]

Under the leadership of Leah Rhys during her seven-year tenure, a fifth grade was added to the Middle School, the first computer lab was built, annual giving tripled to nearly $600,000, and student diversity and global awareness improved. She was also the first head of school to live on campus at the newly acquired Kirkman House, a residential estate on the edge of campus gifted to the school by the family of 1948 Ward-Belmont alumna Patricia Kirkman Colton.[413] The 1990s was also a decade of introspection and greater inclusiveness, as Harpeth Hall sought to recruit a student body that was more ethnically, economically, and religiously diverse. Early nonwhite students included Norda Aguila (class of 1980), Brita Meng (class of 1981), Yi-Fun Hsuch (class of 1982), and Maria del Carmen Severino

Medrano and Constanza Castelnuovo-Tedesco (class of 1982). The first African American students included Cey Gray (class of 1983) and Lethia Michelle Batey (class of 1988), but the number of students of color was not "statistically significant" before 1995.[414] Before the 1990s, Harpeth Hall students regularly hosted exchange students, such as Monica Bonilla from Las Arenas, Spain, in 1988.[415] As tuition

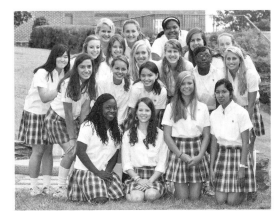

Harpeth Hall students in front of the Daugh W. Smith Middle School, 2009.

increased, the need for financial assistance also grew significantly in order to attract and retain students who were both ethnically and economically diverse.

When Leah Rhys retired in 1998, Ann Teaff was appointed as the school's fifth head of school. Teaff would make increased diversity a priority during her tenure. Led by the admissions office, Ann Teaff, and Board of Trustees members such as Frank Boehm, Ken Melkus, and Carol Clark Elam, Harpeth Hall began to seek families with diverse backgrounds in categories of race, ethnicity, religion, and socioeconomic status. In 1998 students of color made up 10 percent of the student body. This figure has risen to an average of 14 percent (2000–2015).[416] Financial aid also increased from approximately $250,000 in 1997 to $1.66 million in 2014. Such efforts aided the messaging and perception of Harpeth Hall to the greater Nashville community, increasing its attractiveness to students of color and from other diverse backgrounds. A cognizant and proactive approach to diversity also helped Harpeth Hall, like many girls' schools, begin to shed the perception that they were schools for only wealthy white students.[417]

The last quarter of the twentieth century was filled with defining moments. On the cusp of a new century, Harpeth Hall emerged with a clearer vision and message in regard to the advantages of single-sex education for girls in a modern world. Administrators carefully navigated educational and demographic trends that, at times, challenged the school's mission and traditions. And yet the school emerged from the 1980s and 1990s with a stronger sense of self and a commitment to greater student body diversity, competitive athletics, and community service. Lola Blackwell Chambless, class

of 1997, was one student who made the most of what Harpeth Hall had to offer bright and hardworking young women. Chambless served as editor of *Milestones*, president of Mu Alpha Theta (math honor society), vice president of Youth in Government, a member of Key Club (service) and a member of the Cum Laude Society. She was also a National Merit Scholar and a recipient of the following awards: Quill and Scroll Award (English), Pickens Science Award, Elizabeth Pope Evans Award (top five academic students in each class) and Director's Award (chosen by the Upper School director).[418]

After Harpeth Hall, Chambless attended Stanford University, graduating with a BS in 2001, and later Vanderbilt School of Medicine, where she earned her MD in 2005. Outside of school, she remained an avid equestrian, representing the U.S. National Team in numerous competitions and later studying traumatic brain injuries in equestrian athletes. Following her chief residency in neurosurgery in 2012, Chambless became the first female attending physician (and later practicing physician) in neurosurgery at Vanderbilt University Medical Center. She joined the department as an assistant professor specializing in neurosurgical oncology and neuroendoscopy. Lola Blackwell Chambless spoke about the role Harpeth Hall played in developing her academic talents as a young woman:

> *Harpeth Hall was great preparation for working* [in a field] *with mostly men, oddly enough. At Harpeth Hall I made friends based on mutual school and sports interests and never worried about how I was perceived. I think taking high school boys out of the equation makes that more possible. Young women sometimes learn to cover up some of their quirks in the interest of fitting in or appealing to boys. When I am in faculty meetings in my department as the only woman present, I really feel the same way that I did in seminars in high school—engaged, ready to give my opinion, and not afraid to say what I think.*

Chambless experienced firsthand the advantages of an all-girls education, as did increasing numbers of young women in and outside Nashville. This unexpected revival of single-gender schools emerged across the nation in the 1990s. As girls' schools evolved with a renewed sense of purpose, certain customs remained intact even as old stereotypes were traded in for more modern notions of education and gender. The Harpeth Hall School would ride this momentum into the twenty-first century.

EDUCATIONAL TOUCHSTONE

The Harpeth Hall School, 1998–2014

They will know what you believe by the way you go about your work and the way you live your life. I love that we foster that attitude here.
 —*Ann Teaff, Head of School, 2014*

In 2001 Jim Collins, a business and management consultant, authored *Good to Great*, which outlined qualities possessed by successful companies and their leaders. While his targeted audience was Corporate America, his arguments resonated with businesses big and small, for-profit and nonprofit. Collins articulated clear criteria for excellence: "Greatness is not a function of circumstance. Greatness, it turns out, is largely a matter of conscious choice and discipline."[419] He also pointed out practices that prevented organizations from achieving greatness, noting that "good is the enemy of great" and "bad decisions, made with good intentions, are still bad decisions."[420]

In 2004 Harpeth Hall's Board of Trustees and administrative team read the book, formed a Good to Great Committee, and proceeded to share the Collins blueprint for best practices with the faculty. Middle School Director Mary Lea Bryant, a board member at that time, delivered a presentation of the book to the faculty, with whom it immediately resonated. The faculty also read Collins's book, drawing inspiration from his ideas and created a faculty committee to design and implement a strategic school plan.[421] The formation of the Good to Great Faculty Committee coincided with a pivotal time and punctuated an important moment in Harpeth Hall's reemergence as one of the top independent schools for girls in the nation. The school's

Southern Association of Colleges and Schools (SACS) accreditation was up for renewal in 2005, and Harpeth Hall was to host the National Coalition of Girls' Schools (NCGS) conference the same year.

Using the book's principles as a guide, the board committee revised the school's mission statement, and the faculty created a new core purpose: "to nurture a sense of wonder, to instill a will and facility for learning, and to promote cultural understanding, environmental stewardship, and service to others." The core purpose concludes that "the pursuit of these goals will inspire students and faculty to combine knowledge with goodness and reflection with action."[422] While not all of the faculty committee's recommendations were adopted by the Board of Trustees and administration, there were many positive outcomes. Faculty proposals for interdisciplinary and collaborative work to pursue a "big idea" received approval for paid summer stipends, and professional development funds were increased. Additionally, the core purpose provided a guiding "North Star" for faculty and students. The book and subsequent committee, according to Upper School Director Jess Hill, "gave us a common language about becoming a better, 'greater' school." Hill also believes that the core purpose remains a significant selling point: "I still talk about the core purpose with prospective families because I think it is a good reminder of the sincere dedication of our faculty."[423]

Good to Great also outlined a five-level hierarchy of leadership. Contrary to popular perception, Collins argued that Level Five leaders were not "larger than life figures" but rather individuals able to "blend extreme personal humility with intense professional will." Collins continued with his research analysis:

> [L]*eadership is not the only requirement for transforming a good company into a great one—other factors include getting the right people on the bus (and the wrong people off the bus) and creating a culture of discipline—our research shows it to be essential. Good-to-great transformations don't happen without Level Five leaders at the helm. They just don't.*[424]

Head of School Ann Teaff (1998–2014) not only possessed qualities required of Level Five leadership, but her vision, energy, and long-range planning completed a journey of reinvention at Harpeth Hall that began with Leah Rhys in the mid-1990s. As the school's chief executive officer, Teaff focused on five main objectives: first, to improve campus grounds and facilities; second, to develop more effective marketing, communication, and advancement strategies; third, to sharpen the mission and identity of the school; fourth, to cultivate a sense of connection and ownership;

and fifth, to enhance pedagogy and technology with a global and service-based focus.[425] The measure of Teaff's success was candidly summed up by Cari Johns, a junior in 2001: "I think Ms. Teaff is a diplomatic leader, and she has made many great changes to our school.... Frankly, she's bumped Harpeth Hall up a notch."[426]

Ann Teaff's long and successful educational career would begin and end in Nashville. After teaching history for nine years at the University School of Nashville (USN), she moved to Maryland, where she worked at Garrison Forest School as the chair of the History Department (1980–88), head of the Upper School (1988–98), and assistant head of school (1991–98). She

Head of School Ann Teaff, 1998–2014.

married Donald P. McPherson III in Baltimore in 1996, two years before accepting the job as Harpeth Hall's fifth head of school. Teaff would build on the work of Souby, McMurry, Wood, and Rhys. She would bring a calming and stabilizing influence, as had Harpeth Hall's first head of school, Susan Souby, and she would also lead a remarkable series of building campaigns and elevate the school's status, as did Sam McMurry. Teaff cherished her relationships with students and enthusiastically supported them as David Wood had done, and her ability to connect with alumnae, the community, and the Board of Trustees picked up where Leah Rhys had left off. Ann Teaff also capitalized on the revival experienced by many girls' schools nationwide in the 1990s.

As one of her first major initiatives as head of school, Ann Teaff hired Genovese Coustenis Foster (GCF), a Baltimore-based consulting firm, to evaluate the school's market position, core messages, audience, marketing, and communications strategies. GCF's report would reshape the school's long-range planning agenda for the next fifteen years. Some recommendations were simple: choose a formal logo and letterhead, create a

Former heads of school. *Left to right*: Ann Teaff (1998–2014), Leah Rhys (1991–98), David Wood (1980–91), and Polly Fessey, Middle School director (1968–89) and interim head of school (1979–80).

new view book for prospective families, develop and display a core message, and adopt a consistent theme for promotional materials. Based on these recommendations, in 2000 the school adopted the now well-known tagline: Harpeth Hall teaches girls to "think critically, lead confidently, and live honorably." Despite GCF's findings of many positive attributes, the analysis also drew attention to historically persistent challenges:

> *The Harpeth Hall School has a vital message to communicate. Students are provided with a well-rounded environment that includes a rigorous academic program, opportunities to flourish as an individual and future citizen through participation in sports and extracurricular and volunteer activities, all under the warm and caring direction of a dedicated faculty and staff. The school sends strong, vibrant leaders into the world.... [But] there are real or perceived notions that Harpeth Hall lacks the stature it deserves in the community.... Recent efforts to increase student racial, ethnic, and socioeconomic diversity have met with limited success.... A major [challenge] is convincing the surrounding community and prospective families of the value of an education that prepares girls to become leaders in our society.... There is also evidence that some within the school community may not place achievement by girls on equal footing with achievement of boys.*[427]

A U.S. Department of Education Report published in 2005 reflected many of these findings on a national scale. The study reported that girls in single-sex environments held an advantage over girls in coeducational settings in the following areas: scores on subject achievement tests, educational and career aspirations, graduation rates, community and political involvement, and attitudes regarding working women. However, the report also reaffirmed the lack of socioeconomic and racial/ethnic diversity of both boys' and girls' single-sex schools. Moreover, the report concluded that the single-gender environment did not foster greater self-esteem and that sex stereotyping persisted in 50 percent of the studies evaluated.[428]

From 1998 to 2014, Harpeth Hall's trustees and administrators worked diligently and resolutely to make Harpeth Hall a place where girls' self-esteem and self-worth were equally valued when compared to other independent schools in Nashville, including its brother school, Montgomery Bell Academy. Both Teaff and the Board of Trustees believed that the physical grounds should reflect the importance of girls' education through a beautiful campus with first-rate facilities. Over the next thirteen years, Harpeth Hall's

An aerial photograph taken circa 1965 of the Harpeth Hall School campus with Souby Hall, "Little Harpeth" classroom building, Bullard Gymnasium, and the original Louise Bullard Wallace Educational Building.

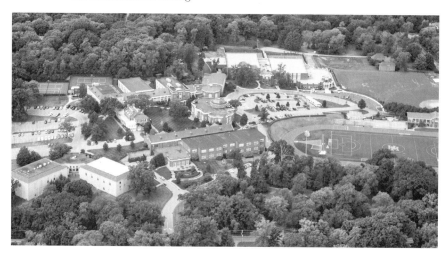

An aerial photograph taken in 2014 of Harpeth Hall School, with Souby Hall located in center of campus along with the Ann Scott Carell Library. West of Souby Hall is the Jack C. Massey Center for Mathematics and Science, Bullard Gymnasium, Hortense Bigelow Ingram Upper School, and Patton Visual Arts Center. South of Souby Hall is the Idanelle McMurry Center for Arts and Athletics and the new Daugh W. Smith Middle School. North of Souby Hall is the Dugan Davis Track and Soccer Complex, Athletic and Wellness Center, synthetic turf field, athletic fields, and undeveloped additional property acquired in 2014.

buildings and grounds were visibly transformed into an impressive campus from every angle. With virtually no building left untouched, Teaff's tenure would include six new construction projects and major renovations to two existing structures.

Carol Clark Elam, class of 1966, served as board chair from 1998 to 2000, and her passion and vision for Harpeth Hall's future created a firm foundation from which Teaff and trustee leaders would launch bold construction and fundraising initiatives. Sadly, Elam did not see the first new building completed, as she passed away in December 2000. On November 18, 2001, the Ann Scott Carell Library, the first major building project in more than a decade, was dedicated and replaced the Annie C. Allison Library built in 1966. Constructed on the same site as the previous library, the new building featured twenty thousand square feet of space and doubled the size of the collection from fourteen thousand to twenty-eight thousand volumes.[429] Funding for this state-of-the-art facility was made possible through an unprecedented and transformative $5.3 million gift from Ann and Monroe Carell. Ann Scott Carell was a Board of Trustees member and

The Ann Scott Carell Library remains a centerpiece on campus. Completed in 2001, the building was a gift from Ann and Monroe Carell.

mother of two graduates: Julie Carell Stadler, class of 1977, and Edie Carell Johnson, class of 1980.[430] The Ann Scott Carell Library continues to serve as the heart of the school and the "information and technology hub of the campus, housing traditional library services along with the school's network and technology support team."[431]

In March 2003, the Patton Visual Arts Center opened—another transformative $5.1 million gift from alumna Robin Ingram Patton, class of 1984. The building included art studios, galleries, a photography classroom, a darkroom and studio, media arts and art history classrooms, and a 125-seat lecture hall.[432] These two buildings, constructed through large gifts by dedicated stewards of the Harpeth Hall community, reflected a new era in which alumnae, patrons, and parents collectively affirmed the school's single-gender mission. Harpeth Hall hosted a fiftieth anniversary gala on its present campus in 2001, headlined by Amy Grant and Vince Gill, which showcased the school to the larger community. Many community members, regardless of their affiliation with the school, began to see firsthand that they were investing in an institution grounded in tradition but also on a course to secure its position as a top girls' independent school. Also in 2001, Martha Ingram, chairman of Ingram Industries, philanthropist, and mother of alumna Robin Ingram Patton, made a $5 million gift to increase the school's general endowment.

From its inception, the Daugh W. Smith Middle School had featured two small buildings connected by a covered breezeway. In 2002 the Harpeth Hall

The Patton Center for the Visual Arts was completed in 2003, a gift from Robin Ingram Patton, class of 1984.

Board of Trustees began to plan for a Middle School makeover as part of a long-range plan to increase enrollment and provide adequate space for grades five through eight. The old buildings were demolished, and a new complex was built that also housed an expanded dining hall, conference rooms, offices, and archival exhibits. The fifty-six-thousand-square-foot Middle School building was made possible by the gifts of many donors. The lead gift was given by the Joe C. Davis Foundation in honor of the Harpeth Hall faculty.[433]

The new Daugh W. Smith Middle School was completed in 2004.

The newly expanded Daugh W. Smith Middle School was dedicated in August 2004 under the leadership of Ann Teaff and Middle School Director Betsy Malone. Malone, who began as a science teacher in 1975, succeeded Lindy Sayers in 1998 as the head of the Middle School. As one student remarked, "Mrs. Malone leads, guides, and endures."[434] The mission of an all-girls school clearly resonated within the Nashville community, as Middle School enrollment at Harpeth Hall increased from 186 in 2000 to more than 270 students, an all-time high, in 2014.[435]

A fourth project, the Dugan Davis Track and Soccer Complex, was completed in December 2003—constructed through a gift from Joe C. Davis in honor of his mother and former faculty member Dugan Davis. Joe's sisters—Anne Davis (class of 1973), Elizabeth (Beth) Bond Davis (class of 1974), and Mary Patricia (Pat) Davis (class of 1982)—were also contributors. Dugan Davis was an adored English teacher from 1972 to 1985 who also established and coached the varsity soccer team in 1980.[436] In 2007 Joe Davis funded the installation of a synthetic turf field, the first at any all-girls school in Tennessee.

Finally, in 2004 the Jack C. Massey Center was renovated thanks to gifts from Alyne Massey, Barbara Massey Rogers, and the Jack C. Massey Foundation, and in 2006 the Louise Bullard Wallace Educational Building was taken down to its structural beams and expanded to more

Martha Ingram, Chairman-Emerita of Ingram Industries, honorary trustee, philanthropist, and advocate for single-gender education, with Head of School Ann Teaff and students, 2002.

than thirty-five thousand square feet.[437] At the same time, the Wallace and Massey buildings were connected with a sweeping activities hallway and administrative corridor that included offices and conference rooms. Lead gifts from Martha Ingram, John Ingram, and Robin Patton made the renovations possible, and the high school was renamed the Hortense Bigelow Ingram Upper School in memory of Mrs. Ingram, a dedicated founding trustee and educational partner for more than twenty years.[438] Supportive families and alumnae, stalwart in their support of single-gender education, propelled Harpeth Hall's mission for academic excellence and distinction into the twenty-first century.

After seeing the new library, one fifth grader remarked, "All this for us?" The beautification of the campus served to elevate students' sense of self-worth and reinforced the value placed on girls' intellectual growth and personal development. The physical transformation of campus was due, in large part, to alumnae donors and community leaders with ties to the school. In addition to major gifts, Harpeth Hall remains the fortunate beneficiary of thousands of successful graduates who have generously given back to their alma mater. Parents and faculty/staff have also played a large role in supporting the school through annual

fund contributions, averaging approximately 90 percent participation from both groups.

The role of fundraising has remained crucial to Harpeth Hall's success over the last two decades. In 1993 Harpeth Hall had initiated a "quiet" campaign that focused on a selected number of major donors with an initial goal of $7.6 million.[439] Dianne Buttrey Wild, class of 1966 and director of alumnae relations from 1989 to 1997, noted that this first major endowment campaign led to a sense of empowerment as they worked to establish and reestablish relationships with donors. Reports from a 2000 national survey revealed that boys' schools were more financially prosperous than all-female institutions. On a national scale, prior to the mid-1990s, married female alumnae contributed far less money on average to their alma maters than their male counterparts, for several reasons: first, less control over household wealth; second, less familiarity with financial decisions; third, less aggressive campaigning and fundraising by girls' schools; and fourth, lack of awareness of the essential role of consistent giving needed for institutional stability and growth.[440]

Beginning in 1993, Harpeth Hall's Development Office began reversing these trends by making endowment and annual fund campaigns more visible, hosting reunion weekend events, publishing an alumnae magazine, emphasizing community outreach, and cultivating relationships with potential donors. Wild recalled annual phone-a-thons held in the library in the mid-1990s before the Internet revolution. In 1998 Sallie King Norton, class of 1971, was named director of alumnae relations. Norton's efforts alongside Beth Boord, director of advancement, led the renamed Advancement Department into the twenty-first century armed with new tools—computers and the World Wide Web. Harpeth Hall's financial trajectory grew brighter but still lagged behind other top-tier independent schools. In 1997 the school's endowment stood at $6.7 million, while Montgomery Bell Academy's endowment was $32.4 million. Harpeth Hall also fell short when compared to the endowments of other prominent girls' schools, such as Hockaday School in Texas ($54.4 million), the Madeira School in Virginia ($31 million), and Girls Preparatory School ($13.8 million) located in nearby Chattanooga.[441]

Harpeth Hall hired a consulting firm in 1998 to assess administrative departments. Particularly the alumnae/development office, ably led by Polly Nichols from 1973 to 2000, had outgrown its organizational structure and needed a clearer delineation of agency and authority.[442] As a result, a director of advancement position was created as the head of three departments: Advancement, Annual Giving, and Alumnae Relations. Led by these new departments and trustees Edie Carell Johnson, class of 1980; Robert F.

McNeilly Jr., board chair from 2001 to 2004; and Jean Ann Banker, the school began the "Campaign for Harpeth Hall" in 2000, which ended in 2005 after raising $44.2 million.[443] The campaign was one of the most successful fundraising efforts for a girls' day school to date.

Susan Moll, appointed director of advancement in 2007, noted, "Wealth creation was happening in the late 1990s and early 2000s. The school's timing was ripe to seek additional gifts. People gave with a sense that they were sharing their wealth and investing in something lasting and worthwhile. They gained a sense of ownership."[444] This phenomenon was occurring at girls' schools nationwide in the early 2000s as schools cultivated new approaches to form lasting relationships, implementing more sophisticated and specific fundraising strategies and establishing early bonds with young alumnae. As Virginia's Foxcroft School's Head of School Mary Lou Leipheimer reiterated, "Women don't give to competition; they give to connection. Why are we surprised by that? It's how they learn too."[445] In sum, Harpeth Hall raised more than $87 million from 1998 to 2014.

Improving and enhancing technology was another goal of the Teaff era. The newly created position of director of the Department of Library and Information Services was first held by Nancy Rumsey, followed by Karen Douse, who served from 2000 to 2012. Efforts in the 1990s spearheaded by then Head of School Leah Rhys and board member and alumna Paula Hughey, class of 1966, initiated an on-campus infrastructural expansion that made technological growth possible. In addition to serving on the Board of Trustees at Harpeth Hall, Hughey was also a member of IBM's development division and served on the company's education committee.[446] By 1997 the school had installed a campus-wide network and computer labs, and in the fall of 2000, Harpeth Hall introduced a laptop initiative into the curriculum. Each student purchased a laptop computer, which was provided and maintained by the school's expanded Technology Department, whose offices were affectionately named the "Bear Cave." Harpeth Hall was one of the first schools, independent or public, to introduce a 1:1 laptop program. Betsy Malone, director of the Middle School from 1998 to 2008, described the importance of introducing the student laptop program in 2002: "At Harpeth Hall, we prepare young women to be community leaders…[W]ith this technology program, our students learn the value of investing in and connecting to their community."[447]

Technology has remained a centerpiece of Harpeth Hall's curriculum and vision. Most notably, Ann Teaff, Karen Douse, and Molly Rumsey were instrumental in the establishment of the Online School for Girls

(OSG) in 2009. The OSG was founded as a web-only, nonprofit consortium that began with four all-female college preparatory schools: Harpeth Hall School, Holton-Arms School (Bethesda, Maryland), Laurel School (Cleveland, Ohio), and Westover School (Middlebury, Connecticut). These institutions came together with common beliefs that online education served as an increasingly powerful way to learn and that an online environment specifically geared toward girls would reinforce common goals of connection and interaction, collaboration and creativity, and real-world application with a global focus.[448] The OSG allows students at Harpeth Hall, across the United States, and internationally to take classes that are not offered at their current schools. From 2009 to 2014, OSG enrollment numbers and courses doubled and expanded to more than eighty participant schools.[449]

Technology has also played a pivotal role regarding marketing and communications at Harpeth Hall. By 2000 the school's website provided prospective families with information before they ever stepped on campus. Harpeth Hall's front door was virtually opened to a much wider audience, and the website also became an information portal for students, parents, and alumnae. In addition, Harpeth Hall's biannual magazine was upgraded to all-color in 2006 and redesigned in 2014. Director of Communications Joanne Mamenta noted, "The objective

Members of the class of 2016 use their laptops to complete an assignment in Dr. Mary Ellen Pethel's world cultures class.

of *Hallways* is to connect alumnae, current families, prospective families, friends, and donors to the school through engaging articles about the school's academics, arts, athletics, and co-curricular programs, as well as success stories and events involving our alumnae."[450] By 2014 the circulation for *Hallways* had increased to nearly 7,700 households, in addition to an electronic weekly newsletter. Beginning in 2008, the school began to leverage social media platforms to increase its presence in the community. In 2010 Harpeth Hall created a video channel hosted by Vimeo and a Facebook page. Two years later, the school debuted on Instagram and Twitter with the handle @HarpethHall. In a world where marketing and media have become ubiquitous, Harpeth Hall remains closely connected and engaged with the school community and the public. Ultimately, however, the best marketing for Harpeth Hall continues to be satisfied families and appreciative alumnae. Despite these technological innovations in marketing, more than 60 percent of prospective families and applicants continue to hear about Harpeth Hall through community connections and testimonials.[451]

With an increasingly competitive applicant pool since the early 2000s, school admissions and financial aid also play a major role in attracting the best students and, in turn, ensuring the success of the school. Dianne Wild began her career at Harpeth Hall as a psychology teacher and part-time counselor in the 1970s. Following her role in development, she moved to admissions in 1998 and was named director of admission and financial aid. As Wild remarked, "From my days as a high school student taking classes in Souby Hall to my career here in the offices of advancement and admissions, I've spent nearly forty years in this building."[452] The Admission Department's expansion has allowed Harpeth Hall to offer a personalized admission process with a number of touch points, including a longer "admission season," multiple prospective parent sessions, increased school visits for prospective students, full-campus open house, admission preview days, interviews, and enhanced ambassador programs. Enrollment and financial aid figures reflect their efforts. Since 1999 enrollment has grown 28 percent from 532 students to 685 students in 2014.

Financial aid remains a large part of the admission process and helps to determine the composition of the student body. Socioeconomic diversity efforts are also largely tied to financial aid and the admissions process. The 1996 financial aid budget was $285,000, and the average award was $3,850. By 2014 the financial aid budget exceeded $1.66 million, with an average award of more than $13,000. The percentage of students receiving financial aid increased from 10 percent to 18 percent during those same

years. The enhancement and expansion of the admission and financial aid processes have remained top priorities since 1996. Over the past two decades, enrollment numbers have steadily risen, financial aid funding has increased an astounding 486 percent, and attrition rates remain low at about 3 percent. While the percentage of ethnically and racially diverse students has more than doubled from 6 to 14 percent of the student body, Harpeth Hall continues to make student diversity a priority. Crissy Wieck Welhoelter, class of 1996, noted that "the quality of the student body only increases when…the diversity of background, thought, and experiences are as rich and varied as possible."[453]

Ann Teaff's reorganization of administrative departments, including Advancement, Communications, Library/Information Services, Admissions, and Financial Aid, provided a clearer focus and chain of command that would pay dividends to the school's long-term viability. After ten years at the helm, Teaff faced her greatest tests as an administrator: the uncertainty surrounding the opening of the high school division of the Ensworth School in 2004 and the Great Recession that began in 2007.[454] Despite these challenges, for the next seven years Harpeth Hall pressed forward with proactive outreach and assertive fundraising campaigns that led to additional building projects, property acquisition, expansion of curricular offerings, and increased enrollment and financial aid. In fact, neither the new competitor school nor the economic recession greatly affected Harpeth Hall.

In 2005 the school turned its attention to athletics and wellness and began a planning process designed to address the need for greater and more modern facilities for girls' sports, physical education, and other wellness activities. Led by Susan Willingham Simons, class of 1960 and board chair from 2004 to 2008, a new athletic facility, fitness center, tennis courts, and athletic fields were proposed. Despite the Great Recession, Harpeth Hall's administration and Board of Trustees, chaired by Dr. Nancy Graves Beveridge, who began her term in 2008, made a crucial decision to initiate a new campaign in December 2008. Director of Advancement Susan Moll recalled:

> *"The Next Step" campaign gave me a glimpse of what it must have been like to fundraise during the depression of the 1930s. I think in 2008 if we had stalled or delayed, we would have lost a great deal of momentum. We needed to ask, and sometimes we had to wait until our donors were in a position to feel secure about their finances. It took some time, but if we had not pressed forward, we would not have been true to our mission of unconditional commitment to academic excellence. We live in a very*

generous community, and Ann Teaff helped to articulate the importance of girls' education. Her efforts have been invaluable in keeping the education of girls a top priority.[455]

The Athletic and Wellness Center opened in January 2014, due in large part to a lead gift made by the Patton family. Eight months later, "The Next Step" achieved its goal of raising $35.6 million by August 2014.[456] Athletic participation and success have continued in the post–Title IX era at Harpeth Hall. However, Morrison and Bullard Gymnasiums lacked adequate spectator space, locker rooms, and regulation ceiling height for volleyball. Yoga classes were taught in a cramped upstairs room, while space for coaches, trainers, storage, and concessions remained minimal. The student body could no longer fit comfortably into the gymnasiums built in 1952 and 1977. The Athletic and Wellness Center alleviated these issues by providing a sixty-thousand-square-foot facility housing two gymnasiums, weight and fitness rooms, a yoga space, two multipurpose classrooms, offices, locker rooms, a spirit store, concessions, archival displays, and the Harpeth Hall Athletic Hall of Fame.[457] Harpeth Hall's new facility was also a reaction to the growth in college athletic scholarships for women. The *Chronicle of Higher Education* stated in 2012, "Nearly 200,000 female athletes will suit up this year on 9,274 NCAA teams. That's an average of 8.7 women's teams per college—the highest number ever."[458]

The new facility offered space for wellness and personal health that benefited the entire student body while also accommodating the growth of sports teams over the last decade. The number of teams for grades five through eight increased with a newly implemented "all play" policy whereby any girl who desired to participate in a sport was able to join a team. Nationally, the total number of high school girls involved in sports rose from 300,000 in 1971 to 2.4 million in 1996 to 7.7 million in 2013. Over the last forty years, female participation rates in sports have increased from less than 8 percent to more than 40 percent of all high school sports.[459] Harpeth Hall boasts forty-four Middle School and Upper School athletic teams, and nearly 70 percent of students participated on at least one athletic team in 2014.[460] Participation in athletics and wellness has more than doubled the number of coaches, physical education teachers, and members in the athletic department over the last twenty years.

Since 1975 Harpeth Hall has won an astounding fifty state championships in nine different sports. In the last fifteen years, track and field, cross-country, swimming, and lacrosse have dominated—winning a combined eighteen state

championships. Notably, the lacrosse team, coached by Legare Vest, gained varsity status in 2002, winning four state titles since, and Polly Linden's swim team, known as the Bearacudas, holds the record for the most consecutive girls' state championships (2001–7) in Tennessee high school swimming history.[461]

While most administrative departments have grown considerably, the Upper and Middle School administrative teams have remained concentrated into key leadership positions. An Upper School dean of students position was created in 1998 during the brief tenure of Steve Chapman. This position, held for sixteen years by alumna Marie Dodson Maxwell, class of 1964, assists with student clubs, trips, discipline, and extracurricular activities. In 1999 LaVoe Mulgrew was named Upper School director. Mulgrew, formerly an English teacher, was well-known for her quick wit, and one alumna remembered her as "industrious, forthright, and intelligent" and a "favorite among students."[462] Mulgrew brought much-needed organization and structure to the Upper School but remained always approachable, quickly gaining the respect of both students and faculty.

Jess Hill, Upper School director, began at Harpeth Hall as an engaging and effective math teacher (1985–88, 1998–2005). Currently in her tenth year at the helm, Jess Hill remains a consummate leader at the Harpeth Hall School. She is the high school's longest-serving academic administrator since Susan Souby. Her decade of leadership has provided a sense of enthusiasm, consistency, inclusion, and attention to detail in the Upper School. Since 2005 Hill has also added transparency and accountability to the Honor System, Honor Council, and Discipline Committee. In 2009 the Middle School also gained new leadership when Mary Lea Bryant was appointed Middle School director. During her tenure, the Middle School has continued to grow, and Bryant maintains an active role in the life and culture of the school. Bryant has contributed to Harpeth Hall for many years—first as a graduate of the class of 1972 and later as a parent, board member, and Middle School counselor. Other integral members of the Harpeth Hall family over the years include administrative assistants. For a combined three decades, Nan Reed, Sally Mabry, Ginger Horton, and Margie Martin provided direction, support, and a friendly face to all who passed their desks.[463]

In the classroom, a philosophical and pedagogical shift occurred in the first decade of the twenty-first century. Mirroring national educational trends, learning in the classroom began to move from the traditional teacher "sage on the stage" model to a more student-centered model. Socratic-style seminars, called "Harkness discussions," remain commonplace in most

Harkness-style discussion takes place in Dr. Jim Cooper's American history class, located in the Louise Bullard Wallace Educational Building, 2007.

Opposite, bottom: In 2013 eight students and two chaperones traveled to Lwala, Kenya, during Winterim to support girls' education initiatives through the Lwala Uniform Initiative, providing new uniforms to 1,100 sixth-grade girls as incentives to stay in school. *Left to right*: students McCall Hagler, Rebecca Pirkle, Kathleen Lang, and Catherine Andrews.

disciplines as students engage in intellectual conversations facilitated by the teacher. Harpeth Hall's Middle School has focused particular attention on developing an active, project-based learning approach that encourages student interaction and collaboration. Both the Middle and Upper School divisions have also stressed STEM (science, technology, engineering, and math). Introductory classes in engineering and anatomy and physiology were added to the Upper School science curriculum in addition to many new STEM course offerings and internships available during Winterim. Moreover, Harpeth Hall students can pursue STEM-related independent study through a partnership with Vanderbilt University. Harpeth Hall also hosts STEM conferences and consortiums for educators and a Summer Institute for Nashville students led by Dr. Stacy Klein-Gardner, director of the Center for STEM Education for Girls.[464]

In addition to STEM education, Harpeth Hall's mission also seeks to emphasize global awareness. Global education and global awareness continue

Middle School students utilize QR code technology and computers to complete a cell construction project in Bekah Hassell's science class, 2013.

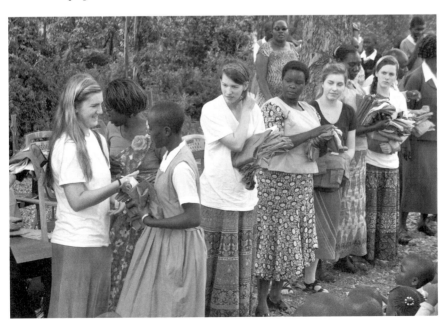

to bring a sense of individual and collective responsibility to Harpeth Hall students. Since 1998 educational trips and internships have ventured beyond traditional Western Europe to include China, Japan, South Africa, Uganda, Australia, Ecuador, India, and Cambodia. Beginning in 2000, Harpeth Hall established student exchanges with schools in South Africa, France, Spain, Germany, and China. In 2011 Harpeth Hall and the Lwala Community Alliance in western Kenya formed a strategic partnership to support girls' education in the rural village of Lwala. Six years after her graduation, Mary Lucille Noah, class of 2008, spent time in Tanzania working with the United Nations (UN) Criminal Tribunal for crimes committed in the Rwandan genocide in 1994. Noah attributed her base knowledge of this human atrocity to a social science course taught by History Department chair Tony Springman her senior year. She also attributed experiences at Harpeth Hall as reasons for her selection: "Both of my Winterim experiences came up when I was interviewing in that I mentioned I had been to South Africa during my junior year and had visited the UN in New York City several times during my senior year Winterim experience with Fox News. It's amazing how those things stick with you."[465]

International exchanges and travel were only part of Harpeth Hall's move toward greater global awareness in the early 2000s. A Green Team Committee, composed of students, teachers and administrators, formed in 2007 to discuss and implement ways to reduce the school's carbon footprint and promote awareness of environmental issues. On the curricular level, the Science Department added environmental science and ecology courses. The Social Science Department dropped its standard European history requirement and added required courses in world history and world cultures, as well as elective courses in modern global issues and world religions. Mandarin Chinese was added to the World Language Department in both Middle and Upper divisions. A new interdisciplinary course, "The Water is Wide," was introduced in 2014—designed to explore issues of water-related natural disasters and human response on local, national, and international levels. Likewise, a Global Scholars Program was approved in 2014, designed to provide students with a curricular and extracurricular focus on service, club involvement, internships, and projects based on cross-cultural connections and interdisciplinary modes of thinking. All of these initiatives support Harpeth Hall's revised mission statement to "develop responsible citizens who have global perspectives and make meaningful contributions to their communities and the world" and to "promote cultural understanding, environmental stewardship, and service to others."[466]

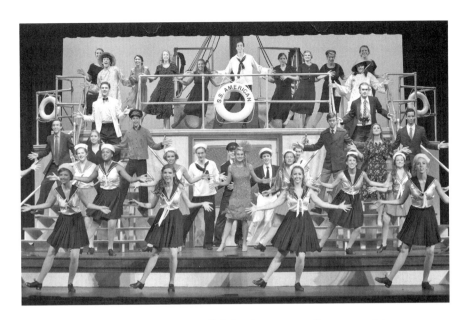

Harpeth Hall School and Montgomery Bell Academy partner for many social events, service projects, and theatre performances. With a proud tradition of theatre and music at Harpeth Hall, one of the annual highlights is the collaborative fall musical, which began in 1998. The 2013 performance of Cole Porter's *Anything Goes* was a smashing success. The director of theatre at Harpeth Hall is Janette Fox Klocko (1988–present).

Much of the school's global focus is centered on another part of its mission and core purpose to provide learning through service. An emphasis on service learning began during the tenure of David Wood, and service remains an integral part of the Harpeth Hall experience. In the spring of 2000, Harpeth Hall was one of only sixty-six schools nationally, and the only one in Middle Tennessee, to be given the National Service Learning School Award. Since 2007 nearly all school-sponsored domestic and international trips have included a service project. Athletic teams and student clubs have service representatives coordinated by the Student Learning Leadership Council. The service program "cultivates leaders and inspires a life-long tradition of service," which includes students from both the Upper School and Middle School. ACTnow, a service club led by English teacher Scottie Girgus, published a book in 2011 entitled *Living on the Edge: Homelessness in Nashville*, and the club continues important work with marginalized groups in Nashville. While service is voluntary and not required, 100 percent of students have participated in service projects since 2005 and contributed more than seventeen thousand service hours in 2013 alone.

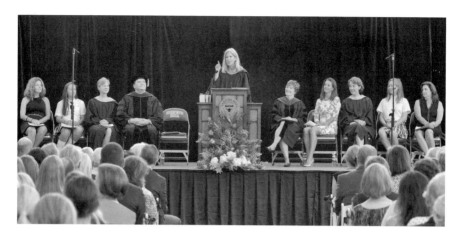

The investiture of Stephanie Balmer was held on September 5, 2014, in the new Athletic and Wellness Center. Other guest speakers on stage include, from left to right, Crissy Wieck Welhoelter, president of the Alumnae Association Board and class of 1996; Ana Gonzalez, class of 2019; Mary Lea Bryant, Middle School director and class of 1972; Dr. Doug Christiansen, vice provost for enrollment and dean of admissions at Vanderbilt University; Emily Cate Tidwell, chair of the Board of Trustees and class of 1975; Reverend Lissa Smith of St. Augustine's Chapel at Vanderbilt, class of 1991; Jess Hill, Upper School director; Annika Brakebill, class of 2015; and Martha Gorham, president of the Parents Association.

At the end of the 2013–14 school year, Ann Teaff retired after sixteen years of leadership. Her final year was memorable and included the completion of the new Athletic and Wellness Center and the dedication of the Ann Teaff Quadrangle. With anticipation and excitement, the Board of Trustees announced Stephanie Balmer as the new head of school in October 2013. Dr. Nancy Graves Beveridge, Board of Trustees chair and class of 1980, stated, "Stephanie Balmer is a strategic thinker who understands Harpeth Hall's culture, mission, and vision for the future. She will be an excellent leader and will contribute greatly to Harpeth Hall's reputation for academic excellence and innovation."[467] Balmer's single-gender educational experience began at Agnes Scott College, an all-female institution located in Atlanta, Georgia. Agnes Scott was founded in 1889 and is considered one of the "Seven Sisters of the South." At Agnes Scott, Stephanie Balmer served as the associate vice president for the Department of Enrollment and dean of admission and financial aid from 1991 to 2008, leading the school to record enrollment numbers, improved academic programs, and greater student diversity.

Following Agnes Scott, Balmer accepted the position of vice president for enrollment, marketing, and communications and dean of admissions

at Dickinson College in Carlisle, Pennsylvania. Experience in higher educational leadership and administration has given Balmer a skill set that includes strategic planning, public speaking, and nonprofit management. Moreover, she recognizes the goals and expectations of the modern independent college prep school, as well as the importance of providing an exceptional education for young women. In her first letter to the Harpeth Hall community, Balmer noted:

> *As a mission-driven school, it is incumbent upon us to provide our students with an expansive and rigorous educational program with contemporary applications and to develop creative problem solvers who will be prepared for an uncertain and rapidly changing world. Our commitment to student mastery of twenty-first-century skills and to a caring community of learning combine to create an educational environment where students thrive as engaged and enthusiastic learners.*[468]

Stephanie Balmer is also the first head of school to have a daughter enrolled while serving as chief administrator since Ward-Belmont's Dr. Ira Landrith. More than a century after Grace Landrith, class of 1916, Isabel Balmer joined the seventh grade as part of the class of 2020.

And so, the story of Harpeth Hall School begins another chapter under new leadership and with the school transitioning to yet another generation of teachers, leaders, and students. Today's students have never lived without the Internet or remember a time before smartphones or social media. The digital revolution continues to change education and society as smart devices and wearable technology, such as the Apple Watch, promise to once again transform the ways in which we communicate, live, and learn. Moreover, the class of 2019 will mark the first graduating class born after 9/11.

Nearly three decades ago, in 1988, then Head of School David Wood outlined the characteristics of a successful school:

> *It is difficult to ascertain exactly what makes a great school. Certainly there must be an outstanding faculty and a capable administrative staff. The parents must be supportive of the school. There must be many extracurricular offerings available, and the students must be willing to work and take advantage of what is offered. The plant needs to be modern and complete. The trustees must give freely of their time, provide wisdom, and raise the resources to run the school. Finally, the school must have loyal, interested, and enthusiastic alumnae whose accomplishments bring pride to their alma mater. Fortunately, Harpeth Hall has*

all of these ingredients. Yet there is also an extra intangible spirit possessed by our students and faculty, and it permeates our entire school. You can feel it just by being on the campus. There is excitement here.[469]

A generation later, Wood's words still resonate. Harpeth Hall's ability to stay relevant in the 1980s and early 1990s as a single-gender school was due to the dedication and support of students/parents, faculty/administration, alumnae, and the board. Harpeth Hall, like many girls' schools, emerged at the turn of the century with a renewed sense of purpose that complemented the school's strong academic and extracurricular programs. With a new message proclaiming that Harpeth Hall teaches young women to "think critically, lead confidently, and live honorably," the school joined a growing chorus in independent education. No longer were all-female schools "educating girls as a way to keep them out of trouble with boys; nor were they doing it simply because it was a precious tradition that had been passed from mother to daughter."[470]

This revival of single-gender education was noted by a 2009 study published by UCLA's Graduate School Education and Information Studies. The study acknowledged recent trends: "[I]nterest in single-sex education has been on the rise over the past two decades…. Sex-segregated schools and classrooms are viewed by many as a possible antidote to gender inequities…. Others raise concerns that [such schools] run the risk of reinforcing sex-based stereotypes."[471] Harpeth Hall has worked vigorously over the past twenty years to combat gender stereotypes and inequities, so much so that some students take for granted the consistent and persistent "girl power" message promoted by the school.

In order to be successful in the twenty-first century, Harpeth Hall capitalized on the premise that girls' schools were best-equipped to handle the educational, physical, and emotional needs of young women. Harpeth Hall also maintained pace with other independent schools in regard to educational technology, a more global curriculum, and state-of-the-art facilities. For current and prospective students, the school offers the total package, including opportunities for participation and leadership in and out of the classroom and experiential learning on and off campus. And yet Harpeth Hall has shown that an institution can build on its historic foundation while renovating the institutional structure. Tradition and progress can be a powerful combination. One thing remains clear: Harpeth Hall relishes its rich history and traditional ties. However, in order to maintain and bolster its reputation, the school has combined a new vision with venture and innovation. The school has truly transformed from good to great.

Epilogue

CELEBRATING 150 YEARS AND THE STATE OF GIRLS' EDUCATION

May Harpeth Hall always change and never change.
—Penny Mountfort, Dean of Faculty, 1985

Head of School Stephanie Balmer opened the 2014–15 convocation ceremony with remarks that reaffirmed the school's mission while challenging current students:

> *Take time to think about this year and beyond. Ask yourself, "What kind of person am I becoming or do I aspire to be?" Often times we spend our time trying to answer* what *we will become—a lawyer, dancer, doctor, engineer, artist, businesswoman, educator, and so on. We should also spend as much time thinking about* who *we will become. What kind of friend, daughter, student, and woman will I be? As a school we will also ask important questions—how does a great school become even greater? What are the attributes of Harpeth Hall on its best day?…. We will take time this year to celebrate the accomplishments of this great school…and find ways to shine a light even brighter on areas of the school where there is a story to be told.*[472]

The story of Harpeth Hall is one of resilience, renewal, and excellence. It is a story of all girls. The school's mission has remained the same since 1865: to educate young women. However, the means and ends have changed. Instead of courses in domestic science, elocution, and letter writing, students build

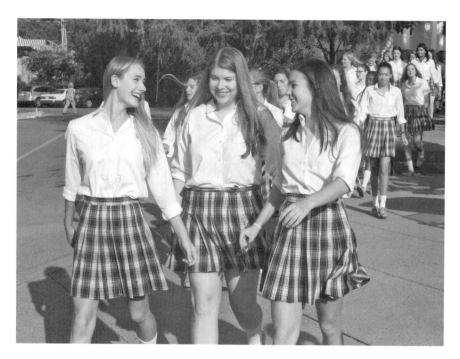

Students walk to opening convocation to begin the 2014–15 school year, led by Margot Dupuis, Ashlyn Dentz, and Delaney Jacoway, class of 2016.

Middle School Orchestra, 2011.

formula-filled Excel spreadsheets in economics, design 3D printer projects, debate current issues with vigor, and gush with excitement after acing their Advanced Placement calculus exam. And yet traditional elements remain steadfast components of the curriculum and school culture. Students no longer bow and curtsey, but Harpeth Hall takes pride in classical offerings in Latin and literature, and students excel in dance, theatre, and music. The school continues to emphasize the importance of service, integrity, collaboration, respect, and courtesy.

In 2004 author Illana DeBare explained the challenge of balancing progress and tradition: "[S]chools have started to look more critically at their expectations of girls' behavior and give girls more room to be noisy, messy, or brash…. Girls' schools traditionally reinforce 'niceness.'"[473] This is true, but certain tenets of education remain timeless. Students may be polite and respectful, but they are also competitors, critical thinkers, global citizens. "Niceness" should not be confused with amiability or civility as society still grapples with a cultural ambiguity surrounding female assertiveness. The role of educated women in American society will continue to evolve, but the goals of girls' schools today are to provide students with the academic tools and inter/intrapersonal skills to accomplish any goal set before them. At Harpeth Hall, smart is cool, hard work is expected, and confidence is compatible with courtesy. Strength of character and civility are not gender-specific.

Some would argue that the twenty-first century has created a culture of perfectionism with unfair expectations for young people, particularly girls. Harpeth Hall, like many girls' schools, minimizes some of these cultural demands through uniforms, which were introduced in the 1970s, as well as traditions and rituals that promote a spirit of sisterhood. Ann Teaff modernized certain traditions such as George Washington Day, where Martha Washington now has a speaking role, but also created new ones, such as eighth-grade and senior speeches. The quest for excellence can place unintended pressure on students to be the best student, athlete, artist, dancer, and musician. Top-tier college preparatory schools can at times send mixed messages to their students to be the best and brightest while remaining happy, healthy, and balanced. This is especially true for girls who participate in multiple extracurricular activities while also managing demanding academic schedules. In a society that focuses heavily on achievement and appearance, both parents and schools encourage students to be involved.

Ironically, the pursuit of perfection can be detrimental to a girl's self-confidence and sense of worth, two qualities that ideally give girls' schools

Dr. Merrie Morrisey Clark, class of 1969 and Social Science Department faculty (1976–2009), and students celebrate another successful performance of the George Washington Day Celebration. Following Patty Chadwell's retirement in 1982, Dr. Clark helped to direct the celebration alongside Leslie Matthews and Susan Russ for more than twenty years. At Ward-Belmont, the event was performed by college students and later moved to the high school. In 1954 Patty Chadwell revived the tradition at Harpeth Hall with the freshman class. The seventh grade has performed this theatrical production featuring dance, song, and short monologues since 1982.

an advantage. Pulling an "all-nighter" to study for a test, participating in one too many extracurricular activities, or taking multiple AP classes ultimately can push students beyond the point of diminishing returns. In recent years, Harpeth Hall has set specific goals and implemented action steps to be more aware, proactive, and responsive to common triggers of student stress. As a college-preparatory school, Harpeth Hall seeks a healthy balance between what society demands of young people and how the school prepares its students to achieve professional and personal success while remaining lifelong learners.

Of course, the desire to make good grades remains ever present. Moreover, the pressures of getting into and attending the "right" college are also much greater for students in 2015 than they were even thirty years ago. Today's students do not wonder *if* they will go to college—they agonize over *where* they will attend. They typically visit and apply to a host of schools, request recommendations from teachers, and painstakingly write college essays.

Class of 2013, College T-Shirt Day.

Increasingly competitive college admissions and costly tuitions amplify student anxiety about high school course selection, club participation, SAT/ACT testing, Advanced Placement (AP) courses, and grade point averages (GPA). In a 2013–14 survey of college tuition and expenses, the College Board reported that a "moderate college budget for an in-state public college for the 2013–2014 academic year averaged $22,826. A moderate budget at a private college averaged $44,750."[474] Harpeth Hall's college counseling office skillfully guides students through this process as they seek the best school to match their individual interests and circumstances, producing an impressive list of college acceptances each year.

As college admission has become more competitive and expensive, the demand for AP courses has also intensified. Advanced Placement classes offer college-level work at the high school level. Each AP course culminates in an exam held in May in which students earning a "3" or higher receive a passing grade for the exam; however, many colleges accept only scores of "4" or "5" for college credit. The number of AP course exams taken by Harpeth Hall students has grown from eleven in 1994 to fifteen in 2004 and twenty-two different AP exams in 2014. This increase in the last decade is due in part to the opening of the Online School for Girls (OSG). The OSG allows Harpeth Hall students to take AP classes not offered by the school, including music theory, psychology, and U.S. government and politics.

Mounting pressure for schools to offer AP courses and for students to take AP courses has had positive effects. Additional course offerings have allowed more students to participate in advanced classes. For example, the Math Department added AP Statistics, the English Department added AP English Language and Composition, the Social Science Department added AP World History, and the Science Department now offers both years of the

new AP Physics redesign. Along with a higher percentage of students taking AP courses and exams, Harpeth Hall scores have continued to increase in recent years, with 85 percent scoring a "3" or higher in 2010 to 95 percent scoring a "3" or higher and 74 percent scoring a "4" or "5" in 2014.

Mathematics, a historically weak subject for girls, has surprisingly become a strong suit for students at Harpeth Hall. Seventy-five years ago, Ward-Belmont dropped advanced mathematics from its curriculum. Today, an impressive 100 percent of graduating seniors take a fourth year of math beyond the required three years. Moreover, the number of students who choose to take an AP math class has risen dramatically. Since 2013, 60 percent or more of all seniors enroll in an AP math class. Students not only take AP math but are also enormously successful. Harpeth Hall students averaged an unprecedented 4.8 average score, with nearly 50 percent of seniors taking either the AB or BC Calculus exam. In addition, the Math Department was awarded a PTC "First Tech Challenge" grant to start a robotics team in September 2014.

The Science Department is also making strides to improve the participation of girls in STEM-focused learning, including an engineering course; independent studies; and the Science Olympiad competition. Beyond the three-year requirement, 64 percent of all seniors take a fourth year of science, and anatomy and physiology is a popular elective on-campus. Moreover, Winterim internships related to medicine and laboratory research remain highly competitive. The emphasis on challenging STEM-related courses for girls will no doubt be used to measure and gauge the academic rigor of girls' schools nationwide. Over the next decade, Harpeth Hall must show that girls are as prepared and inspired to enter fields of science and math as they are for careers in the humanities, fine arts, and social sciences. The school must also provide state-of-the-art facilities for STEM-related courses.

Another vital component of Harpeth Hall's continued success is the school's ability to consistently raise much-needed funding. Neither Ward Seminary nor Ward-Belmont maintained an endowment. Harpeth Hall's first capital campaign established the school's endowment. This major fundraising effort—led by Mary Stumb, class of 1953; Polly Nichols, class of 1953; and Britton Nielson—began in the late 1960s and raised $300,000. Prior to 1968, Harpeth Hall had no endowment "because no one gave to girls' schools at that time," according to Mary Stumb.[475] By 1983 the endowment had grown, but only modestly, to $750,000. By the late 1980s, a capital campaign entitled "A Plan with a Purpose" added nearly $1 million to the

endowment. However, three major capital campaigns within a twenty-year period (1993–2014) and wise investment decisions significantly improved the long-term financial landscape of the school.

In June 2014, at the close of "The Next Step" campaign, Harpeth Hall's endowment crossed the $40 million threshold, an incredible increase of more than $39 million over the past thirty years.[476] The role of fundraising and endowment cannot be overstated. In times of financial downturns and unexpected budgetary demands, the strength of any independent school depends on its endowment and wise money management. Ward-Belmont and many other girls' schools across the nation learned this fact the hard way. Harpeth Hall's financial trajectory remains strong and promises future security for the education of young women in a single-gender environment.

Class of 2015 National Merit Scholars. The six National Merit semifinalists for 2014–15 were Annika Brakebill, Carolyn Edwards, Catherine Falls, Callie Hubbell, Rebecca Rousseau, and Elizabeth Stinson. Obi Ananaba and Devin Graham were named National Achievement semifinalists. National Merit Commended Students winners included Obi Ananaba, Brianna Bjordahl, Marliese Dalton, Reagan Freeman, Kate Goldenring, Gracie King, Briley Newell, and Grace Turner. Noni Marshall was named Outstanding Participant in the National Achievement Scholarship Program.

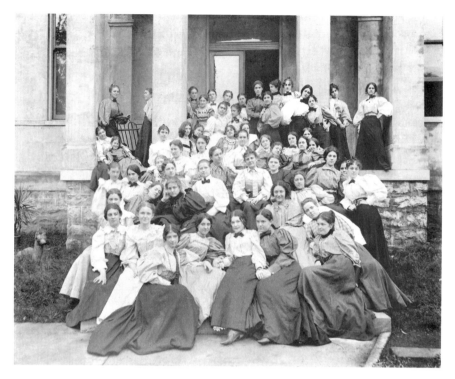

Ward Seminary, 1885.

The roles and expectations of women in education and society are largely unrecognizable from their 1865 counterparts. Nineteenth- and early twentieth-century traditions at Harpeth Hall include the Step Singing ceremony, George Washington Day Celebration, and social clubs that promote school spirit and a sense of belonging. Such time-honored rituals harken back to the days of Ward Seminary, Belmont College, and Ward-Belmont. Other customs have been modified in terms of both imagery and meaning. While senior girls still don white dresses for graduation events, they no longer do so as a symbol of impending marriage and motherhood. The May Queen, now represented by the Lady of the Hall, is awarded to the student who best reflects the highest ideals of Harpeth Hall—intellect, integrity, compassion, and commitment to her school and community. The views of young women *about* women have also evolved dramatically over the past 150 years. Women began to enter the workforce in the late nineteenth century as low-level laborers and teachers. In 1920 women gained political enfranchisement as full citizens

Class of 2015 on Senior Recognition Day.

able to vote. In both world wars, women played instrumental roles on the homefront but dutifully relinquished their jobs when American soldiers returned home.

In the 1960s and 1970s, women sought equality in work, education, and society in a renewed women's movement. Modern notions of feminism emerged during this period; however, instead of inspiring equality, the term was burdened by negative connotations. As Laurel Cunningham, class of 2015, stated, "I think for a long time people saw feminism as women who were anti-men and overbearingly independent." Recent years have shed light and meaning on ideas of gender opportunity and parity—defining a millennial "new woman" in the twenty-first century. As Cunningham continued, "[M]ore people today understand that feminism is a positive for everyone, both men and women. For me feminism is simply the equal right and opportunity to be as successful in life as anyone else. It is as natural to me as the right to free speech, press, and privacy."[477] Coincidentally, and with some irony, the class of 2015 chose as its theme "Good Vibes in 2-0-1-5," based on the dominant cultural themes of the 1970s. Inside the revered Senior House, a sign hangs above each door. Much like football players before a game, Harpeth Hall seniors slap the signs on their way out the door. Class of 2015 members Lois Efionayi, Elizabeth LeBleu, and Laurel Cunningham explain:

We have a sign that says S15TERHOOD above one door and FEMIN15M above the other. Sometimes at Harpeth Hall we almost too often get the message of "women can do anything" thrust upon us. So we half-jokingly began to talk about feminism as our theme, but the more we thought about it, the more we realized that it is exactly what we want to represent. We have talks in the Senior House about public figures and celebrities who promote themselves as women and as advocates for women. We also talk about what we can do to get our male counterparts to understand the true meaning of feminism. Men can and should be feminists too. We see the future of all-girls education as continually progressive... reinforcing the idea of women's success in all areas of life and the power of confidence in and out of the classroom.... [But] all-girls' schools need to be decisive and assertive about the information they present and not send mixed messages.[478]

Mayor Karl Dean presented then Head of School Ann Teaff with a resolution declaring May 1, 2014, "Ann Teaff Day" in Nashville. He told the all-school audience of students and faculty that Harpeth Hall provided them with the tools to achieve any goal and quipped that he expected a Harpeth Hall girl to become Nashville's first female mayor. Ann Teaff echoed Dean's words, "You take all of that strength and you go out into the world and you dream big dreams, and if that includes being mayor, so be it."[479]

Such sentiments seem unimaginably removed from those of Dr. William Ward, who feared the mere participation of women in politics, business, or public life: "If the 'coming woman' is to come to that, let her never come."[480] While Harpeth Hall reveres its tradition and history, the school is an ever-evolving institution that will always hold its belief in girls' education and empowerment most dear. Anne Walker Harrison, class of 2006, wrote, "During my freshman year [of college], I signed up for a sociology course that turned out to be a 500-person class. On the first day I instinctively sat on the front row.... I found myself surrounded by empty seats. I credit Harpeth Hall with ingraining in me the impulse to get the most from learning opportunities rather than shrinking from them, something I realized that day."[481] Students at Harpeth Hall "can dare to be smart, to be bold, to be spontaneous, to be their authentic selves, and to become whoever and whatever they want. Here all of the captains, presidents, and editors are girls."[482] Harpeth Hall is a unique place where all of the leaders are girls and all of the girls are leaders. The "coming woman" has arrived.

SCHOOL LEADERS, 1865–2015

WARD SEMINARY

Dr. William Ward, 1865–87
Eliza Hudson Ward, ex-officio president, 1865–87
J.B. Hancock, principal, 1887–90
Reverend B. Charles, principal, 1890–92
Dr. John Deill Blanton, president, 1892–1912; vice president, 1912–13
Dr. Ira Landrith, president, 1912–13

BELMONT COLLEGE FOR YOUNG WOMEN

Ida Hood, co-president, 1890–1913
Susan Heron, co-president, 1890–1913
Dr. Ira Landrith, regent, 1904–12

THE WARD-BELMONT SCHOOL

Dr. Ira Landrith, president, 1912–16
Dr. John Deill Blanton, president, 1916–33
Anna Hawes Blanton, principal of Home Department, 1892–1916

Leila Mills, principal of Home Department and dean of women, 1916–31
John Barton, vice president, 1927–33; president, 1933–36
Emma Sisson, dean of residence and ex-officio president, 1931–40
Annie Claybrooke Allison, Preparatory School principal, 1932–45
Andrew Benedict, vice president 1934–36, president, 1936–39
Dr. Joseph Burke, president, 1939–45
Susan Souby, Preparatory School principal, 1946–51
Dr. Robert Provine, president, 1945–51

THE HARPETH HALL SCHOOL

Susan Souby, head of school, 1951–63
Idanelle McMurry, head of school, 1963–79
Polly Fessey, interim head of school, 1979–80; director of the Middle School, 1968–89
David Wood, head of school, 1980–91
Betsy Turnbull, chief administrator of Upper School, 1985–88
Susan Baughman, director of the Upper School, 1989–97
Lindy Sayers, director of the Middle School, 1989–98
Leah Rhys, head of school, 1991–98
Steve Chapman, director of the Upper School, 1997–99
Betsy Malone, director of the Middle School, 1998–2008
Ann Teaff, head of school, 1998–2014
LaVoe Mulgrew, director of the Upper School, 1999–2005
Jess Hill, director of the Upper School, 2005–present
Mary Lea Bryant, director of the Middle School, 2008–present
Stephanie Balmer, head of school, 2014–present

TIMELINE

1865	Ward Seminary opens in September in downtown Nashville with forty-six students.
1866	Ward Seminary purchases property on Eighth Avenue.
1879	Edgefield Seminary, operated by Mrs. Henri Weber, merges with Ward Seminary.
1887	Death of Dr. William Eldred Ward, July 20, 1887.
1890	Belmont College for Young Women opens with ninety students on the former Belle Monte estate of Adelicia Acklen.
1892	Dr. John Diell Blanton becomes president of Ward Seminary.
1897	First organized public women's basketball game played in the state of Tennessee results in a score of Vanderbilt University 5, Ward Seminary 0.
1900	Death of Eliza Hudson Ward.
1904	Dr. Ira D. Landrith is named regent of Belmont College for Young Women.
1907	Ward Seminary opens a "suburban" annex called Ward Place, located on the St. Thomas Midtown Hospital Campus between West End Avenue and Charlotte Avenue.
1913	The Ward-Belmont School opens in September with President Dr. Ira D. Landrith and Vice President Dr. J.D. Blanton.
1916	Dr. J.D. Blanton becomes president of the Ward-Belmont School.
1921	Death of Susan L. Heron, March 9, 1921.

1925	The Ward-Belmont School receives accreditation as the first junior college through the Southern Association of Colleges and Schools.
1928	The Ward-Belmont School of Music changes to the Ward-Belmont Conservatory of Music.
1929	A carillon is installed in the Ward-Belmont Bell Tower.
1932	Sarah Colley Cannon ("Minnie Pearl") graduates from the Ward-Belmont School of Expression.
1933	Death of Dr. J.D. Blanton.
	Death of Ida E. Hood, December 29, 1933.
1934	President Franklin Delano Roosevelt visits the Ward-Belmont School.
1936	Cornelia Clark Fort graduates from Ward-Belmont's high school. She later witnessed the Pearl Harbor attack from the air, served as an aviator in World War II, and was the first female pilot to die on active duty in 1943.
1939	Dr. Joseph Burke is named president of Ward-Belmont.
1945	Dr. Robert Provine is named president of Ward-Belmont.
1951	Ward-Belmont closes after Tennessee Baptist Convention assumes control of the school.
	Belmont College (now Belmont University) reopens on Ward-Belmont's campus as a coeducational Baptist college.
	Community leaders move Ward-Belmont's college preparatory division to the P.M. Estes estate; it reopens as the Harpeth Hall School in September 1951.
	Susan Souby is appointed first Harpeth Hall head of school.
1952	Harpeth Hall receives accreditation through the Southern Association of Colleges and Schools.
1953	The Bullard Gymnasium opens.
1954	The original Louise Bullard Wallace Educational Building is completed.
	P.E. teacher Patty Chadwell revives the George Washington Day Celebration tradition at Harpeth Hall.
1963	Idanelle McMurry is appointed Harpeth Hall head of school.
1966	The Annie C. Allison Library opens, named for the former Ward-Belmont high school principal, Annie Allison, who served from 1925 to 1945.

1968	The Daugh W. Smith Middle School opens, headed by Polly Fessey. The Middle School was named for Dr. Daugh Smith, who served as a founding member of Harpeth Hall's Board of Trustees and served as its chair for twenty-one years.
1971	The Daugh W. Smith Middle School adds a sixth grade.
1972	Title IX becomes law as part of the Educational Amendments of 1972.
1973	Harpeth Hall adopts a school uniform featuring signature dress Campbell plaid skirts and white button-down shirts.
	Inaugural year of Winterim program.
	The basketball team is the first girls' sport at Harpeth Hall to join the Tennessee Secondary School Athletic Association.
1975	Harpeth Hall claims its first athletic state championships in track and cross-country.
1976	A new theatre, gallery, and gymnasium are completed. In 1977 the facility is dedicated as the McMurry Center for Arts and Athletics and includes the Catherine E. Morrison Gymnasium, Marnie Sheridan Art Gallery, and the Frances Bond Davis Theatre.
1978	Amy Grant graduates from Harpeth Hall.
1979	Polly Fessey is appointed interim head of school.
1980	David Wood is appointed Harpeth Hall head of school.
1981	Tracy Caulkins Stockwell graduates from Harpeth Hall.
1982	The Honor Council and Honor Code are formalized.
1985	Jack C. Massey Center for Mathematics and Science is completed.
1988	The traditional beanie hats worn by seniors are discontinued.
1989	The position of Upper School director becomes permanent with the appointment of Susan Baughman. Lindy Sayers succeeds Polly Fessey as Middle School director.
1991	Leah Rhys is appointed Harpeth Hall head of school.
	National Coalition of Girls' Schools formed.
	The Kirkman House estate is gifted to the school and serves as the residence for the head of school and family.
1993	The Daugh W. Smith Middle School adds a fifth grade.

1994	Reese Witherspoon graduates from Harpeth Hall.
1997	A campus-wide Internet network is established.
1998	Betsy Malone is named director of the Middle School.
	Ann Teaff is appointed Harpeth Hall head of school.
1999	LaVoe Mulgrew is named the director of the Upper School.
2001	The Ann Scott Carell Library opens, the first major building project since 1985, and begins a campus-wide building and renovation campaign. This facility anchors the Ann Teaff Quadrangle along with Souby Hall.
2002	A student laptop program is initiated, with each student receiving a laptop computer.
2003	The Patton Visual Arts Center opens and includes art studios and gallery space, classrooms, a dark room, and the Richards Room, a large lecture hall.
	Dugan Davis Track and Soccer Complex is completed and dedicated in honor of longtime English teacher and soccer coach Dugan Davis.
2004	The new Daugh W. Smith Middle School is dedicated, providing additional space to expand middle school enrollment; includes a large campus dining hall.
2005	Jess Hill is named director of the Upper School.
2007	Upper School renovations are completed, and the building is renamed the Hortense Bigelow Ingram Upper School.
2009	Harpeth Hall is a founding member of the Online School for Girls.
	Mary Lea Bryant becomes new Middle School director.
	Death of Idanelle McMurry on October 29, 2009.
2014	Financial aid budget exceeds a record-breaking $1.66 million.
	The Athletic and Wellness Center opens in January. The facility provides two gymnasiums, a fitness center, a wellness classroom, locker rooms, offices, and four tennis courts.
	Stephanie Balmer is appointed Harpeth Hall head of school.
2015	Harpeth Hall celebrates 150 years of all-girls education dating back to Ward Seminary. The school also celebrates its traditional ties to Belmont College for Young Women and Ward-Belmont.

Appendix C

GEORGE WASHINGTON DAY
CELEBRATION INDEX

YEAR	GEORGE WASHINGTON	MARTHA WASHINGTON
1922	Alex Morrison	Mary Kennedy
1923	Marty Williamson	Helen Campbell
1927	Rose Morrison	Myrtle Carter
1928	Dorothea Gilbert	Doc Logan
1929	Rose Flentye	Christine Caldwell
1930	Dorothy Rose	Marianna Brown
1931	Fern Hair	Ruth Strangward
1932	Mary Katherine Stubbins	Kathryn Rush
1933	Lora Gillis	Lillian Jones
1934	Mary Lula Pivoto	Ruth Robinson
1935	Jean Stewart	Louise Robinson
1936	Elizabeth Rogers	Louise Fosgate
1937	Margie Ashcroft	Jayne Coyle
1938	Walton Shanklin	Jane Ellen McWhorter
1939	Carol Nelson	Elizabeth Wingate
1940	Frances Farwell	Diddy Kelly
1941	Mary Bauman	Molly Bellamy
1942	Helen Camp	Mary Schwartz
1943	Rusty Crane	June Ritchie
1944	Mary Margaret Neal	Marnie Petrie
1945	Marilyn Fleming	Anne Warnock
1946	Jane Knabe	Carolyn Buie
1947	Pat Tanton	Audrey Horst

APPENDIX C

YEAR	GEORGE WASHINGTON	MARTHA WASHINGTON
1948	Challie Thornton	Mabel Durrett
1949	Mary Thompson	Claire Kelton
1950	Boo Ingram	Peggy Rich
1951	Ridgely Duvall	Ada Oakley
1954	Florence Stumb	Liz Smith
1955	Judy Maddox	Merilyn Hovey
1956	Ruth Thomas	Linda Christie
1957	Carol Beaman	Judy Lackey
1958	Betty Jane Guffee	Mary Corinne Brothers
1959	Kay Keeble	Susie Glasgow
1960	Susan Cone	Doris Matthews
1961	Judy Kinnard	Dee Evans
1962	Pam Polk	Nickye Yokley
1963	Marguerite Weaver	Jacque Brown
1964	Dottie Guffee	Caroline Phillips
1965	Margaret Sharp	Carol Procter
1966	Lil Dobson	Melissa Burrus
1967	Kirk Bond	Tish Scott
1968	Mary Follin	Shealia Phillips
1969	Florence Gifford	Parkesy Casselbury
1970	Jodie Sartor	Kathy Follin
1971	Suzy Peeples	Sabele Foster
1972	Laura Whitson	Lee-Lee Bright
1973	Lee Ann Thornton	Beth Davis
1974	Ducky Gulbenk	Tara Crenshaw
1975	Susan Thornton	Trudy Ward
1976	Allison Floyd	Terri Welch
1977	Lisa Bass	Amy Grant
1979	Katie Groos	Vicki Irwin
1980	Martha Evers	Virginia Calton
1981	Melanie Patterson	Allison Wills
1982	Carey Clarke	Kristen Kirby
1983	Lezley Dale	Anne Smith
1984	Annis Marney	Annie B. Williams
1985	Christine Johnston	Jenny Walker
1986	Courtney Coker	Julia Sutherland
1987	Emily Haynes	Elizabeth Branham
1988	Kara Emerson	Amy Hamilton
1989	Alexis Reed	Malena Salberg
1990	Lindsley Welborn	Akin Vaughan

APPENDIX C

Year	George Washington	Martha Washington
1991	Katherine Wray	Lacey Galbraith
1992	Brianne Frazier	Jennifer Kain
1993	Catherine Workman	Amy Enders
1994	Mandy Lomax	Tallu Schuyler
1995	Kathryn Frazier	Katy Manier
1996	Allyson Foreman	Tricia McWilliams
1997	Dacia Beard	Hannah Galbraith
1998	Audrey Ball	Abi Markham
1999	Kendra Abkowitz	Becca Lewis
2000	Nancy Sisk	Abby Lipshie
2001	Morgan Stengel	Anna Gernert
2002	Grace Herbert	Mary Katherine Bartholomew
2003	English Taylor	Annie Brown
2004	Macy Hughart	Allie Carver
2005	Sabin Nettles	Andee Johnson
2006	Carly Rolfe	Emmy Weikert
2007	Madison Longmire	Griffin Saunders
2008	Anna Russell Thornton	Meg Stark
2009	Sarah Hill	Maggie Rutherford
2010	Sarah Gresham Barr	CiCi Rutherford
2011	Anna Kate Rader	Lark Morrison
2012	Sloane Fuller	Keely Hendricks
2013	Summer Kapanka	Sophia Howard
2014	Camillle Patton	Lady Frances Hamilton

LADY OF THE HALL INDEX

1952: Ruthe Donahoo Berger
1953: Louise Buttorff Bullard
1954: Martha Jean Grizzard
1955: Rosalie Phillips Adams
1956: Carolyn Carmichael
1957: Linda Davis Christie
1958: Evelyn Ames Davis
1959: Elizabeth G. Guffee
1960: Katherine Walker Keeble
1961: Doris Franklin Matthews
1962: Judith McDowell Kinnard
1963: Pamela Gayle Polk
1964: Jacqueline Glover
1965: Caroline Major Phillips
1966: Mary Carol Procter
1967: Melissa Burrus
1968: Patricia Vanamee Scott
1969: Barbara Brent Meacham
1970: Karen Jean Vaughn
1971: Martha Elizabeth Lewis
1972: Sabele Foster
1973: Susan Lange Duvier
1974: Lee Ann Thornton

1975: Margaret Ellen Hobbs
1976: Susan Young Thornton
1977: Frances Adams Diefendorf
1978: Amy Lee Grant
1979: Susan Amelia Spickard
1980: Andree Le Jeune Akers
1981: Denise Elizabeth Smith
1982: Elizabeth Kirby Cochran
1983: Sarah Winn Nichols
1984: Lillian Patton Bradford
1985: Elizabeth Hayes Hightower
1986: Carol Thornton Cavin
1987: Susan Huntington Wattleworth
1988: Annis Morison Marney
1989: Shannon Paige Ferragina
1990: Murray Tate Polk
1991: Emily Wendel Haynes
1992: Carrie Sinclair Crossman
1993: Katherine Randall Sherrard
1994: Helen Fern Elizabeth Whetsell
1995: Katherine Williams Wray
1996: Jennifer Berry Kain
1997: Julia Claire Brown
1998: Kathryn Pierce Celauro
1999: Elizabeth Lindsay Voigt
2000: Katherine Marguerite Hill
2001: Susan Margaret Oliver
2002: Rebecca Wells Brown
2003: Raleigh Anne Blank
2004: Ann Crockett Hale
2005: Brittany Nicole Northcross
2006: Ellen Hudson Regan
2007: Ann Elizabeth Killian
2008: Carolyn Cate Tidwell
2009: Emily Allen Carpenter
2010: Katherine Grace Martin
2011: Katherine Ann Milam
2012: Caroline Elizabeth Hawkins
2013: Margaret Helen Rutherford
2014: Rebecca Bryan Morris

NOTES

Acknowledgements

1. Jan Ellen Tye, *Chimes* 12, no. 2 (April 1949): 1.

Introduction

2. See also Wiebe, *Search for Order*. Wiebe argues that during the Gilded/Progressive Era, urban areas grew and increasingly connected to smaller "island" communities. In Nashville, as the downtown grew, suburban communities emerged such as Belle Meade, further extending the size and scope of the city. Likewise, outlying areas were more accessible to Nashville as the city grew, such as Murfreesboro and Lebanon, connected by railroads.

3. Ingram, *Apollo's Struggle*, 47.

4. Additionally, the National Teachers Association (NTA) formed in 1867 and is today called the National Education Association (NEA). The Southern Association of College Women later merged with its counterparts in the northern and western regions to form the American Association of University Women in 1921.

5. *Ward-Belmont Hyphen*, "Ward Seminary Founded During Post-War Chaos" (November 3, 1934): 1. The *Ward-Belmont Hyphen* served as the weekly student periodical from 1913 to 1951. Ward Seminary first opened under the name W.E. Ward's Seminary.

6. The democratization of education was not a new concept, but the emphasis on democratic education increased with the growth of government, immigration,

women's education, African American education, and the Morrill Land Acts of 1862 and 1890. For more on reform and pedagogical developments, John Dewey's works must be consulted—see *Democracy and Education*, *Experience and Education*, and *Moral Principles in Education*.

7. Lucas, *American Higher Education*, 152. See also Goodenow and White, *Education and the Rise of the New South*, and Button and Provenzo, *History of Education and Culture in America*.

8. Hale and Merritt, *History of Tennessee and Tennesseans*, 1,494.

9. Porter quote was reprinted in *W.E. Ward's Seminary Annual Announcement*, 1885–86, 2.

10. *Nashville Banner*, April 13, 1925. Other local colleges and schools included University of Nashville (1826), Fisk University (1865), Vanderbilt University (1873), George Peabody College for Teachers (1875), Meharry Medicial College (1876), and Nashville Bible College (1891), today Lipscomb University.

11. See also Duncan, *History of Belmont College*, and Morrison, *Voyage of Faith*.

12. National Coalition of Girls' Schools, "Case for Girls," http://www.ncgs.org/CaseForGirls.aspx.

13. Nashville Board of Trade, *Yearbook of the Nashville Board of Trade*, 10.

14. Nashville's larger metropolitan area (including thirteen counties) boasts a population of more than 1.5 million people, U.S. Census Bureau Report, 2010.

CHAPTER 1

15. Portions of this chapter appeared previously in Pethel, "Coming Woman," 183–204. Reprinted with the permission of the Tennessee Historical Society, War Memorial Building, Nashville, Tennessee.

16. Harwarth, *Women's Colleges in the United States*, 8.

17. Colton, "Standards of Southern Colleges for Women," 458–59.

18. Davis, "Quiet, Even Growth," 6. The need for a new school was highlighted, as the Nashville Female Academy, which opened in 1820, was unable to successfully reopen after four years of Union occupation during the Civil War.

19. *Ward-Belmont Hyphen*, "Ward Seminary Founded During Post-War Chaos," 1.

20. Portions of the previous analysis and primary source quotes are reprinted with the permission of the Tennessee History Society.

21. Speer, *Sketches of Prominent Tennesseans*, 420. Eliza Hudson's uncle, Dr. Elias W. Napier, established the first iron manufacturing foundry in Tennessee.

22. Ibid.

23. Ibid., 423.

24. At the age of sixteen, Ward enrolled in Green Academy in Huntsville and excelled in history, geography, and English.

25. In Speer, *Sketches of Prominent Tennesseans*, Ward is listed as having an AM (Master of Arts) and DD (Doctorate of Divinity) but not a JD (Juris Doctorate).

26. Ibid., 421.

27. Little is known about Dr. William E. Ward from 1862 to 1865; however, he did travel extensively and lived in New York City in 1864. Ward visited and observed countless schools during his venture north and returned to Nashville at the end of the Civil War with a plan to start a school for girls. The last week of February 1862 marked the beginning of Union occupation as Mayor Cheatham turn over the local government to Union forces.

28. Speer, *Sketches of Prominent Tennesseans*, 421. Sallie, who graduated from her father's school in 1877; Florence, who joined her sister as a Ward Seminary graduate in 1879; Eunice, who graduated from the school in 1883; William Jr., who became the business manager for the Cumberland Presbyterian Board of Publication in the early 1900s; and Rebecca Ward.

29. Speer, *Sketches of Prominent Tennesseans*, 422. For more, see Pethel, "Coming Woman," 183–204.

30. *Ward-Belmont Hyphen* 15, no. 9, "Reminiscences of Ward Seminary" (November 21, 1925): 1.

31. Salisbury, *Higher Education in Tennessee*, 254.

32. Davis, "Quiet, Even Growth," 7.

33. *The Iris*, 1906, 114–15. This piece was written by W.E. Ward Jr., son of the school's founder, Dr. Ward. It was published in 1906 but refers to the school as he fondly remembered from his childhood. While there were several male students who attended primary grades, William Ward Jr. was the only man to attend Ward Seminary through the Intermediate Department (equivalent to middle school).

34. *Ward-Belmont Hyphen*, "Reminiscences of Ward Seminary," 1.

35. Speer, *Sketches of Prominent Tennesseans*, 423.

36. *Ward-Belmont Hyphen*, "Reminiscences of Ward Seminary," 1. The initial curriculum was reprinted in this issue of the student newspaper. After 1895, course work would shift gradually to a liberal arts curriculum and also include some more practical courses of study, including secretarial work and domestic science.

37. From 1903 to 1912, several brochures for the Ward Conservatory of Music were published with extensive listings of music curriculum, instructors, and testimonials.

38. W.E. Ward's Seminary, *Second Annual Commencement*, program, June 26, 1867, 1.

39. Davis, "Quiet, Even Growth," 6.

40. Ibid., 7.

41. Ibid.

42. Ibid.

43. *Annual Announcement of Ward's Seminary*, 1894–95, 38.

44. *Ward-Belmont Hyphen*, "Reminiscences of Ward Seminary," 1. Portions of the previous analysis and primary source quotes are reprinted with the permission of the Tennessee History Society.

45. *Ward-Belmont Hyphen*, "Ward Seminary Founded During Post-War Chaos," 1.

46. *War-Belmont Hyphen*, "Ward Seminary Was a Woman's Idea" (June 14, 1928): 15.

47. *Annual Announcement of Ward Seminary for Ladies*, 1885–86. Portions of this paragraph are reprinted with the permission of the Tennessee History Society. For more, see Pethel, "Coming Woman," 183–204.

48. Wisconsin Education Association Council, *Research Brief*. An interesting quote that reflects the pay and feminization of primary and secondary teachers from the Littleton School Committee of Littleton, Massachusetts, in 1849: "God seems to have made woman peculiarly suited to guide and develop the infant mind, and it seems…very poor policy to pay a man 20 or 22 dollars a month, for teaching children the ABCs, when a female could do the work more successfully at one third of the price." PBS, "Only a Teacher," http://www.pbs.org/onlyateacher/timeline.html.

49. *Ward-Belmont Hyphen*, "Reminiscences of Ward Seminary," 1.

50. Ibid.

51. McRaven, *Nashville*, 128–29.

52. *Ward-Belmont Hyphen*, "Reminiscences of Ward Seminary," 1.

53. Report of J.B. Killebrew, assistant superintendent of public instruction for the State of Tennessee to the Thirty-eighth General Assembly, January 1873, 28. Also see *Ward-Belmont Hyphen*, "Reminiscences of Ward Seminary," 1.

54. Ward, "Coming Woman," 25.

55. Portions of Dr. Ward's 1880 speech and the analysis that follows are reprinted with the permission of the Tennessee History Society. For more, see Pethel, "Coming Woman," 183–204.

56. Speer, *Sketches of Prominent Tennesseans*, 423.

57. *Ward's Seminary Bulletin* 20 (1904–5): 51–59. It is impossible to precisely determine the number of lawyers, as names in the directory are not denoted with the degree of Juris Doctorate (JD). Still, their mothers, presumably widows, list very few students, yet there remain a handful who have no apparent sponsor or parental funding. Ward Seminary did award several scholarships each year beginning in the 1880s.

58. Ibid., 2.

59. Ibid.

60. *Times-Picayune*, vol. 37, July 20, 1873, 3. The school was first called W.E. Ward's Seminary and sometimes Ward's Seminary before settling on the name Ward Seminary.

61. *Nashville*, 122. William Speer reported that of the three thousand students who passed through the halls of Ward Seminary, the following states were represented: Tennessee, Kentucky, Alabama, North Carolina, South Carolina, Florida, Georgia, Mississippi, Louisiana, Arkansas, Texas, California, Missouri, Illinois, Idaho, Ohio, Wisconsin, Iowa, Pennsylvania, and the Indian nations. Speer, *Sketches of Prominent Tennesseans*, 422.

62. Speer, *Sketches of Prominent Tennesseans*, 423.

63. Ibid. Portions of the previous analysis are reprinted with the permission of the Tennessee History Society.

64. Salisbury, *Higher Education in Tennessee*, 254. Hancock was a graduate of Cumberland University, the alma mater of William E. Ward.

65. Speer, *Sketches of Prominent Tennesseans*, 422.

66. Salisbury, *Higher Education in Tennessee*, 254.

67. Ibid.

68. *The Iris*, 1898, 11.

69. "Scrapbook" and "Reminiscences," Boxes 92–95, Sadie Warner Frazer (1885–1974) Papers, Accession 1983.040, Tennessee State Library and Archives. Sadie's grandfather James C. Warner was the family patriarch and headed the Nashville Railway and Light Company. Her father, Percy Warner, later led the company and was a major figure in the Nashville community in the early 1900s. Sadie married George Augustine Frazer in 1905. Most notably, she was an avid suffragist. As such, she served as the transportation chairman for a National Suffrage Convention held in Nashville in 1914 and marched in a parade from Public Square to Centennial Park to advocate the right of women to vote.

70. Waller, *Nashville in the 1890s*, 34.

71. Davis, "Quiet, Even Growth," 8.

72. Ibid.

73. The couple also raised two other daughters: Anna Treadwell and Almeria (Mea) Blanton.

74. *The Iris*, 1906, 13.

75. Davis, "Quiet, Even Growth," 8.

76. *The Iris*, 1900, 68. Reprinted with the permission of the Tennessee Historical Society.

77. *Ward Seminary Bulletin* (1900–1901): 48–59.

78. Ibid., 9. Reprinted with the permission of the Tennessee Historical Society.

79. *The Iris*, vol. 4, 1902, n.p.

80. *Ward Seminary Bulletin* 45 (1909–10): 79.

81. *Baptist and Reflector*, June 6, 1912, 12.

82. Ibid., 1909–10, 8.

83. *The Hustler* 8, no. 22 (March 17, 1897): 1. The game was played in Vanderbilt's Old Gymnasium. This article was written by a male student reporter from Vanderbilt who snuck into the game and wrote a fascinating account from the perspective of a young man.

84. Ibid., 60–61.

85. *The Iris*, 1903, 32.

86. Ibid., 49.

87. Ibid., 32.

88. Ibid., 33. Portions of the previous analysis and primary source quotes are reprinted with the permission of the Tennessee History Society.

89. *The Iris*, 1906, 91.

90. Davis, "Quiet, Even Growth," 23.

91. *The Iris*, 1898–1912.

92. Albin Krebs, "Clare Boothe Luce Dies at 84: Playwright, Politician, Envoy," *New York Times*, October 10, 1987, http://www.nytimes.com/learning/general/onthisday/bday/0310.html. Reprinted with the permission of the Tennessee History Society.

93. *The Iris*, 1906, 114–15.

94. *Ward Seminary Junior School Catalog*, 1912–13, n.p. Belmont University Special Collections.

95. The Junior School primary curriculum included three years of arithmetic (Milne), reading, French, English, geography (Frye), spelling, Bible, art, singing and gymnasium. William J. Milne was an influential educator who spent his career in the state of New York. He served as principal of several schools and completed his career in 1890 at New York State Normal College, which changed its name to New York State College for Teachers in 1914, the same year of his death. He wrote several textbooks for arithmetic and mathematics. For a full-text version of his most popular book, go to http://www.archive.org/details/milnesnewyorkst00milngoog. In addition, Alex E. Frye wrote geography books regularly used in social science courses in the 1890s and early 1900s. The Intermediate Department curriculum added penmanship, nature study, and history. By the sixth and final year of Junior School, many students had added Latin and science to round out their studies.

96. Leonard, *Woman's Who's Who of America*, 752.

97. Ibid.

98. *Harvard Crimson*, "Harvard Men Try Out for Wellesley Parts." Portions of this analysis and primary source quotes are reprinted with the permission of the Tennessee Historical Society.

99. Excerpt from *Nashville Tennessean*, 1912, taken from *Concerning Miss Edith Margaret Smaill*, brochure.

100. Ibid.

101. *Ward Seminary Bulletin* (1909–10): 8.

102. Ibid.

103. *Annual Announcement of Ward's Seminary*, 1892–93, 25.

104. Colton, "Standards of Southern Colleges for Women," 458–59. For more on Elizabeth Colton, see Mary Lynch Johnson, "Elizabeth Avery Colton," *Dictionary of North Carolina Biography*, University of North Carolina Press, http://ncpedia.org/biography/colton-elizabeth-avery.

Chapter 2

105. The "Seven Sisters" include Barnard College (New York, affiliated with Columbia University since 1900), Bryn Mawr College (Pennsylvania, the first to offer graduate degrees to women), Mount Holyoke (Massachusetts, founded by early education advocate Mary Lyon), Radcliffe College (Massachusetts, known also as the "Harvard Annex"; fully merged with Harvard in 1999), Smith College (Massachusetts, founded in 1871), Vassar College (New York, adopted a coeducational model in 1969), and Wellesley College (Massachusetts, founded in 1870). For more, see Kendall, *"Peculiar Institutions."*

106. Charles Eliot cited in Horowitz, "'Hateful' Wellesley Inaugural Address," 31.

107. Harwarth, *Women's Colleges in the United States*, 8.

108. Ibid. Also see Farnham, *Education of the Southern Belle*, 29–69.

109. *Belmont College for Young Women Prospectus*, n.d.

110. Wardin, *Belmont Mansion*, 8. Dr. Wardin is a former history professor at Belmont University and the founder of the Historic Belmont Association.

111. Brown, "Adelicia Acklen," Tennessee Online Encyclopedia, January 2010.

112. *Blue and Bronze*, "Story of Belmont," 21. They brought many students and faculty from Martin Female College in Pulaski, Tennessee. Today, the school is Martin Methodist College.

113. *Evening Herald*, "A Big Transaction," June 10, 1890, n.p. They purchased the property from Lewis Baxter, who had bought the entire seventy-eight-acre Belmont estate from Adelicia Acklen.

114. *Nashville Banner*, "Belmont College," September 5, 1890, 2.

115. *Confederate Veteran*, 1894, 224; *Confederate Veteran*, July 1896.

116. Hood and Heron quoted in "Background and History of Belmont College," Belmont University Special Collections, no author, n.p., 1964, 1.

117. *Nashville Daily American*, September 5, 1890, 5.

118. Like Susan Heron and Ida Hood, the founders and faculty of many southern schools for girls hailed from the North, mainly because those qualified to teach

or manage a seminary or "college" were educated in northern schools that were more prevalent above the Mason-Dixon line.

119. *Blue and Bronze*, "Story of Belmont," 19–20.

120. *Pulaski Citizen*, "Martin Female College," May 14, 1885, 3.

121. *Blue and Bronze*, "Story of Belmont," 20–21.

122. Smith, *Church on the Square*, 115.

123. Martin College experienced a bit of a scandal in 1884 when then superintendent W.K. Jones left abruptly for Texas after the trustees had invested money for recent additions. The trustees scrambled two months before the fall term to find a capable replacement. Joseph L. Armstrong came with a strong educational background, including Columbia University, and strong recommendations, but after one school term, he departed for a professorship in Missouri.

124. Smith, *Church on the Square*, 116.

125. Rich, *Lawyers Reports Annotated*, 181. Duncan found a quirky state provision that forced the state to represent his interests, and the case *State v. Martin Female College* was filed in January 1888. Interestingly, Duncan actually received more attention in another high-profile case as a plaintiff who challenged the legality of the sale of alcohol in Tennessee.

126. Harwarth, *Women's Colleges in the United States*, 10.

127. *Announcement and Prospectus of Belmont College*, 1895, 27.

128. Ibid., 1891, 24–25.

129. Ibid., 1895, 24. Not allowing students to receive packages of food was most likely for health reasons.

130. Ibid. Day students often carried letters and correspondence to Vanderbilt or other local young men for boarding students.

131. *Blue and Bronze*, "Story of Belmont," 21.

132. *Evening Herald*, "Belmont Remodeled," February 10, 1890, 2; *Evening Herald*, "Big Transaction."

133. Wardin, *Belmont Mansion*, 39. After Hood and Heron purchased the mansion and surrounding acreage, they consulted Thomas Lynch Dismukes, a local architect. He presented a plan that would turn the Belmont Mansion into a French château with Flemish Renaissance elements and a mansard, terra-cotta roof. They opted to leave the mansion's outward appearance and instead renovate the interior of the former estate home.

134. *Ward-Belmont Hyphen*, "The History of Belmont College" (November 10, 1934): 1. Later, the basement was converted to music rooms, while the main floor contained classrooms and administrative offices. An elevator was also added in 1890, and twenty-eight twelve- by fourteen-foot bedrooms, an art room, an infirmary and a drawing/sitting room composed the second and third stories.

135. *Nashville Daily American*, September 7, 1890.

136. Harriett Mary Goodin, "A Tribute to the Founders of Belmont," *Blue and Bronze*, 1913.

137. Wardin, *Belmont Mansion*, 41. Today, on the campus of Belmont University, Founders Hall is called Barbara Massey Hall. The beautiful dining rooms are still used for receptions and special events, but the dorm rooms have all been converted into office space.

138. *Nashville Daily American*, September 5, 1890, 5.

139. *The Aitrop*, 1904; *Milady in Brown*, 1905–13.

140. *Milady in Brown*, 1905. Muskogee, Oklahoma, became part of the Creek Indian Territory after the Indian Removal Act of 1830. The city was also the site of the region's U.S. Indian Agency, which still serves today as a museum. In 1872, the Missouri-Kansas-Texas Railroad extended through the territory, and Muskogee served as the area's major station. Shortly afterward, the territory was opened to settlers during a period of western land rushes. The city grew to more than twenty thousand inhabitants after 1900. The "Five Civilized Tribes" (Cherokee, Creek, Choctaw, Seminole, and Chickasaw) met in Muskogee in 1905 and drafted a constitution for their proposed "State of Sequoyah." Muskogee was to be the state capital; however, the "State of Sequoyah" did not receive federal recognition, led in part by a veto from Theodore Roosevelt, and Oklahoma was admitted as the forty-sixth state in 1907.

141. Ibid., 17–20. The girls formed "State Clubs" based on states with a significant and fairly consistent number of students in the student body. As a sample, the 1905 *Milady in Brown* shows the number of students as follows: Kentucky, 17; Missouri, 12; Louisiana, 4; Tennessee, 43; Texas, 21; Mississippi, 12; Illinois, 9; Alabama, 10; and Arkansas, 9.

142. Colton, "Standards of Southern Colleges for Women," 460, 463.

143. *The Aitrop*, 1904; *Annual Announcement and Prospectus of Belmont College*, 1890, 1895; *Milady in Brown*, 1905–1912.

144. *Announcement and Prospectus of Belmont College*, 1906, 34.

145. *Nashville Daily American*, September 5, 1890, 5; June 5, 1891, n.p.

146. *Blue and Bronze*, "Editorials," February 1904, 28.

147. *Announcement and Prospectus of Belmont College*, 1906, 17–36.

148. Ibid., 37. Catalogues from various years specifically lay out the course outline leading to a BA, which included courses in algebra, geometry, trigonometry, analytics, geology, physics, chemistry, ancient history, modern history, American history, literature, ethics, Livy, Horace, Virgil, Shakespeare, civics, astronomy, English grammar, composition, two additional units of English, four years of French, and various other electives.

149. Ibid. The "AM" represented a Master of Arts degree.

150. Colton, "Standards of Southern Colleges for Women," 458–70. Colton described four categories and bases her classifications on 1906 Carnegie Foundation definition of a college, as well as SACS and SACW. Belmont College was listed in the fourth-tier group, consisting of fifty-five institutions that claimed to be colleges by retaining the name "college" but produced "mainly secondary-school work." Colton outlined the following criteria for a school to truly be considered a college: first, requirement of fourteen or more units for entrance; second, pledge not to allow their college instructors to do any preparatory teaching; third, pledge not to allow their conditioned freshmen to make up work in a preparatory school; fourth, pledge not to allow their preparatory student to take any college courses; and fifth, provide libraries, laboratories, and other buildings and equipment necessary for maintaining a high standard of scholarship and efficiency.

151. Ibid., 472–73.

152. Laura Lewter schedule, Belmont College for Young Women, n.d.; *The Aitrop*, 1904.

153. Ibid.

154. *The Aitrop*, 1904, 63–70.

155. *Musical Herald*, 1908, 4.

156. Ibid.

157. Ibid.

158. *Announcement and Prospectus of Belmont College*, 1906, 8.

159. Willye O. Smith, "Halloween Night," *Blue and Bronze*, 1904, 21–22.

160. DeBare, *Where Girls Come First*, 92.

161. Ibid. The first student president of the organization was Miss Mary Rankin, and Pearl Garrett was the first Belmont delegate who attended the YWCA annual conference, held that year at Lake Geneva in Wisconsin in 1896.

162. *The Aitrop*, 1904, 120.

163. For more, see Reich, *Clara Schumann*.

164. Brée, *Leschetizky Method*, 3. Theodore Leschetizky implemented a teaching approach in which he considered the student's personality, musical ability, and learning style and formed an individual teaching plan for each pupil. Leschetizky encouraged a lifelong study and love for music and was also famous for the quote, "No art without life, no life without art."

165. *Nashville Daily American*, September 7, 1890.

166. *Milady in Brown*, 1905, 17.

167. Grace Mauzy, "The Music of Belmont," *Blue and Bronze*, 13.

168. Cumberland Presbyterian Church, "Ira Landrith." The website for this church is a collection of events and records from the life of Ira Landrith, taken and cited with primary sources generated by the Cumberland Presbyterian Church.

Landrith received the following degrees, some of which are no longer conferred by academic institutions: BS (1888), LLB (1889), LLD (1903), and DD (1904).

169. Hale and Merritt, *History of Tennessee and Tennesseans*.

170. *Cumberland Presbyterian*, May 24, 1906, 610–11. For more, see Frank Hanly and Oliver Wayne Stewart, eds., *Speeches of the Flying Squadron* (Indianapolis, IN: Hanly & Stewart distribution agents, 1915), which can be accessed through Cumberland Presbyterian Church, "Ira Landrith." The Prohibitionist Party only garnered 1.2 percent of the popular vote.

171. Ibid.

172. Ibid. Also see *1890 Census of Davidson County, Tennessee* and *1900 Census of Davidson County, Tennessee*. Their first daughter, Marian Landrith, was born in 1892 and died in infancy.

173. Dr. Landrith and his wife, Hattie, did have a son in 1897 and named him Ira DeWitt Landrith, after his father. Ira Jr. passed away in 1905 at the age of eight years old and was buried beside his sister Marian, who died in infancy.

174. *Milady in Brown*, 1908–12; *Milestones*, 1913–15.

175. *Catalogue and Announcement of the Ward-Belmont School for Young Women*, 1914–15, 67–69. Grace is listed as a senior in the 1915 *Milestones*, but in the *Catalogue and Announcement of the Ward-Belmont School for Young Women*, 1914–15, she is listed as matriculate of the first class of Ward-Belmont following the 1913–14 school year.

176. *Milestones*, 1915, 43.

177. DeBare, *Where Girls Come First*, 130.

178. *Milady in Brown*, 1905, 18, 34–35, 69, 88, 120, 153, 185.

179. Ibid., 35.

180. Ibid., 12, 19, 33, 35, 74, 105, 120, 133, 150, 185.

181. Ibid., 12. An excerpt of the poem reads, "'Twas after all the light and warmth and joy; Of Belmont's happy 'Recreation Night.' The girls had danced the last to 'Home, Sweet Home,' And now they slept and dreamed till morning."

182. Ibid., 185.

183. Ibid.

184. *Milady in Brown*, 1908, 19.

185. Mallie G. Wilson, "Retrospection," *Blue and Bronze*, 1904, 19. Mallie Wilson married a U.S. Army colonel but maintained her reputation as a poet. During her career, she penned a rather well-known poem entitled "Bataan," which memorialized one of her sons, Captain William E. Wilson Farrell, who died fighting off the cost of Bataan in the Philippines during World War II.

186. DeBare, *Where Girls Come First*, 136–37.

187. Before the Civil War, Nashville's only real suburb outside of downtown was located in East Nashville, across the Cumberland River, and called Edgefield.

West Nashville, and the schools that accompanied its development, did not emerge until the mid-1870s.

188. Belmont University, "Belmont: Then and Now," June 21, 2014, http://belmontthenandnow.com/about.

189. Ibid.; *Blue and Bronze*, March 1913; Smith, *Church on the Square*, 119. Although the women retired in 1912, they continued to remain active for a number of years. Following their retirement, the pair took an extended European tour before returning to their Belle Meade home. They also remained active as members of Christ Church Cathedral and the Centennial Club. Ida E. Hood passed away in 1920, and Susan L. Heron died in 1933.

190. Hood and Heron are buried in Section 12, Lot 262, at the Mount Olivet Cemetery. Beside their marker is the Reeves monument. Henrietta Kendrick Reeves organized Nashville's first poetry society and served as president of the Nashville Centennial Club. Their marker is near the Adelicia Franklin Acklen Cheatham family mausoleum.

191. In a tribute to Ida E. Hood following her death, it was noted that "Miss Hood retained her active interest in the institution until the time of her death and also retained her contacts with 'her girls' whose lived she had influenced through her years of teaching." *Ward-Belmont Hyphen* (January 13, 1934): 1.

192. *Ward-Belmont Hyphen*, "History of Belmont College," 1.

193. *Ward-Belmont Hyphen*, "Reminiscences of Ward Seminary," 4.

194. Lillian S. Craig, "A Love Token," *Blue and Bronze*, 16.

195. DeBare, *Where Girls Come First*, 87–88.

CHAPTER 3

196. Benedict, Cannon, and Cayce, "Bells of Ward-Belmont," 382. This passage refers to a 1968 reunion held for all Ward-Belmont alumnae. Sara Colley Cannon is best known for her stage name and persona "Minnie Pearl."

197. *Women Working; Women of Courage*, "Early College Women," 1.

198. Harwarth, *Women's Colleges in the United States*, 14.

199. *Milestones*, 1916, 157.

200. *Women in Congress*, "Mary E. 'Betty' Farrington."

201. West End Home Foundation, "Mary Elizabeth Cayce."

202. James, James, and Boyer, *Notable American Women*, 506. Grinder's Switch was an actual railroad switch located just outside Centerville, Tennessee.

203. Sarah Cannon Research Institute, "Our History," 2014, http://sarahcannon.com/locations/tristar/about/our-history.dot. The Minnie Pearl Cancer Foundation is called PearlPoint Cancer Support.

204. To read Sarah Cannon's story, see *Minnie Pearl*.

205. *Milestones*, 1944, 1947–49.

206. Jean Ward Oldfield, interview by author, March 20, 2014.

207. *San Jose Mercury News*, "Mary Margaret 'Curly' Neal," Obituary, June 11, 2013. Other prominent Ward-Belmont alumnae include actress and singer Mary Martin, who attended in 1928–29, most famous for her Broadway role as Peter Pan, and Lila Acheson Wallace, who co-founded *Reader's Digest* in 1922.

208. For more on changing leadership at Belmont College and Ward Seminary prior to the merger, see Chapter 2.

209. *1930 Census of Davidson County*; excerpts of *Minutes of the General Assembly of the Presbyterian Church in the United States of America*, 1900–1941, which can be accessed through Cumberland Presbyterian Church, "Ira Landrith." Landrith continued to serve as a Presbyterian minister in the Presbyterian USA denomination and lived for many years in Chicago, Illinois, and Winona Lake, Indiana, before ending his career in Pasadena, California. Ira's wife, Hattie, died sometime between 1920 and 1930, as census records changed his status from married to widower. Ira did remarry a third time, although his date of marriage is unclear. He married Sallie A. Alexander of Wilson County, Tennessee. Census records from 1930 also show Landrith was living as a resident in a hotel.

210. Waller, *Nashville in the 1890s*, 32.

211. Ibid. Reprinted with permission from the Tennessee Historical Society. For more on Clarence B. Wallace and Wallace University School, see Vanderbilt University Special Collections, "Preparatory Academies and Vanderbilt University," August 2006, http://www.library.vanderbilt.edu/speccol/exhibits/preparatory/wallace.shtml. The school was located on West End Avenue from 1914 to 1941.

212. *Ward-Belmont Hyphen* (1928). In 1915, Montgomery Bell Academy moved to its present location on Harding Road. Vanderbilt University and Peabody College were already located in West Nashville. By 1915, nearly all of Nashville's private college preparatory schools, colleges and universities had moved to West Nashville.

213. Doyle, *Nashville in the New South*, 211. In November 1925, Nashville lost a landmark. The main Ward Seminary building was torn down, remembered today by a Metro Nashville Historical Marker sponsored by Ward DeWitt Jr., great-grandson of William and Eliza Ward. It is located by the Nashville Sporting Goods store at 169 Eighth Avenue North just behind Hume-Fogg High School and Commerce Street. The *Ward-Belmont Hyphen* reported, "This school was one of the strong foundation stones of education in the South. It has long been cherished in the hearts of many people and it is with sorrow they must stand and watch the bricks thrown one by one into a pile to be carted away."

214. One common text used was Mollie Huggins, *Tennessee Model Household Guide: Practical Help in the Household* (Nashville, TN: Publishing House Methodist Episcopal Church South, 1897).

215. Collegiate courses were denoted by Roman numerals, and college preparatory courses were denoted by letters.

216. *Ward-Belmont Bulletin* (1919–20): 74–77.

217. *Annual Catalog and Announcement for the Ward-Belmont School*, 1917–22.

218. *Ward-Belmont Conservatory of Music Catalog*, 1929–30, 11.

219. Ikard, "Nashville Conservatory of Music," Tennessee Online Encyclopedia. See also Doyle, *Nashville Since the 1920s*, and Ikard, "Signor de Luca," 176–94.

220. Tennessee State Library and Archives, Kenneth Daniel Rose Papers, 1879–1957, processed 1961.

221. Eva Massey is of no relation to Jack Massey (1904–1990), namesake of the Jack C. Massey Graduate School of Business and Massey Auditorium at Belmont University. She is also of no familial connection regarding the Jack C. Massey building located on the Harpeth Hall campus.

222. *Ward Conservatory of Music, Eva Massey, Teacher of Piano*, brochure, n.p., 1910, Belmont University Special Collections.

223. Ibid.

224. *Milestones*, 1924, 15.

225. *Annual Catalog and Announcement for the Ward-Belmont School*, 1927–28, 57.

226. Cowan, *Annie Was a Lady*, 29, 75. For more on Annie Allison, see Chapter 4.

227. *Milestones*, 1926–45. Annie Allison received her BA and MA from the George Peabody College for Teachers. She also pursued graduate work at the University of Chicago. Before the principal position was created, there were two vice-presidents, a dean of women, and a dean of faculty.

228. Theodora Scruggs also taught psychology, history, and other English language arts courses. Scruggs never married but instead devoted her life to Ward-Belmont and the young women whom she taught.

229. Posse Gymnasium was founded by Swedish-born Baron Nils Posse. He published *Special Kinesiology of Educational Gymnastics* in 1890 and established a gym in Boston to train teachers in gymnastics, calisthenics, and physical culture/education.

230. *Milestones*, 1926, 8.

231. The Harpeth Hall School campus features the Catherine E. Morrison Gymnasium, built in 1976. Catherine E. Morrison, like Theodora Scruggs, never married or had children of her own. Instead, she chose to shape the lives of Ward and Ward-Belmont students with untiring guidance and mentorship.

232. *Ward-Belmont Alumnae Journal*, August 1935.

233. Moore, *Gilly Goes to Ward-Belmont*, 71–73.

234. DeBare, *Where Girls Come First*, 92.

235. *Ward-Belmont School Annual Catalog and Announcement*, 1940–41, 15.

236. Ibid., 93.

237. Moore, *Gilly Goes to Ward-Belmont*.

238. Ibid., 22–23.

239. Ibid., 28.

240. Benedict, Cannon, and Cayce, "Bells of Ward-Belmont," 381.

241. Ibid., 379.

242. Moore, *Gilly Goes to Ward-Belmont*, 41–42.

243. Ibid., 37. Jascha Heifetz was a Lithuanian-born American violinist who was arguably the greatest violinist of the twentieth century, performing from 1917 to 1967.

244. Avery, *Best Type of Girl*, 150–200.

245. Marietta Douglas, "What Is a Carillon?" Yale University, June 2002, http://www.cs.yale.edu.

246. Louise Davis, "Belmont Carillon Tolls Memories," *The Tennesseean*, May 3, 1989.

247. *Ward-Belmont Hyphen* (April 20, 1929): 1–3.

248. Ibid., 2.

249. The bowling alleys and tennis courts were part of the original estate built by Adelicia Acklen.

250. Rosalyn Kirsch Scrapbook, 1920, Belmont Special Collections.

251. *Ward-Belmont Hyphen* 15, no. 9, "Ward-Belmont Alphabet" (November 21, 1925): 1.

252. Jimmy Bryant, "From the UCA Archives: A Brief History of Women's Basketball," *Log Cabin Democrat*, November 13, 2011, http://thecabin.net/sports/college.

253. Avery, *Best Type of Girl*, 255–64.

254. *Logos II* 9, no. 3 (December 1979).

255. Moore, *Gilley Goes to Ward-Belmont*, 26. The clubs for boarding students that maintained club houses in Club Village were X.L., Tri-K, Anti-Pandora, T.C. (Twentieth-Century), Del Vers, Penta Tau, Osiron, Agora, A.K., and F.F. Day; school clubs that met in a separate facility were Angkor, Triad, Eccowasin, and Ariston. These four day school clubs still exist today at Harpeth Hall.

256. Ibid.

257. Ibid.

258. *Bulletin*, "May Day Revisited" (Spring 1983). Belmont College.

259. Ibid.

260. Harpeth Hall modified this tradition in a way that remains more compatible with modern notions of girls' education, intellectual achievement, professional

opportunity, and gender roles. Harpeth Hall continues to name a "Lady of the Hall" each year, perform a Step Singing exercise as part of Commencement Exercise, and wear white dresses for graduation. For more, see Chapter 6.

261. *Annual Catalog and Announcement for the Ward-Belmont School*, 1927–28.

262. Ibid., 70–71.

263. Ibid., 1920–24.

264. Ibid., 1925–47.

265. Ibid., 1950–51.

266. Ibid.

267. DeBare, *Where Girls Come First*, 95.

268. Avery, *Best Type of Girl*, 254.

269. Ibid., 1935–42. Only since the 2000s, with educational initiatives in STEM (science, technology, engineering, and math), have girls' schools begun to reverse this historical trend.

270. *Annual Catalog and Announcement for the Ward-Belmont School*, 1924–25, 22.

271. *Ward-Belmont Hyphen* 15, no. 9 (November 21, 1925): 4.

272. Margaret D. Binnicker, "Harpeth Hall School and Ward-Belmont," Tennessee Online Encyclopedia, January 2010.

273. Ward-Belmont School Commencement Program, May 31, 1938.

274. *Annual Catalog and Announcement for the Ward-Belmont School*, 1950–51.

275. *Milestones*, 1915–40. Dr. Joseph Burke died in 1947, two years after his retirement.

276. *Annual Catalog and Announcement for the Ward-Belmont School*, 1947–48.

277. Milton Randolph, *Nashville Banner*, March 16, 1951, reprint in *Ward-Belmont Hyphen* (March 22, 1951): 1.

278. Clarence Duncan, "CU Is Returned to Former Board," *Nashville Banner*, March 20, 1951. Cumberland University ultimately broke with the Tennessee Baptist Convention and reunited with the Cumberland Presbyterians.

279. Clarence Duncan, "Baptists Take Over Ward-Belmont; Changes Awaited," *Nashville Banner*, February 28, 1951, 1–8.

280. Ibid.

281. *Ward-Belmont Hyphen* 39, no. 22, "Resolutions Submitted to Baptist; Club Village Contributes $1000" (March 22, 1951): 1, 8.

282. The school continues many of the traditions first begun at Ward's Seminary and Belmont College for Young Women. Today, Harpeth Hall is open to grades five through twelve. There is no official relationship between Belmont University and the Harpeth Hall School.

283. Harwarth, *Women's Colleges in the United States*, 17. Also see U.S. Department of Education, *120 Years of American Education*.

284. Louise Lasseter LeQuire, "Alumna Compares Small Private College with Large University," *Ward-Belmont Hyphen* (March 22, 1951): 2–6.

CHAPTER 4

285. The Harpeth Hall emblem and motto was developed by Head of School Susan Souby and Latin teacher Pat Ottarson.

286. Other reunion organizers included Sarah Bryan Benedict, class of 1933, May Queen, and daughter-in-law of the late Andrew Benedict (vice president of Ward-Belmont from 1934 to 1938); Jane Deloney, class of 1939 and sister of Patty Chadwell; and Mary Elizabeth Cayce, class of 1928 and faculty member from 1930 to 1945.

287. Moore, *Gilly Goes to Ward-Belmont*, 82–88.

288. DeBare, *Where Girls Come First*, 94.

289. Patty Chadwell, Cum Laude Induction Keynote Speech, circa 1983, n.p., Harpeth Hall Archives.

290. *Milestones*, 1935–81; Harpeth Hall Athletic Hall of Fame Exhibit, 2014.

291. "Harpeth Hall Faculty, 1951–1952," n.p., Harpeth Hall Archives.

292. "To the Patron of the Harpeth Hall School," July 25, 1951, n.p. William Waller's wife was Elizabeth Estes Waller.

293. *Focus on Harpeth Hall*, "The Belles of Ward-Belmont," 2000–2001, 27.

294. *Ward-Belmont School Annual Catalog and Announcement*, 1950–51, 61–69.

295. Ibid., 44.

296. Morrison, *Voyage of Faith*, 24. Mountfort transitioned from teaching science to become the first full-time counselor the late 1960s. She was later named dean of faculty.

297. Ophelia Thompson Paine, interview by author, Nashville, Tennessee, July 10, 2014.

298. *Harpeth Hall Student and Faculty Handbook*, 2010–11, 5.

299. Morrison, *Voyage of Faith*, 40.

300. Ward-Belmont graduates donned traditional black caps and gowns, but from its inception, Harpeth Hall adopted white dresses for graduation, as well as Step Singing and Senior Recognition Day.

301. "George Washington Day Index," Harpeth Hall Archives.

302. Morrison, *Voyage of Faith*, 72.

303. DeBare, *Where Girls Come First*, 94.

304. There were fifty seniors, thirty-nine juniors, forty sophomores, and thirty-two freshmen. For a complete list of names, see Morrison, *Voyage of Faith*, 28–30. Full

text can be accessed via the Harpeth Hall Digital Collection, https://archive. org/details/voyageoffaithsto00harp.

305. Ibid., 34.

306. Morrison, *Voyage of Faith*, 24–26.

307. Ibid., 41. In fact, Harpeth Hall did not have a music teacher or student musical group (instrumental or choral) until the 1960s.

308. Morrison, *Voyage of Faith*, 26–27.

309. Ibid., 64.

310. *Nashville Banner*, July 22, 1975.

311. Harwarth, *Women's Colleges in the United States*, 15.

312. *Harpeth Hall School Catalog*, "History of Harpeth Hall," 1981, xv.

313. *Milestones*, 1964–70; Morrison, *Voyage of Faith*, 64–65.

314. "Heads of School," Harpeth Hall Archives, n.d., n.p.

315. *Ward-Belmont Hyphen* (August 1975).

316. Class of 1968 alumnae, interviews by author with Linda Blair Cline, Allison Hammond, Barbara Richards Haugen, Kate Cooper Leupin, Anne Beach Was, and Ophelia Thompson Paine, Nashville, Tennessee, July 10, 2014.

317. Ibid.

318. Ibid.

319. Margaret Hylton Jones, "Honor Your Favorite Teacher," *PAGE One* (September/ October 2003): 12. Professional Association of Georgia Educators.

320. Ibid.

321. Morrison, *Voyage of Faith*, 66.

322. Ibid.

323. *Harpeth Hall School Catalog*, "History of Harpeth Hall," xv.

324. Cowan, *Annie Was a Lady*, 70–71. Cowan was the cousin of Annie Allison, and *Annie Was a Lady* is a well-written account of Allison's life generally, as well as her life in Nashville from 1872 to 1950. The book is available in the Harpeth Hall library and in the archives.

325. Morrison, *Voyage of Faith*, 66.

326. *Harpeth Hall School Catalog*, "History of Harpeth Hall," xv.

327. "Board of Trustees," Harpeth Hall Archives, n.d., n.p.

328. Morrison, *Voyage of Faith*, 70.

329. Ibid., 68.

330. *Harpeth Hall School Catalog*, "History of Harpeth Hall," xv.

331. "Heads of School," Harpeth Hall Archives, n.d. n.p.

332. *Harpeth Hall School Catalog*, "History of Harpeth Hall," xv.

333. Harwarth, *Women's Colleges in the United States*, 26.

334. United States Department of Justice, "Title IX of the Educational Amendments of 1972," http://www.justice.gov/crt/about/cor/coord/ixlegal.php.

335. Class of 1968 alumnae, interviews by author, July 10, 2014.

336. Ibid.

337. Ibid.

338. *Winterim Catalog*, 1974, Harpeth Hall Digital Collection, https://archive.org/details/winterimcourse197479harp.

339. Ibid., 12.

340. The previous auditorium, built in 1961, seated four hundred and was renovated to provide additional classroom space for the humanities and social sciences.

341. Morrison, *Voyage of Faith*, 42.

342. DeBare, *Where Girls Come First*, 158.

343. Ibid., Appendix A, 334–35.

344. Herbert Moore, headmaster at the time, of Holland Hall in Tulsa, Oklahoma, "installed the Harpeth Hall Chapter into the national organization recognizing the academic excellence at the secondary school level." Morrison, *Voyage of Faith*, 73.

345. *Ward-Belmont Hyphen* (August 1975).

346. Cochran, *Celebrating Milestones*, 103.

347. DeBare, *Where Girls Come First*, 166–67. DeBare contended that there are several possible reasons for this trend, including trustee boards' preference for men as a stabilizing force during socially turbulent times as well as for fundraising purposes.

348. *Nashville Banner*, July 22, 1975.

349. *Milestones*, 1986, 86, 142, 168.

350. Beth Richardson Trescott, interview by author, Nashville, Tennessee, April 13, 2014.

Chapter 5

351. Class of 1982 alumnae, interviews by author with Louisa Gibbs Bassarate, Allison Wills Brooks, Frannie Douglas Corzine, Capell Teas Simmons, and Julia Sawyers Triplett, Nashville, Tennessee, May 5, 2014.

352. The Winterim program is a mini-term in January intended for freshman and sophomore electives and junior and senior internship and travel. The purpose of Winterim is to provide experiential learning, stimulate intellectual curiosity, and combine classroom academics with the larger world.

353. Class of 1982 alumnae, interviews by author, May 5, 2014.

354. *Milestones*, 1972–98. Emily Fuller also taught math and joined the Harpeth Hall faculty in 1972. In 1986, she became Winterim director and continued to teach

math. She was later named director of special programs, a new position created in 1989.

355. DeBare, *Where Girls Come First*, 188.

356. Franklin Road Academy also began as an all-boys' school in 1971 but began admitting girls in 1982. All of the other private schools mentioned date back to the late nineteenth or early twentieth centuries.

357. Class of 1982 alumnae, interviews by author, May 5, 2014.

358. Ibid.

359. The four male teachers in 1979–80 were history teachers Steve Kramer, Bradley Williams, and Norman Byrd and French teacher William Lauderdale. Other male faculty hired in the 1980s during a wave of hiring male faculty at girls' schools included Heath Jones, Gordon Turnbull, Mark Webb, Tom Young, Michael Goodwin, Paul Poropatic, Dr. Michael Bouton, Steve Kramer, Jim Warren, Dr. Parsons and Dr. Frontain. Peter Goodwin joined the faculty in 1981 along with Paul Tuzeneu (1984), Art Echerd (1986), Tony Springman and Tad Wert (1987), and Jim Cooper (1988).

360. DeBare, *Where Girls Come First*, 189.

361. *Milestones*, 1982–91. Ironically, full-time faculty numbers did not decrease, expanding to forty-four teachers in the high school in 1987; however, the number of faculty did shrink to thirty-seven by 1991.

362. Capell Teas Simmons, interview by author, Nashville, Tennessee, July 7, 2014. Other teachers remembered fondly as role models and excellent teachers included Janet Hensley, dean of students; Joan Metz Warterfield, English teacher; Dugan Coughlan Davis, Middle School English teacher; Ginger Osborn Justus, JD, philosophy and psychology teacher; and Anita Woodwock Schmid, counselor and psychology teacher.

363. Ibid.

364. Beth Blaufuss, "Twin-H Rance Loses First Family," *Logos II* 8, no. 5 (May 1988). Betsy Turnbull served as both an administrator and American history teacher until 1988, when Betsy, Gordon, and their son, Alec, moved to Virginia.

365. *Milestones*, 1989, 60.

366. Ibid., 1988, 70.

367. Ibid.

368. "Heads of School," Harpeth Hall Archives.

369. Ibid.

370. Leslie Matthews, interview by author, Nashville, Tennessee, May 9, 2014. The 1985 yearbook was dedicated to Matthews. By 2000, Matthews had shifted from directing the dance companies to yoga and dance classes. Beginning in 2000, Harpeth Hall dance companies performed two dance concerts, one per semester.

371. *Milestones*, 1981, 144–45.

372. "Harpeth Hall Stories," *Harpeth Hall* brochure, n.d., n.p.

373. DeBare, *Where Girls Come First*, 261. The two remaining public girls' schools by the 1990s were Girls' High in Philadelphia and Western High School in Baltimore.

374. *Milestones* 1973, 110. The team's first season ended in six wins and eight losses. Harpeth Hall's first basketball team was coached by Susan Litton Webster.

375. Permanent Exhibit, Harpeth Hall Athletic and Wellness Center. It should be noted that the first team state title for tennis was not won in 1986.

376. The rifle team was disbanded after 1988 due to the passing of Coach Emmons Woolwine. It would reemerge in 2011.

377. Harpeth Hall Athletic Hall of Fame. At the University of Florida, Caulkins won forty-nine national titles. She went on to win four gold medals and two silvers at the 1979 Pan Am games. The United States boycott of the 1980 Olympics prevented her from competing, but she broke four of her own national records at the 1981 U.S. Championships.

378. Ibid.

379. Tennessee Sports Hall of Fame, "Susan Russ," http://tshf.net/halloffame/russ-susan. Russ was inducted into the Tennessee Sports Hall of Fame in 2005. Among her accolades, Coach Russ was named NFICA Tennessee Girls Cross Country Coach of the Year (1995), Tennessee State Track Coach of the Year (1991, 1992, 2003), NFHS Sectional Coach of the Year (2003), Metro Cross Country Coach of the Year (ten times), Regional Cross Country Coach of the Year (eight times), and Regional Track Coach of the Year (eight times). In 2008, she was inducted into the TSSAA Hall of Fame. For two years, Russ served as both the PE Department chair and athletic director. In 1989, the position was split. Lori Graves would serve as PE Department chair until 2011–12.

380. *Logos*, "Legendary Coach Susan Russ Retires" (August 17, 2012).

381. Rebecca Miller, "Visors Mark the Rite of Passage," *Logos II* 9, no. 2 (October 1988). In part, the beanie hats were discontinued because the manufacturer went out of business.

382. *Milestones*, 1988, 2.

383. Ibid. Well-respected math teacher Carol Oxley retired after twenty-nine years of service (1969–98).

384. *Milestones*, 1989, 4–5.

385. *Milestones*, 1991, 2.

386. Tennessee Foreign Language Teaching Association, "Joyce Ward," http://www.tflta.org/ward.html. "From 1970 to 2007 Joyce Ward taught at The Harpeth Hall School where she served as chair of the Foreign Language Department

for fifteen years. With her passion for academic travel, she led fifteen trips from 1983 to 2006, mainly to Italy, Greece and Egypt, where students participated in archeological digs made possible through a research facility run by the University of Chicago in Egypt. She was named Outstanding Teacher of the Year in 1984 and was the first recipient of the Owen Chair for Excellence in Teaching in 1994. Additionally, she was named Tennessee Latin Teacher of the Year by the Tennessee Foreign Language Teachers Association in 1984, and received the Golden Apple Award for Teaching Excellence from Peabody College–Vanderbilt in 1997." Joyce Ward passed away in April 2013 after a long illness.

387. Cochran, *Celebrating Milestones*, 122. The average enrollment in the 1970s stood at 525 students.

388. *Milestones*, 1980–91. Faculty numbers fell in the 1980s from fifty-five members at its highest point to thirty-six teaching faculty by 1990.

389. DeBare, *Where Girls Come First*, 188.

390. Cochran, *Celebrating Milestones*, 123.

391. Garrison Forest School, "Whiney Ransome, Founding Director of the James Center," www.gfs.org/directory; DeBare, *Where Girls Come First*, 189.

392. DeBare, *Where Girls Come First*, 204.

393. Ibid., 204–7.

394. Sadker and Sadker, *Failing at Fairness*, 44.

395. DeBare, *Where Girls Come First*, 200–202.

396. The authors Brown and Gilligan described the study's participants and the study as a part of a series within the Harvard Project on Women's Psychology and Girls' Development: "At the heart of our narrative are the voices of nearly one hundred girls at the Laurel School for girls in Cleveland, Ohio…. Although most of the girls come from middle-class or upper-middle-class families and the majority are white, it is important to emphasize that about 20 percent of the girls are from working-class families and are attending the school on scholarship, and that about 14 percent of the girls are of color. In this group of girls, color is not associated with low social class, and low social class is not associated with educational disadvantage." Brown and Gilligan, *Meeting at the Crossroads*, 5.

397. University of Louisville and Louisville Presbyterian Theological Seminary, "Grawemeyer Award in Education," April 28, 1992, http://grawemeyer.org/education/previous-winners/1992-carol-gilligan.html.

398. Brown and Gilligan, *Meeting at the Crossroads*, 7–10.

399. Ibid., 217.

400. Cochran, *Celebrating Milestones*, 129.

401. Ibid., 122.

402. Ibid., 124.

403. Monisha Chakravarthy, "Reese's High School Homecoming," *Teen People*, October 2005, 102–4. The author of the article, Monisha Chakravarthy, is also a 2006 alumna of Harpeth Hall.

404. *Harpeth Hall News*, "Will the Real Reese Witherspoon Please Stand Up?" (Spring 1994).

405. Chakravarthy, "Reese's High School Homecoming," 103.

406. Reese Witherspoon, e-mail message to Scottie Coombs, July 29, 2014.

407. Jenelle Riley, "Reese Witherspoon, Bruna Papandrea Push for Female-Driven Material with Pacific Standard," *Variety*, October 2014, http://variety.com/2014/film/features/reese-witherspoon-production-company-female-driven-material-1201323117.

408. *Sixty Minutes*, "Reese Witherspoon: Ready for a Change," December 21, 2014, http://www.cbsnews.com/videos/reese-witherspoon-ready-for-a-change (accessed December 22, 2014).

409. Chakravarthy, "Reese's High School Homecoming"; Witherspoon, e-mail message to Scottie Coombs, July 29, 2014.

410. Anne King, interview by author, Nashville, Tennessee, April 30, 2014; Cochran, *Celebrating Milestones*, 122.

411. The event was organized by Hilrie Brown, then admissions director at Harpeth Hall.

412. Cochran, *Celebrating Milestones*, 119.

413. The home has served as the residence of the head of school since 1991. The original owner of Kirkman House was William Polk Kirkman, first cousin once removed to Van Leer Kirkman, the owner of the Kirkman Building, where Ward Seminary first held classes.

414. *Milestones*, 1974–88; class of 1982 alumnae, interviews by author, May 5, 2014.

415. Carrie M. Smith, "Monica Makes the Move," *Logos II* 9, no. 2 (October 1988).

416. Admissions Office, Harpeth Hall Archives, "SACS Multi-Year Comparison."

417. Dianne Wild, interview by author, Nashville, Tennessee, May 13, 2014.

418. *Milestones*, 1997, 34.

Chapter 6

419. Collins, *Good to Great*, 1–143.

420. Ibid.

421. Committee members included Donna Clark, Joe Croker, Scottie Girgus, Peter Goodwin, Melinda Higgins, Joyce Ward, Melissa Wert, Karen Sutton, Sallie Norton, LaVoe Mulgrew (Upper School director, 1999–2005), Jess Hill (Upper School director, 2005–present), and Middle School representatives Betsy Malone (Middle School director, 1998–2008), Marees Choppin, Carole

Hagan, Adam Ross, and Robert Benson. The committee was chaired by Upper School history teacher Bonnie Moses.

422. Harpeth Hall School, "School Profile," www.harpethhall.org.

423. Jess Hill, interview by author, Nashville, Tennessee, July 3, 2014. Another recommendation was to move all teachers from a five-class teaching load to a four-class teaching load. This change was implemented in 2013.

424. Jim Collins, "Level 5 Leadership: The Triumph of Humility and Fierce Resolve," *Harvard Business Review* (July 2001): 1–5.

425. Ann Teaff, interview by author, Nashville, Tennessee, June 20, 2014.

426. *Milestones*, 2002, 106.

427. "Harpeth Hall Draft Report: Marketing Analysis and Communications Recommendations," published by Genovese Coustenis Foster, 1999, 1–3, 6.

428. Mael, Alundo et al., "Single-Sex Versus Coeducational Schooling," 77–79.

429. Harpeth Hall School, "Library and Technology," http://www.harpethhall. org/podium/default.aspx?t=151817.

430. Advancement Database, Harpeth Hall School. Edie Carell Johnson was also an active part of the Board of Trustees and served as chair, 2012–13. The Carell family set up a restrictive endowment within the school's larger endowment, equal to 20 percent of the construction costs, to assist with the building's upkeep and maintenance.

431. Ibid.

432. The Richards Room was given by alumna Barbara Richards Haugen, class of 1968.

433. The Joe C. Davis Foundation was started by Joe C. Davis Jr. in 1976. His mother was Frances Bond Davis, who graduated from Ward Seminary in 1912 and later attended Vanderbilt and Columbia Universities. The Harpeth Hall theatre is named the Frances Bond Davis Auditorium in her honor as "a lady whose life is an inspiration for young women—past, present, and future." In 1993, the Joe C. Davis Foundation made a gift of $150,000 to fund scholarships (the Frances Bond Davis Scholarships) in honor of Davis's 100th birthday. Frances Bond Davis died in 1999 at the age of 105. Joe Davis was a member of the Harpeth Hall Board of Trustees in the 1970s and was very active as an alumnus and board member at both Montgomery Bell Academy and Vanderbilt University. For more on the life of Joe C. Davis, see Wills, *Joe C. Davis Jr.*

434. *Milestones*, 2000, 113. Malone served as the director of the Middle School for ten years and retired in 2008.

435. Ibid.; Harpeth Hall Admissions Office; Harpeth Hall Archives, "New Middle School," 2002.

436. Dugan Davis passed away in 2004, just one year after the completion of the track and soccer complex built in her honor. Two of her grandchildren are also alumnae: Francis Dean (class of 2012) and Wallen Dean (class of 2014).

437. *Harpeth Hall Student and Faculty Handbook*, 2013–14, 6. The original Wallace Building was constructed in 1978.

438. Lead gifts for the Hortense Bigelow Ingram Upper School were made through the Ingram Charitable Fund, which includes Robin Ingram Patton (granddaughter), John Ingram (son), and Martha Ingram (daughter-in-law).

439. *Harpeth Hall Archives*, "A Development Assessment for Harpeth Hall School," 7. An earlier capital campaign in 1983 raised $3 million, with $1 million designated toward the endowment.

440. DeBare, *Where Girls Come First*; Dianne Wild, interview by author, May 13, 2014.

441. *Harpeth Hall Archives*, "Development Assessment for Harpeth Hall School," 21.

442. Polly Nichols was the first person to serve as alumnae director on staff. She held this position from 1973 to 1981. From 1981 to 2000, she served as the director of development of planned giving, a job that was ultimately divided into two full-time positions in 2000 when Nichols retired.

443. Additional changes were made in the Development Office. The name was changed from "Development" to "Advancement," and the Department of Communications was removed from the Advancement Office in 2005.

444. Susan Moll, interview by author, Nashville, Tennessee, May 15, 2014.

445. DeBare, *Where Girls Come First*, 211.

446. Dianne Wild, interview with author, May 13, 2014.

447. *PR Newswire*, "Girls Start Early as Technology Leaders," 2002, http://www.prnewswire.com. Contributions made by Bronson Ingram helped fund technological expansion on Harpeth Hall's campus.

448. *Harpeth Hall Student and Faculty Handbook*, 2013–14, 7.

449. Online School for Girls, http://www.onlineschoolforgirls.org. In 2010–11, Molly Rumsey served as the interim director of the OSG before her appointment as the director of library and information services at Harpeth Hall in 2012.

450. Joanne Mamenta, interview by author, Nashville, Tennessee, May 18, 2014.

451. Ibid.

452. Dianne Wild, interview with author, May 13, 2014.

453. Harpeth Hall Alumnae Annual Fund, *Harpeth Hall Stories*, brochure, n.d.

454. The Ensworth School had been a feeder school since 1958, but it opened a high school in 2004, with its first class graduating in 2008. Its announcement to expand to K–12 also influenced the decision to build a larger, more modern middle school facility.

455. Susan Moll, interview by author, Nashville, Tennessee, May 15, 2014.

456. Dr. Beveridge was board chair from 2008 to 2012 and from 2013 to 2014. Under her leadership, Harpeth Hall started and completed "The Next Step" capital campaign. The campaign co-chairs were Barabara Richards Haugen, class of 1968, and Jane Berry Jacques, class of 1972.

457. For more on the inductees to the Harpeth Hall Athletic Hall of Fame, see Harpeth Hall School, "Athletic Hall of Fame," http://www.harpethhall.org/podium/default.aspx?t=174321.

458. Wolverton, "Female Participation in College Sports."

459. National Federation of State High School Associations, "High School Participation Rate Increases for 24th Consecutive Year," http://www.nfhs.org/content.aspx?id=9628.

460. Harpeth Hall School, "50 Reasons," www.harpethhall.org.

461. The Middle School swim team began in 2003, when TISCA voted to remove eighth graders from high school teams. The swim team added its eighth state championship in 2014.

462. *Milestones*, 2000, 112.

463. On Harpeth Hall's campus, the Leigh Horton Garden was dedicated in 1985 after Ginger and Fred Horton's daughter, Leigh Horton, class of 1985, passed away from cancer in 1984.

464. The Center for STEM Education was founded in 2011, made possible by a grant from the Edward E. Ford Education Foundation and Harpeth Hall donors. This center is a national clearinghouse for research-based information and innovative practices in STEM education for girls.

465. Mary Lucille Noah, e-mail message to Susan Moll, July 1, 2014.

466. Harpeth Hall School, Harpeth Hall Mission Statement, www.harpethhall.org.

467. *Nashville Post*, "Harpeth Hall Announced New Head of School," October 29, 2013, http://nashvillepost.com/news/2013/10/29/harpeth_hall_announces_new_head_of_school.

468. Harpeth Hall School, "Head of School," www.harpethhall.org.

469. David Wood, Alumnae Directory Draft, 1988–89, Harpeth Hall Archives.

470. DeBare, *Where Girls Come First*, 202.

471. Sax, "Women Graduates of Single-Sex and Coeducational High Schools," 6.

Epilogue

472. Stephanie Balmer, "Convocation Remarks," Harpeth Hall School, Nashville, Tennessee, August 20, 2014.

473. DeBare, *Where Girls Come First*, 98.

474. The College Board, "Trends in Higher Education," 2014, https://trends.collegeboard.org/college-pricing.

475. Mary Stumb and Polly Nichols, e-mail to Susan Moll, May 13, 2014. In August 2013, Harpeth Hall launched the public phase of the 2008–14 capital campaign:

"The Next Step: Strengthening the Mind, Body, and Spirit." The goals of the campaign included a new Athletic and Wellness Center, acquisition of contiguous property, increased endowment, and a sustained Annual Giving program.

476. In 1993–98, the strategic plan called "Opening Doors" was developed to address future program, faculty and new facility needs. It raised the endowment from $2 to $9 million and raised nearly $8.5 million total. In 2000, a five-year $42 million capital campaign entitled "The Campaign for Harpeth Hall" was launched to address these needs. Another goal met during the capital campaign was more than doubling the endowment—from $9 million to more than $21 million. The Campaign for Harpeth Hall concluded in September 2005, exceeding the original goal by more than $2 million.

477. Laurel Cunningham, interview by author, Nashville, Tennessee, September 3, 2014.

478. Class of 2015, interviews by author with Lois Efionayi, Elizabeth LeBleu, and Laurel Cunningham, Nashville, Tennessee, September 9, 2014.

479. "Ann Teaff Day" presentation by Mayor Karl Dean, Nashville, Tennessee, May 1, 2014. Mayor Dean's remarks read, in part, "On behalf of all the citizens of Nashville thank you for making such a wonderful contribution to Harpeth Hall. Thank you for making such a wonderful contribution to our entire city. You will be missed. You have been great, and I, and everyone, wish you all the best."

480. Ward, "Coming Woman," 25.

481. Harpeth Hall Alumnae Annual Fund, *Harpeth Hall Stories*, brochure, n.d.

482. Harpeth Hall Archives, "The Harpeth Hall Endowment: The Challenge for Leadership," n.d., 3.

SELECTED BIBLIOGRAPHY

HARPETH HALL SCHOOL ARCHIVES, ANN SCOTT CARELL LIBRARY, HARPETH HALL SCHOOL

Archival Materials

Harpeth Hall Athletic and Wellness Center Permanent Exhibit
Harpeth Hall Athletic Hall of Fame
RG1: Ward Seminary; Belmont College for Young Women
RG2: Ward-Belmont School
RG3: Harpeth Hall School
 Patty Chadwell Collection
 Reese Witherspoon Collection
RG4: Board of Trustees
RG5: Heads of School
 Susan Souby Collection
 Idanelle McMurry Collection
 David Wood Collection
RG12: Buildings and Grounds
RG13: Alumnae/Advancement
RG15: Photographs

Periodicals

The Aitrop, 1904.
Annual Announcement of Ward's Seminary, 1877–93.
Blue and Bronze, 1904–13.
The Chimes, 1920–51.

Focus on Harpeth Hall, 2000–2001.
Harpeth Hall News, 1990–95.
Harpeth Hall School Catalog, 1951–81.
Harpeth Hall Student and Faculty Handbook, 2000–2014.
The Iris, 1898–1913.
Logos II and *Logos*, 1979–2014.
Milady in Brown, 1905–13.
Milestones, 1914–2014.
Ward-Belmont Alumnae Journal, 1925–45.
Ward-Belmont Bulletin, 1919–25.
Ward-Belmont Conservatory of Music Catalog, 1920–38.
Ward-Belmont Hyphen, 1913–51.
Ward-Belmont School Annual Catalog and Announcement, 1913–51.
Ward Seminary Bulletin, 1900–1910.
Ward Seminary Junior School Catalog, 1910–12.
Winterim Catalog, 1974–2014.

Miscellaneous

Concerning Miss Edith Margaret Smaill. Brochure.
Ward, William E. "The Coming Woman." *Annual Commencement of W.E. Ward's Seminary for Ladies*, 1885–86.
W.E. Ward's Seminary. *Second Annual Commencement.* June 26, 1867.

Interviews

Louisa Gibbs Bassarate
Allison Wills Brooks
Linda Blair Cline
Scottie Fillebrown Coombs
Frannie Douglas Corzine
Laurel Cunningham
Lois Efionayi
Peter Goodwin
Allison Hammond
Barbara Richards Haugen
Jess Hill
Anne King
Janette Fox Klocko
Elizabeth LeBleu
Kate Cooper Leupin
Joanne Mamenta
Leslie Matthews
Susan Moll
Jean Ward Oldfield
Ophelia Thompson Paine
Molly Rumsey

SELECTED BIBLIOGRAPHY

Capell Teas Simmons
Tony Springman
Ann Teaff
Beth Richardson Trescott
Julia Sawyers Triplett
Anne Beach Was
Dianne Wild

ADDITIONAL ARCHIVAL MATERIALS
Belmont University Special Collections

Announcement and Prospectus of Belmont College, 1890–1912.
Annual Announcement and Catalog of W.E. Ward's Seminary, 1877–78.
Conservatory of Music Collection.
Faculty brochures and promotional materials.
Rosalyn Kirsch Scrapbook, class of 1920.

Tennessee State Library and Archives

Kenneth Daniel Rose Papers, 1879–1957.
Ward-Belmont Collection, 1913–51.

Periodicals

Baptist and Reflector, 1912.
Confederate Veteran, 1894–96.
Cumberland Presbyterian, 1906.
Davidson County Census, 1890–1930.
Evening Herald, 1890–91.
Musical Herald, 1908.
Nashville Banner, 1890–1975.
Nashville Daily American, 1890–91.
Nashville Tennessean and *The Tennessean*, 1912–89.
New York Times, 1987.
Times-Picayune, 1873.
U.S. Census Bureau Report, 1880–2010.

OTHER SOURCES

Avery, Gillian. *The Best Type of Girl: A History of Girls' Independent Schools*. London: Andrè Deutsch, 1991.

Benedict, Sarah Bryan, Sarah Colley Cannon, and Mary Elizabeth Cayce. "The Bells of Ward-Belmont: A Reminiscence." *Tennessee Historical Quarterly* 30 (Winter 1971): 345–68.

Binnicker, Margaret D. "Harpeth Hall School and Ward-Belmont." Tennessee Online Encyclopedia. http://tennesseeencyclopedia.net.

Brée, Malwine. *The Leschetizky Method: A Guide to Fine and Correct Piano Playing.* Mineola, NY: Dover Publications, 1997.

Brown, Lyn Mikel, and Carol Gilligan. *Meeting at the Crossroads: Women's Psychology and Girls' Development.* Cambridge, MA: Harvard University Press, 1992.

Brown, Mark. "Adelicia Acklen." Tennessee Online Encyclopedia. http://tennesseeencyclopedia.net.

Button, Warren, and Eugene F. Provenzo, eds. *History of Education and Culture in America.* 2nd ed. Englewood Cliffs, NJ: Prentice Hall, 1989.

Cannon, Sarah. *Minnie Pearl: An Autobiography.* New York: Simon and Schuster, 1980.

Cochran, Heather, ed. *Celebrating Milestones: The Life and Legacy of the Harpeth Hall School.* Nashville, TN: FRP, 2001.

The College Board. "Trends in Higher Education." https://trends.collegeboard.org/college-pricing.

Collins, Jim. *Good to Great: Why Some Companies Make the Leap and Others Don't.* New York: HarperCollins, 2001.

———. "Level 5 Leadership: The Triumph of Humility and Fierce Resolve." *Harvard Business Review* (2001): 66–76.

Colton, Elizabeth Avery. "Standards of Southern Colleges for Women." *The School Review* 20 (September 1912): 458–75.

Cowan, Dakie C. *Annie Was a Lady: A Biography of Annie Claybrooke Allison.* Nashville, TN: First Printing, 1985.

Cumberland Presbyterian Church. "Ira Landrith." http://www.cumberland.org/hfcpc/minister/LandrithIra.htm.

Davis, Louise. "A Quiet, Even Growth." *Nashville Tennessean Magazine* (November 28, 1948).

DeBare, Ilana. *Where Girls Come First: The Rise, Fall, and Surprising Revival of Girls' Schools.* New York: Penguin Books, 2004.

Dewey, John. *Democracy and Education.* New York: MacMillan Publishing, 1944.

———. *Experience and Education.* New York: Collier Books, 1938.

———. *Moral Principles in Education.* Boston: Houghton Mifflin Company, 1909.

Doyle, Don. *Nashville in the New South, 1880–1930.* Knoxville: University of Tennessee Press, 1985.

Duncan, Ivar Lou Myhr. *A History of Belmont College.* Nashville, TN: Belmont College, 1966.

Farnham, Christie Anne. *The Education of the Southern Belle: Higher Education and Student Socialization in the Antebellum South.* New York: New York University Press, 1994.

Goodenow, Ronald K., and Arthur O. White, eds. *Education and the Rise of the New South.* Boston: Hall Publishing, 1981.

Hale, Will T., and Dixon Lanier Merritt. *A History of Tennessee and Tennesseans.* New York: Lewis Publishing Company, 1913.

Harpeth Hall Archives. "A Development Assessment for Harpeth Hall School." Lyndhurst, NJ: Marts and Lundy Inc., 1999.

Harvard Crimson. "Harvard Men Try Out for Wellesley Parts: Innovation Calls for Men to Carry Male Roles in 'The Man of Destiny' Under Auspices of Dramatic Club." February 8, 1932.

Harwarth, Irene. *Women's Colleges in the United States: History, Issues, and Challenges.* Washington D.C.: U.S. Department of Education, 1997.

Horowitz, Helen Lefkowitz. "The 'Hateful' Wellesley Inaugural Address." *Wellesley* (1995).

Ikard, Robert. "Nashville Conservatory of Music." Tennessee Online Encyclopedia, 2010, http://tennesseeencyclopedia.net.

———. "Signor de Luca and the Nashville Conservatory of Music." *Tennessee Historical Quarterly* 60 (2001): 176–94.

Ingram, Martha. *Apollo's Struggle: A Performing Arts Odyssey in the Athens of the South, Nashville, Tennessee.* Franklin, TN: Hillsboro Press, 2004.

James, Edward T., Janet Wilson James, and Paul S. Boyer. *Notable American Women: A Biographical Dictionary.* Cambridge, MA: Harvard University Press, 1971.

Jones, Margaret Hylton. "Honor Your Favorite Teacher." *PAGE One* (September/October 2003): 12.

Kendall, Elaine. *"Peculiar Institutions": An Informal History of the Seven Sister Colleges.* New York: Putnam, 1976.

Killebrew, Joseph Buckner. *Report of J.B. Killebrew, Assistant Superintendent of Public Instruction for the State of Tennessee to the Thirty-eighth General Assembly.* Nashville, TN: Jones, Purvis & Company, January 1873.

Lasser, Carol, ed. *Educating Men and Women Together: Coeducation in a Changing World.* Urbana: University of Illinois, 1987.

Leonard, John William, ed. *Woman's Who's Who of America.* New York: American Commonwealth Company, 1915.

Lucas, Christopher. *American Higher Education: A History.* New York: MacMillan, 2006.

Mael, Fred, Alex Alundo et al. "Single-Sex Versus Coeducational Schooling: A Systematic Review." *U.S. Department of Education Office of Planning, Evaluation, and Policy Development.* Washington D.C.: U.S. Department of Education, 2005.

McCandless, Amy Thompson. "Progressivism and the Higher Education of Southern Women." *North Carolina Historical Review* 70 (July 1993): 302–25.

McRaven, Henry. *Nashville: "Athens of the South."* Chapel Hill, NC: Scheer & Jervis, 1949.

Montgomery, Rebecca. *The Politics of Education in the New South: Women and Reform in Georgia, 1890–1930.* Baton Rouge: Louisiana State University Press, 2006.

Moore, Gilbertine. *Gilly Goes to Ward-Belmont.* Nashville, TN: Benson Printing, 1973.

Morrison, Louise Douglas. *A Voyage of Faith: The Story of Harpeth Hall.* Nashville, TN: First Printing, 1980.

Nashville: An Illustrated Review of the Progressive Importance. Nashville, TN: Enterprise Publishing Company, 1885.

Nashville Board of Trade. *Yearbook of the Nashville Board of Trade.* Nashville, TN: Marshall & Bruce Company, 1907–8.

Pethel, Mary Ellen. "'The Coming Woman': Ward Seminary, 1865–1913." *Tennessee Historical Quarterly* 72 (Fall 2013): 183–204.

Reich, Nancy. *Clara Schumann: The Artist and the Woman.* Revised ed. Ithaca, NY: Cornell University Press, 2001.

Rich, Burdett A., ed. *The Lawyers Reports Annotated, Book XXI, 1893.* Rochester, NY: Lawyers Co-Operative Publishing Company, 1915.

Riley, Jenelle. "Reese Witherspoon, Bruna Papandrea Push for Female-Driven Material with Pacific Standard." Variety, October 2014. http://variety.

com/2014/film/features/reese-witherspoon-production-company-female-driven-material-1201323117.

Sadker, David, and Myra Sadker. *Failing at Fairness: How Our Schools Cheat Girls.* New York: Simon & Schuster, 1994.

Salisbury, Merriam Lucius. *Higher Education in Tennessee.* Washington, D.C.: Government Printing Office, 1893.

Sax, Linda J. "Women Graduates of Single-Sex and Coeducational High Schools: Differences in Their Characteristics and Their Transition to College." Los Angeles, CA: Sudikoff Family Institute for Education & New Media, UCLA Graduate School of Education & Information Studies, 2009.

Sixty Minutes. "Reese Witherspoon: Ready for a Change." December 21, 2014. http://www.cbsnews.com/videos/reese-witherspoon-ready-for-a-change.

Smith, John Abernathy. *Church on the Square: A History of the First United Methodist Church Pulaski, Tennessee.* Pulaski, TN: First United Methodist Church, 2010.

Speer, William S., ed. *Sketches of Prominent Tennesseans.* Nashville, TN: Albert B. Tavel, 1888.

Tennessee Foreign Language Teaching Association. "Ward, Joyce." http://www.tflta.org/ward.html.

Tennessee Sports Hall of Fame. "Russ, Susan." http://tshf.net/halloffame/russ-susan.

United States Department of Education. *120 Years of American Education: A Statistical Portrait.* Washington, D.C.: Government Printing Office, 1993.

United States Department of Justice. "Title IX of the Educational Amendments of 1972." http://www.justice.gov/crt/about/cor/coord/ixlegal.php.

Waller, William. *Nashville in the 1890s.* Nashville, TN: Vanderbilt University Press, 1970.

Wardin, Albert W., Jr. *Belmont Mansion: The Home of Joseph and Adelicia Acklen.* 2nd edition. Nashville, TN: Belmont Mansion Association, 2002.

The West End Home Foundation. "Mary Elizabeth Cayce." https://www.westendhomefoundation.org/mary-cayce.

Wiebe, Robert. *The Search for Order, 1877–1920.* New York: Hill and Wang, 1967.

Wills, Ridley, II. *Joe C. Davis Jr.* Nashville: YMCA of Middle Tennessee, 2001.

Wisconsin Education Association Council. *Research Brief.* Madison: Wisconsin Education Association Council. http://www.weac.org/pdf/2011-12/merit.pdf.

Wolverton, Brad. "Female Participation in College Sports Reaches All-Time High." *Chronicle of Higher Education.* http://chronicle.com/article/Female-Participation-in/130431.

Woman of Courage. "Early College Women: Determined to Be Educated." St. Lawrence County, NY: Branch of the American Association of University Women, 1987.

Women in Congress, 1917–2006. "Mary E. 'Betty' Farrington." Prepared under the direction of the Committee on House Administration by the Office of History & Preservation, U.S. House of Representatives. Washington, D.C.: Government Printing Office. http://history.house.gov/People/Detail/13007.

Women Working: 1800–1930. Cambridge, MA: Harvard University Library Open Collections Program. http://ocp.hul.harvard.edu/ww/index.html.

INDEX

INDEX

INDEX

ABOUT THE AUTHOR

Author and historian Mary Ellen Pethel received her PhD from Georgia State University. She currently teaches in the Social Science Department at the Harpeth Hall School and serves as the school archivist. In addition she teaches as an adjunct in the Honors Program at Belmont University. Dr. Pethel is also a historical consultant for the West End Home Foundation.

Dr. Pethel published *Berry College: A Century of Making Music* in 2010. Other publications include "Sport and the Outward Life: Young Women Athletes as Progressive Players" in *Tennessee Women in the Progressive Era* and "Lift Every Female Voice: Education and Activism in Nashville's African American Community" in *Tennessee Women Volume II*. Her academic interests include gender and politics, American cultural and intellectual history, urban studies, and the Gilded Age/Progressive Era.